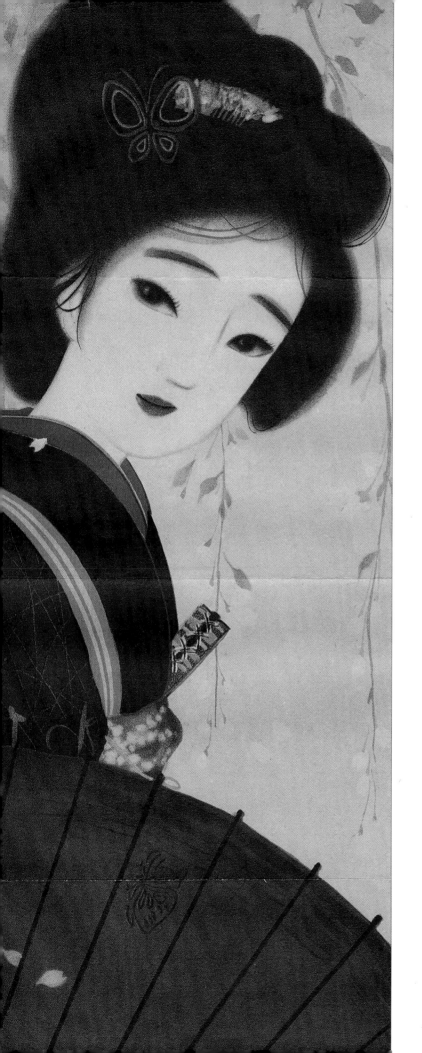

Dangerous Beauties and Dutiful Wives

Popular Portraits of Women in Japan, 1905-1925

Edited and with a Preface by
KENDALL H. BROWN

DOVER PUBLICATIONS, INC.
Mineola, New York

Bibliographical Note

Dangerous Beauties and Dutiful Wives: Popular Portraits of Women in Japan, 1905–1925 is a new compilation of images from rare albums [n.p., n.d.], first published by Dover Publications, Inc., in 2011. Every effort has been made to assure the best quality possible in the reproduction of these images; however, damage to the original prints has resulted in areas of uneven tone and unavoidable markings in the present edition. Kendall H. Brown has selected and, with the assistance of Kuniko Brown and Dr. Keiko Tanaka, identified the images and their original sources (where available) and provided detailed captions; he also has written a Preface specially for the Dover edition.

Library of Congress Cataloging-in-Publication Data

Dangerous beauties and dutiful wives : popular portraits of women in Japan, 1905–1925 / edited and with a preface by Kendall H. Brown. — Dover ed.
 p. cm.
 ISBN-13: 978-0-486-47639-1
 ISBN-10: 0-486-47639-1
 1. Women in art. 2. Prints, Japanese—20th century—Themes, motives. I. Brown, Kendall H. II. Title: Popular portraits of women in Japan, 1905–1925.
 NE1326.5.W65D36 2011
 769'.420952—dc22
 2010047039

Manufactured in the United States by Courier Corporation
47639101
www.doverpublications.com

PREFACE

Beauty for the Masses: *Bijin Kuchi-e* of the Taishô Period

Dangerous Beauties and Dutiful Wives: Popular Portraits of Women in Japan, 1905–1925 introduces *kuchi-e* (frontispiece illustrations; literally "mouth pictures") of *bijin* (beauties) from popular magazines of the Taishô period (1912–1926). Despite the long prestige in Japan of modern *bijin* paintings *(bijinga)* and the more recent status accorded the *bijin* genre in mid-twentieth century woodblock prints, advertising posters, and even postcards, pictures of beauties as frontispiece illustrations have received little notice.[1] Although it constitutes the most widespread subject and pictorial format in modern Japanese art, the *bijin kuchi-e* genre was not studied until the end of 1990, nearly a century after its ascendance. Even then, scholars focused narrowly on works in the woodblock medium from the late Meiji era (1868–1912) in the magazine *Bungei kurabu* (Literature Club).[2]

As such, the images here present an untapped resource for the study of Taishô visual culture. Thousands of different designs were created, with many produced in editions numbering in the tens of thousands or greater. Most basically, these *kuchi-e* demonstrate the growing diversity of reprographic techniques that are a key index of Japanese modernity. More critically, as signal images in new "mass culture" *(taishû bunka)* magazines, they point to some fundamental values within popular culture and to the female consumers who were their primary audiences. These humble pictures illuminate the critical role of the *bijin*—the quintessential Japanese woman— in debates about the identity of the modern nation and the role of art.

These *kuchi-e* also constitute a trove of "undiscovered" artworks that disclose important lessons for the study of Japanese art and artists in the interwar years. They mediate between the modern categories of "fine art" and "popular art," simultaneously linking and distancing them. They are created by artists whose success can be measured by the amount of work they were paid to produce, or by their acceptance at government art salons. *Kuchi-e* also provided a source of regular income that allowed artists to pursue careers as exhibition-hall artists. *Bijin kuchi-e* were a means by which ideas about "fine art," along with the names and styles of artists competing in that arena, were disseminated to mass audiences. And for those artists whose work in other formats earned them a place in modern Japanese art history, their *kuchi-e* demonstrate important early developments in theme and style.

Ubiquitous in their own time, *kuchi-e* have become all but invisible in ours. Reasons for the dearth of attention paid *bijin kuchi-e* extend from obvious issues of quality and rarity to nuanced matters of style and content. First, unlike their more illustrious late-Meiji predecessors rendered through the woodblock printing technique, with its respected artisans and old pedigree, these works were created through the modern Western techniques of lithographic or photo offset printing. Not merely lacking cachet, these processes often rendered an artist's design with less precision and chromatic intensity than did woodblock printing. The fact that *kuchi-e* were folded once or twice to fit into the magazines produced residual creases, the literal imprint of their second-class status. In addition to these physical defects, the enormous print runs reinforced their position as "paper ephemera" rather than as art objects. Thus, collectors ignore Taishô *kuchi-e* in favor of "genuine" paintings, prints, or woodblock-printed *kuchi-e* from late Meiji by the same artists.

Second, in terms of style, Taishô *bijin kuchi-e* may seem too conservative, too diverse, and, paradoxically, too repetitive. In an era when avant-garde artistic styles

were being adapted from European painting and prints, *bijin kuchi-e* avoided obvious signs of art's historical progress. Yet, compared with the lyrical mix of Western naturalism and Japanese ukiyo-e sensibility that unifies *bijin kuchi-e* from late Meiji, Taishô examples lack a dominant approach or aesthetic sensibility. Although most were made by artists affiliated with *nihonga* ("Japanese painting" utilizing pre-modern materials, formats, and subjects), some were made by artists in the competing *yôga* (Western-style painting) camp. A few borrow the styles of Art Nouveau or Impressionism, while others recall ukiyo-e in style and the bust-length portrait associated with Utamaro (Fig. 1). Many seem like *nihonga*-style *bijin* paintings writ small.

Third, thematically, these mass-circulated images of women from the 1910s evince a kind of emotional affect aimed at a growing middle-class audience of young

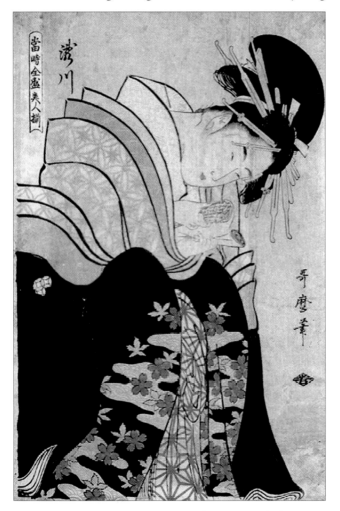

Fig. 1. *Kitagawa Utamaro. Takigawa from* Array of Supreme Beauties of the Present Day, *c. 1794. Scripps College, Claremont, California. 97.1.1.*

Japanese women that reads as maudlin sentimentality for viewers in other times and places. In their original context in magazines, these *bijin kuchi-e* served as a kind of visual preface to the contemporary social issues discussed in the articles and the familiar romantic struggles narrated in the serialized fiction. While the tension between themes of government-sanctioned morality and personal independence was widely relevant in Taishô, when the images are cut off from their immediate cultural frame, it becomes difficult to empathize with the messages and their sensibility.

Finally, not only are these pictures pulled out of their social frame, they also are unmoored from their physical context. In magazines, they participated in a visual dialogue with a variety of images of women, including color cover designs *(hyôshi-e),* monochrome illustrations *(sashi-e)* in the fiction, photos of persons in the news, and advertisements.[3] The magazines are display spaces and meeting grounds for a vast range of styles, themes, reprographic techniques, and functions. Together with the cover images that they often resemble, the frontispiece pictures give the *bijin* an iconic status.

In the visual cacophony that was the modern magazine and modern society, the *kuchi-e bijin* stood as a familiar figure, a beacon of cultural continuity even while still signaling the possibility of adaptation. Although these images—like the women's magazines in which most appeared—were marginalized by modernist critics and collectors who disdained their conservatism and lack of "authenticity," in the present age we may well find some merit in the values of Taishô women and their icons. In fact, Kaburaki Kiyokata, arguably the leading establishment *bijinga* painter and perhaps the most prolific *bijin kuchi-e* illustrator, wrote that he preferred to have his work published in lithography, collotype, or three-color offset printing because, relative to woodblock printing, they better reproduced his ideas and thus allowed him greater creativity in his painted designs. Further, these new technologies imparted a kind of "moist" (atmospheric) sensibility suited to his style and theme.[4]

Towards Modern *Bijin* Pictures

Seen *en masse* and out of context, *bijin kuchi-e* may seem like a cliché of Japanese art, an image of a kimono-clad beauty so familiar that we are tempted to dismiss

it altogether or to denigrate it as the "wrong kind" of modern Japanese art. Yet, at the very least, these *bijin* connect to a long history of beauties in Japanese and Asian culture. As a pictorial category in China, representations of beauties date to at least the tenth century, when early Song dynasty texts refer to a painter specializing in *meirenhua (bijinga),* a subject distinct from the older theme of palace ladies. By the late Ming dynasty (1368–1644), the genre was widespread among commercial urban painters. In Japan, *Bijin* is listed after *Shinnyo* (Divine Women) and *Retsujo* (Brave Women) in Kano Ikkei's *Kôsoshû,* a compendium of Chinese pictorial themes published in 1621. While Ikkei's thirty-six *meiren/bijin* subjects are Chinese, Japanese painters at the time were also depicting contemporary Japanese women in the latest clothing and hairstyles. By the end of the seventeenth century, artists designing for the rapidly expanding market of woodblock prints frequently depicted fashionable young beauties, designating them as *bijin* in titles. Literally meaning "beautiful person," *bijin* sometimes referred to males as well as females, and both were the subjects of erotically charged art.[5] By the end of the eighteenth century, *bijin* denoted women almost exclusively and was applied to paintings and prints of courtesans and geisha as well as shopgirls and non-professional women of all classes by such noted ukiyo-e luminaries as Sukenobu (1671–1750), Harunobu (1725?–1770), Kiyonaga (1752–1815), Utamaro (1753?–1806), and Eisen (1790–1848). [6]

In the Meiji period, this association of *bijin* with a wide range of contemporary women—including the potentially subversive courtesan and geisha—continued in such series as *Shinbijin* (New Bijin, 1897; Fig. 2) and *Meisho bijin awase* (Comparison of Famous Places and Beauties, 1897) by Chikanobu (1838–1912). Similar styles redolent of old ukiyo-e prints and book illustration were initially deployed to illustrate new literature, the familiarity of the pictures balancing a literature that often sought new effects and language. With the dramatic rise in large-scale publishing brought about by expanding literacy and modern transportation, serialized fiction began to appear in newspapers and magazines and in book form. Frequently, black-and-white pictures were inserted to break up the lengthy text and to help readers—many of them only recently and marginally literate—to better visualize the stories.

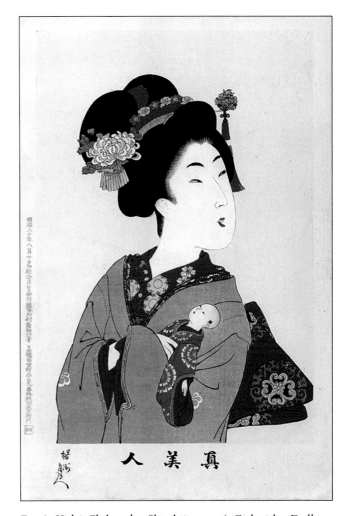

Fig. 2. *Yôshû Chikanobu.* Shin bijin, no. 4, Girl with a Doll, *1897. Scripps College, Claremont, California. Purchase by the Aoki Endowment for Japanese Arts, SC2001.2.92*

By the late 1890s, a new generation of artists was employed to create illustrations that connected better with contemporary literature. Termed *sashi-e* (literally, "insert picture"), these illustrations had to be fresh in spirit and able to capture the emotional resonance of the fiction they accompanied. Artists like Watanabe Seitei (1851–1918), who had studied in Paris for three years, sought to capture the spirit of observation suggested by photography and rendered it through the drawing-in-the-round and illusionistic space of Western art, then merged it with some of the graphic devices of Japanese woodblock prints and the sensibilities of lyrical Shijô-style painting. Often, the artist produced a full-color painting of the design, or fully painted the keyblock print, which the carver and printer than rendered in print form to preserve the feeling of the brush painting. This process, called *sashiage,* differed markedly from

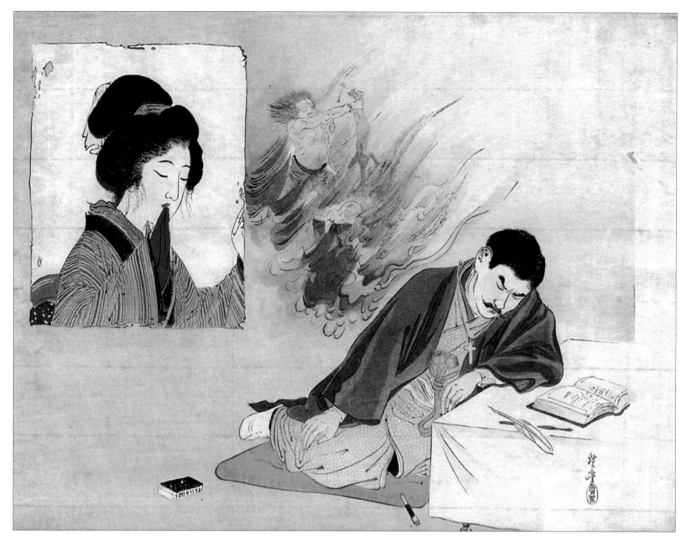

Fig. 3. *Terasaki Kôgyô. "Beauty in the Dream, The Holy Cross," published in* Bungei kurabu, *c. 1900-10.*
Scripps College, Claremont, California, 2008.1.10

the traditional method in which the artist made a monochrome drawing and then wrote the names of the colors to be used in each area.

In the competitive, and potentially highly lucrative, world of book sales and rentals, publishers soon began to commission artists to create full-color prints that were "folded into" *(orikomi)* the front of books. These *kuchi-e* and their creators soon became an indispensible part of late Meiji publishing. In 1895, the publishing company Hakubunkan launched the popular literature magazine *Bungei kurabu,* featuring lavish woodblock-printed *kuchi-e* by leading illustrators. The following year, the publisher Shun'yôdô relaunched the rival *Shin-shôsetsu* (New Novels), also featuring color *kuchi-e,* though reproduced in woodblock, lithograph, and (from 1902, exclusively) collotype.

Initially, the frontispiece illustrations for both magazines showed figures from each issue's lead story. Although *Shin-shôsetsu* maintained this approach, using *yôga* and *nihonga* artists to design their covers and *kuchi-e, Bungei kurabu* quickly began to feature *kuchi-e* not directly related to the stories. Reportedly, artists late in meeting their deadlines did not read the stories, instead substituting generic *bijin* images linked to the season, to the twelve animals of the zodiac, or to nothing at all. *Bungei kurabu* featured only one *bijin kuchi-e* in 1895, and several more in 1896, but from 1897 began to use *bijin* predominately for their frontispiece pictures. In the twenty years until they stopped issuing woodblock-printed *kuchi-e* in 1914, the magazine featured 295 *kuchi-e* by twenty-two artists (Fig. 3). Of these, 228 were unrelated to the stories, and all but one featured a *bijin.*[7]

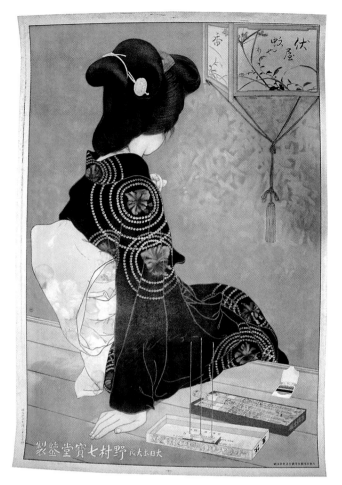

Fig. 4. *Kitano Tsunetomi. Poster for Nomura Shippôdô, c. 1910. Collection of Darrel C. Karl.*

The New Status of *Bijinga* and the *Bijin*

The disengagement of *kuchi-e* from narrative took place within lively debates that sought to extend the designation of "fine art" beyond large-scale sculpture and painting. In 1907, the painter and leading illustrator Kajita Hanko (1870–1917) wrote that in order to be different from *sashi-e, kuchi-e* should connect to the narrative by bringing out the main character's personality, yet maintain their integrity as paintings by exhibiting a strong aesthetic sense. Hanko concluded that *kuchi-e* should evolve from being something like ukiyo-e prints to an identity like that of pure painting; as such, *kuchi-e* artists were of a higher status than mere illustrators.[8] Itô Shinsui reiterated this idea in the early 1920s, signaling the status of *kuchi-e* as quasi-independent pictures in Taishô.[9]

The standing of *bijin* illustration is connected to the rise of *bijinga* as a distinct category within the new discursive realm of fine art *(bijutsu).*[10] Theoretically, the concept of beauty *(bi)* links *bijutsu* and the *bijin* linguistically and

philosophically, associating both with the field of aesthetics *(bigaku),* and distancing Japanese art from mere functionality and distinguishing Japanese beauties from the servile status of the geisha. Socially, the category of *bijinga* achieved critical mass when *bijin* paintings were displayed in the Ministry of Education's annual art exhibition (Bunten), initiated in 1907. From the 1915 Bunten, an entire room was dedicated to *bijinga*, with paintings by male and female artists hung side by side. This display contrasted dramatically with the situation at the Chicago World's Fair in 1893, where *bijin* paintings by a handful of female artists were segregated in the Women's Pavilion. Although popular with the public, the *bijin* gallery *(bijinga shitsu:* officially, the "third room") was savaged as vulgar by some critics, precipitating debate over the appropriateness of *bijin* in the national salon at a time when works by the same artists were featured in *kuchi-e,* art postcards *(bijin ehagaki),* and in the unabashedly commercial sphere of advertising posters (Fig. 4). Despite the criticism, *bijinga* continued to be exhibited in large numbers at Bunten and its successor, Teiten, throughout the Taishô and early Shôwa periods.[11]

Bunten's aim of bolstering the status of art as a measure of national prestige linked *bijin* images with the concerted attempt to redefine Japanese identity. Pictures of beauties expressed the integrity of Japanese culture in at least two ways. First, in response to dominant Western association of Japanese art with craft—the product of artisans concerned with technique, rather than artists who expressed salutary themes—the government sought to refine painting, the finest of the fine arts, by encouraging *bijinga* as a kind of rarified Japanese painting that reified Japanese concepts of beauty. Second, because Western fascination with Japan was fixated on the subservient and sexual geisha, there was a concerted effort to distance Japanese women and Japanese culture from the exotic and to reconstruct them as the exalted. Thus, the noble woman, the aspiring girl student, the pure country lass, the virtuous wife, and the self-sacrificing mother are constructs of femininity that dominate *bijin* painting from late Meiji through World War II.

Paradoxically, the rise of depictions of clothed Japanese women in *nihonga* was precipitated by the rendering of a naked French woman in *yôga.* When Kuroda Seiki (1866–1924) exhibited an oil of an unclothed European woman in *Morning Toilette,* it ignited an extensive discussion of

the Western idea of the (female) body not as an object of erotic titillation but as an allegory for elevated and eternal values.[12] The subsequent "debate on the nude" *(ratai-ron)* focused on the appropriateness of Western concepts of fine art in modern Japan, and foregrounded the notion of a distinctly Japanese feminine ideal.

One result was new attention paid to the *bijin* in *nihonga,* based, arguably, on two critical ideas. First, since *bijinga* had an illustrious history in Asian art extending from India to Japan, it could define an Asian approach to female beauty that crystallized a pan-Asian culture across space and time.[13] Moreover, within the history of depicting beauties, the emphasis on historical fashion and custom suggested a cultural evolution that culminated in modern Japan as both the "storehouse" and apex of Asian civilization. At the same time, as *nihonga* was being formulated as an art of the spirit, as opposed to the materiality of Western oil painting, the *nihonga bijin* was well suited to represent the *bijin* as both an historic reality and an abstraction of nature—a transcendent (if ambiguous) ideal that could take on all manner of associations. In sum, the *bijin* became a work of art, literally and figuratively. And she looked forward in time, as well as backward.

The rising status of *bijinga* paralleled the evolving concept of the *bijin* in literature and in the lives of women who might be termed *bijin.*[14] *Bijin* ideology included nationalistic claims to the unique purity of Japanese womanhood, calls to reform women's education to create the kind of women better suited to the imperial state, and proto-feminist interpretations that equated beauty with the strength to transcend conventional ethics. Critical discussion of the *bijin* revolved around the concepts of beauty, including differences between beauty in the abstract (imagination) and in practice (reality), beauty in nature and in art, and the relationship between inner and outer beauty. One fertile idea was that physical but idealized images of *bijin* in literature and art are based on the natural world, yet transcend that world, and as such can be appropriated by living women who then *become* actual *bijin.* In other words, the *bijin* ideal had practical consequences.

The depth and breadth of *bijin* discourse is suggested by several short-lived journals devoted to defining her: *Bijin* (1889), *Nihon no bijin* (1891) and *Bijin gahô* (1910–1911). The latter featured articles by a range of writers, including

bijin artists Terasaki Kôgyô (1866–1919) and Ikeda Shôen. There were also books devoted to the subject, including Aoyagi Yumi's *Nihon no bijin* of 1913. In addition, popular magazines of all kinds devoted articles to the *bijin* phenomenon, and art journals contained discussions on *bijinga.* For instance, the September 1910 issue of *Nihon bijutsu* was devoted to the *bijin,* offering essayists debating the definition of beauty, the conflation of beauty with women, and the connection of *bijinga* to the core values of a culture. *Bijin* discourse extended to women's education, clothing reform, marriage customs, the legality of prostitution, and a range of issues now termed "women's studies." *Bijin* discourse paid studious attention to the appearance of the modern *bijin.* The attempt to define standard features and connect them to the modern lifestyle linked *bijin* theory, *bijin* fiction and, as the pictures in this volume demonstrate, popular *bijin* art.

Picturing Beauty in Taishô *Kuchi-e*

Pictures of *bijin* constitute dense visual fields that presented their audiences with a welter of ideas both familiar and new. To the twenty-first century viewer, however, the *bijin* in Taishô *kuchi-e* may well evince a kind of banal sugariness. The elegant confections of hairstyle and kimono pattern, in combination with the flawless skin and doleful eyes, may make them seem more like brittle dolls than flesh-and-blood heroines or icons of modern femininity. Yet, these *bijin,* like those who fill the pages of popular literature, provided compelling figures for their audience. They represented not only the temporal quality of fashionability *(ryûkô),* but also were linked to supposedly timeless ideals of deportment and custom. To read the "landscape of the *bijin,*" in the phrase of literary critic Karatani Kôjin,[15] is to gain sensitivity to details of dress and nuance of depiction that span the visual and literary realms. Fiction of the era is full of descriptions of *bijin* that parallel these painterly depictions in their combination of the particular and the poetic. In art, as in literature, this dense mix of surface effects can suggest character, so that interior beauty is expressed through a code of visual cues.

Decoding the *bijin* means translating visual descriptors, understanding a diverse taxonomy of types, reading social themes, and interpreting styles. Most *kuchi-e* match typical prose descriptions of *bijin* in treating the face as countenance—a physical manifestation of personality.

For instance, the woman's skin is as white and luminous as her heart is pure and clear. Her eyes are compassionate, and her brow elegant, even noble. Her lips should be delicate but full, indicating both an abundance of passion and its control. Her face may be thin or full, depending as much on her emotional state as her genetics. Her body may be slim and as supple as a willow, or more robust following modern ideas. Her posture, whether upright or inclined, is the arrangement of the body as the expression of character or mood.

While these qualities of appearance seem to express innate qualities of character, hairstyle and clothing most dramatically signal the style of the *bijin*, and thus her sense as well as her sensibility. The hair of the *bijin* must be full, rich, and lustrous. Whether the backward-looking *shimada* for unmarried women or *marumage* for wives, or the more progressive *yakaimaki* (chignon) or *sokuhatsu* ("gathered back hair"), and their countless variations, coiffure indicates age, social status, and degree of affiliation with Japanese or Western culture. In any case, the thickness of the hair suggests vitality, and its shine implies physical and moral cleanliness. The choice of hair ornament—fashion items that may also serve as keepsakes, investments, or even weapons—potentially expresses character, as does the firmness of their placement.

Clothing is the most costly and complex aspect of appearance for the *bijin*. Clothes reflect economic and marital status but are also a matter of personal choice. While élite women and women in some modern professions wore Western clothes in public, in Taishô the majority of women still dressed in kimono. Kimono-clad *bijin* dominate *kuchi-e*, and the details of Japanese dress are an integral part of these pictures. At the very least, in its material, cut, color, and pattern, the kimono denotes season, both in the time of the year and the time in a woman's life. Lighter and brighter designs with larger, bolder motifs were appropriate for young, unmarried women, while simpler, darker and more subdued designs signaled the sober propriety of married middle age. The kimono was combined with the underkimono (*nagajuban), obi,* inner collar *(han'eri),* protective collar *(kake'eri)* and, in cold weather, a *haori* jacket. This plethora of clothing items gave female novelists and artists multiple opportunities to express fashion sense, and, as a result, personality. In Taishô, women prominently displayed the *han'eri,* often buying one in a simple color, then dyeing it to accent an outfit.

How a *bijin* looks is equaled by what a *bijin* does. In rare cases, *kuchi-e* show a woman returning the viewer's gaze, forcing a self-awareness on the viewer or suggesting a complicity in the acts of viewing and being viewed. In the vast majority of cases, however, *bijin* seem to exist for the viewer, either being posed and displayed like objects in a still life or shown engaged in some task meant to convey their character. Most often they look at something, an act that is relatively passive but at the same time mirrors the viewer's act of looking, so that subject and object exist in a kind of circle of regard. For male viewers this may signal their status as outsiders, as voyeurs; for female viewers (arguably the primary audience), it suggests the intimate and reflexive relationship of sororal equals and maternal exemplars.

In Taishô *kuchi-e, bijin* often look out a window to a nearby landscape or to gaze at plants, pose in front of flora, or, in a few cases, pick flowers or tend them. In nearly every image there is a seasonal reference so that the woman stands for the season and for the appreciation of it. Because the clothing of the *bijin* is linked to the season, the relationship is harmonious. These images invoke an ideology of naturalness by which the particular construct of feminine beauty, and its associations, are naturalized—seen as existing without contrivance. Nature also may function allegorically, so that fresh snow symbolizes purity and cherry blossoms evoke transience. The typical downward cast of the eyes suggests a gaze inward, as if to imply that the lessons of the season are being internalized by the *bijin,* who is, fundamentally, reflective. This quality of "romantic introspection" to suggest personality and an inner life was carried over from Meiji *kuchi-e,* where it often expressed melancholy or world weariness.[16]

Relative to woodblock prints from the Edo, Meiji, and even Taishô periods, *kuchi-e* include relatively few images depicting women bathing or applying makeup. These familiar scenes are downplayed or missing, as are the other usual indices of eroticism. In sum, these *bijin* are sensual without the sexuality deployed by many of the same artists in their paintings and woodblock prints. Courtesans, geisha, and other women associated with the values of the floating world are largely exchanged for wives, daughters, and other women of the imperial

state. This change is not so much the reflection of social evolution as it is the substitution of one fantasy for another. Entirely absent are the women who worked in the fields, factories, and shops of modern Japan.

When *bijin* are active, their activity is linked to the domestic sphere. In the *kuchi-e* gathered here, we see women painting, writing, reading books and newspapers, playing music, arranging flowers *(ikebana),* and grooming their children. Not surprisingly, we observe women doing the kinds of things that are described as properly feminine activities in the magazines in which these *kuchi-e* appear. That these activities, whether new or time-honored, take place in the timeless flux of seasons underscores the authority of their message.

If *bijin* were constituted physically by appearance and socially by activity, the resulting product created a *bijin* type that could be fitted into a complex taxonomy organized through temporal, geographic, cultural, and even literary dimensions. Because fashion was integral, *bijin* of different historical eras were associated with distinct styles of clothing, hair, and makeup, so that appropriating a historical style could create a particular kind of "retro" chic. Similarly, because there were regional styles, one could effect, in whole or part, an association with a Tôhoku, Tokyo, Kyoto, or other regional look. Different facial types—oval, plump, angular—were connected with different regions as well as social status groups, so that class and geographic identity could be read into a *bijin* as well as consciously projected by her. Finally, because many *bijin kuchi-e* illustrate characters in fiction or refer obliquely to them, a fuller understanding of *bijin* imagery must take into account human character types as well as literary typologies. As vital as these fictional characters were for the original audience of these pictures, they are largely lost to us now. As a result, these *bijin kuchi-e* speak in a language we struggle to understand.

Given the link between physical beauty and character, the *bijin* matrix extended to the realm of ethics. Thus *bijin* could be classified along a variety of moral criteria that lauded the pure and the healthy (and enjoyed their opposites while condemning them). There was even a brief vogue for the short-lived, sickly, or hapless *(hakumei) bijin,* who was perhaps the necessary counterbalance to the strong, demure, natural, and refined *bijin* who embodied the ostensible verities of Japanese culture. From Meiji to Taishô, the *bijin* shifted from a site (and sight) of eros, reflecting the old, playfully subversive values of the floating world, to a new stature that, according to Kiyokata, expressed the "purity, nobility, composure, intellect and modern aspect of women."[17] Within an essentially conservative view of femininity, Taishô *bijin kuchi-e* evince a subtle variety of female types, both physically and emotionally, that open them to multiple readings.

Exploration of female psychology is associated with the prints of Utamaro, and the deployment of the bust portrait in Taishô *kuchi-e* seems a conscious nod to his method of suggesting interiority. Yet, where Utamaro's prints have a graphic sharpness, with the exception of some works in a neo–ukiyo-e style, Taishô *kuchi-e* exude a distinctive softness of line and richness of atmosphere. Together with domestic themes and passive poses, this warm, painterly style seems a way of bringing the "touch" of Western-style painting into *kuchi-e* without upsetting the romantic mood. The solid texture and illusionism of Western painting is smoothly synthesized with the linearity, color harmonies, and shallow compositions of ukiyo-e just as surely as the narrative sensibility of Western illustration is combined with the iconic quality of Edo-period *bijin* prints. The mix of reality and fantasy seems both a formal process and a highly valued product, creating images of women who seem delicate yet strong. Indeed, stylistically these *bijin* hover in a twilight between the real and the imaginary. They are informed by nature but not limited by it. They inhabit the realm of the ideal.

The Physical Context for *Bijin Kuchi-e:* Taishô Women's Magazines

The *bijin* that dominates Taishô *kuchi-e* culminated in developments in the social ideology of women and the nation, and in the practice and theory of art. Practically, it depended on dramatic changes in magazine publication. Popular periodicals developed so quickly in the early twentieth century that the period of circa 1910 to 1935 has been called "the age of the magazine."[18] The growing literacy resulting from mandatory primary education and the encouragement of secondary education for girls increased the number of women able to read magazines by the 1910s. The equally rapid development of an urban, industrial economy meant that these women had the means to buy the magazines aimed at them. The Postal Mail Act of 1883 created uniformly low prices for

mailing magazines, and the completion of major rail lines in the 1890s ensured rapid distribution to most major cities. Starting in 1909 some magazine retailers were able to return unsold stock to publishers. By Taishô the consignment system of magazine sales was widespread, encouraging bookshops and other distribution points to take on a wider variety of magazines, and more copies of them. Finally, from around 1914, creation of a magazine distributors' and sellers' cooperative ended the practice of discounting, ensuring publishers a profit if their product sold well.

These institutional changes sparked a publishing revolution, with women's magazines leading the deluge of new publications that culminated with the first million-selling journal, Kôdansha's general-interest journal *Kingu* (King), in 1927, followed by *Shufunotomo* (The Housewife's Companion) in the early 1930s. Magazines, most with mechanically printed *sashi-e, kuchi-e,* and/or *hyôshi-e* (cover pictures), catered to every taste. But those intended for the housewife who aspired to a successful, modern family life achieved a critical mass. Leaving aside a handful of feminist journals like the famous *Seitô* and *Fujin kôron,* even a partial list of middle-brow women's magazines (with their start of publication) is impressive: *Shinfujin* (1888) and *Fujin shinpô* (1897), *Fujinkai* (1902), *Fujin sekai* (1906), *Fujin gahô* (1907), *Fujokai* (1910), *Shinfujin* (1911), *Shukujo gahô* (1912), *Katei zasshi* (1915), *Shin katei* (1916), *Fujinkai* (1917), *Fujin kurabu* (1920), *Reijokai* (1922), and *Josei* (1922). Added to this group were girl's magazines such as *Jogaku sekai* (1901), *Shôjo sekai* (1906), *Shôjo no tomo* (1908), *Shôjo gahô* (1912), *Shôjo* (1913), *Shin shôjo* (1915), and *Shôjo kurabu* (1923). The number of different titles produced by the same publisher points to the narrow-casting as magazines targeted specific readers of different ages, levels of education, and even politico-cultural orientation, so that by the 1920s they reached factory workers, rural women, middle-class wives, and schoolgirls of various types and interests.

According to a 1922 study conducted by the Tokyo City Office, out of 2,000 women surveyed, 1,184 read magazines; of this group, 845 read women's magazines.[19] Readers were drawn to the diverse mix of information and entertainment in these magazines, where the dominant tone of moral education found common cause with tips on cooking, child-raising, and health as well as melodramatic fiction and voyeuristically helpful confessional articles. These magazines gave women access to up-to-date information on rational domestic engineering through practical articles *(jitsuyô kiji),* even as they were informed on how they could remain *a la mode* in clothing, coiffure, and makeup through fashion articles *(ryûkô kiji).* By emphasizing consumption of the kinds of commodities sold in department stores, and by stressing the group consciousness of fashion within editorial policies that generally taught girls and women to be "good wives and wise mothers" *(ryôsai kenbo)* in accord with government directives, these magazines reinforced social norms of citizenship and gender identity even as they offered women a taste of empowerment through decision making, female networks, and contemporary models of female accomplishment in Japan and abroad.

Bijinga Themes: "Golden Fan" and Women's Fiction

For all the sound advice aimed at middle-class women, in their serial novels *(rensai shôsetsu),* women's magazines—like fiction magazines—also provided those same women with fantasies of forbidden romance, true love (in a world of arranged marriage), or even the rejection of marriage and child bearing. However, each gasp of human desire *(ninjô)* was countered by a louder ennunciation of social obligation *(giri).* The conflict between these values, with the triumph of morality, was the dominant theme of Taishô women's literature. The heroines of these stories were often subjects of *kuchi-e,* and even when they were not, generic *bijin* still evoked their spirit so that subtle hints of erotic challenge, virtuous sacrifice, or demure composure emanated from most frontispiece pictures.

To elucidate some of these themes as well as to point out the multiple points of relevance to a broad female audience, it is worth introducing the characters and plot of one typical serial novel. *Kinsen* (Golden Fan), which ran in *Shufunotomo* in 1919 to 1920 with *kuchi-e* by the distinguished female artist Shima Seien, was written by Watanabe Katei (1864–1926). Katei was famous for his novel *Uzumaki* (Spiral, 1913–14), which had ignited a vogue for spiral-shaped objects in women's fashion, goods, and graphic design. Even the bare-bones story line of *Kinsen*—leaving out the myriad plot gyrations, coincidental meetings, and near misses that would have spared heartache for the heroines—conveys the convoluted and romantic nature of popular Taishô fiction.

Fig. 5. *Shima Seien. "Girl of Sorrow, Tazuko," from* Golden Fan, *published in* Shufunotomo, *April 1920.*

Kinsen is the saga of the Hirota family, once wealthy moneylenders now struggling to survive in a changing world. When the matriarch Oetsu's husband dies, her eldest daughter, Teiko, and her adopted husband, Kanji, run the family finances into the ground. Kanji goes to Manchuria to make money, but when his letters stop, the family gives him up for dead. Desperate, Oetsu's daughter Nobuko decides to marry Tachibana Shôgo, the conflicted playboy scion of the rich Tachibana family. Soon after the marriage, Teiko marries Hosokawa Seijirô, and Shôgo begins to visit his illegitimate son Michio and his former mistress Kitano Kiyoko. Kiyoko hates Nobuko for stealing Shôgo's affections. When Kanji returns from Manchuria, seemingly with a fortune, he understands Teiko's new situation but wants to live with their daughter Shizue. He offers a huge sum to Oetsu to gain possession of the eleven year-old girl.

When Shizue does not return from school one day, Oetsu is frantic. Kanji gets a ransom note, and after he pays, he and Shizue head to Tokyo. They stop at Nagoya when Shizue comes down with a high fever. At the hospital, Kanji begins to doubt the girl's identity because of her poor education and manners. In the next room is Tazuko, a girl about the same age as Shizue, accompanied by a woman, Hisako. Tazuko suffers from an eye disease and wears black eyeglasses. The girls become friends, and Hisako and Kanji like each other. When Tazuko and Hisako suddenly leave, Kanji and Shizue move to Tokyo. They live in a large house named the Flower Mansion for its large flower garden. There, a female tutor, Sumiko, teaches Shizue. One day, Kanji meets Hisako and Tazuko and invites them to live at the Flower Mansion. Sumiko soon becomes jealous of the younger Hisako. One night Hisako overhears Sumiko talking with a strange man about killing Kanji. Later, the man abducts Kanji after Sumiko has anesthetized him. The abductor is Kitano Toraichi, the brother of Shôgo's mistress, Kiyoko. The cruel Kiyoko and her kindly son Michio initially take care of Kanji in a storehouse basement.

With Kanji absent, Toraichi comes to live with the supposed Shizue, who is really his daughter. Hisako and Tazuko are turned out and move to a small house. Hisako had been asked to care for Tazuko by her estranged elder brother, her source of money. Because Hisako has fallen in love with Kanji, she can't ask her brother for money. Now Hisako and Tazuko are both ill and penniless. Tazuko tells Hisako that she will work as a street fortune-teller. Actually, Tazuko is the real Shizue, and Hisako's brother is Shizue's adoptive father, Seijirô. Just after Hisako start to work as a servant at Kiyoko's house, Kiyoko and Michio leave and Hisako has to care for the sick man in the basement. Hisako doesn't know that the man is Kanji, but Kanji realizes that the woman is Hisako. Sumiko leaves the Flower Mansion just after Kanji 's abduction and lives happily in a large house. One night, Sumiko meets the destitute Tazuko as she tells fortunes on the street and takes her as a virtual prisoner.

Oetsu goes to Tokyo searching for her granddaughter. One night she sees a young street fortune-teller, but doesn't realize it is Shizue. Nobuko considers leaving Shôgo and the Tachibana family since Shôgo's father doesn't like her, preferring Kiyoko and her son Michio. Nobuko decides that she will be happy when everybody else is happy and goes to see Oetsu in Tokyo. Shôgo also goes to Tokyo seeking a new life with Nobuko. Nobuko runs across Shizue, who reveals the plot and asks for help. Seijirô, who had taken Shizue from Oetsu, also comes to

Tokyo, where he, Toraichi, and Sumiko are caught. In a happy ending, Kanji and Hisako get together, Nobuko and Shôgo are united, Michio is adopted by Nobuko and Shôgo, and the saintly Nobuko looks after both the real and ersatz Shizues.

Seien's *kuchi-e* help viewers visualize the protagonists and "read" their character, but, more critically, they signal the emotional tenor of each chapter. For example, in chapter sixteen (Fig. 5), "Anesthetic," the key plot line is the abduction of Kanji and Sumiko's rapid departure, but the dominant mood is of the deepening sadness for the Hirota clan. At the end of the chapter Oetsu comes to Tokyo and the Flower Mansion, looking in vain for Shizue. As Oetsu leaves, Tazuko (the real Shizue) thinks she hears the voice of her grandmother, but with her dim eyesight she is unable to recognize Oetsu—and the old lady does not realize her missing granddaughter is nearby. Seien's depiction of Tazuko, with the title "Girl of Sorrow, Tazuko *(kanashimi no shôjo, Tazuko)*," pulls the reader into the thoughts of the young heroine. In

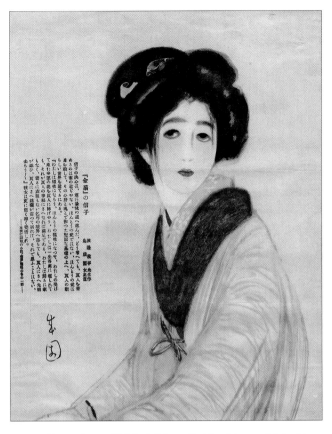

Fig. 7. *Shima Seien. "Nobuko" from* Golden Fan, *published in* Shufunotomo, *August 1920.*

similar fashion, in chapter eighteen (Fig. 6), "Street Fortune Teller," the *kuchi-e* title is simply "Hisako," and Hisako's plight at Tazuko's absence is the emotional theme. Hisako's concern is heightened when Tazuko does not return home at night, and the reader knows the situation is more dire since Tazuko has been abducted by Sumiko, and that Oetsu had, in fact, seen Tazuko plying her trade in the street but did not realize that the poor girl is actually her granddaughter.

Chapters twenty, "Sacrifice," and twenty-one, "Love Rival," juxtapose the main rivals and contrast the self-sacrificing ethos of the "good wife" with the rationalizations of the woman of pleasure. The text inserted into the picture of the noble Nobuko (Fig. 7) spells out her realization of wifely sacrifice at the critical moment when, after first deciding to leave the Tachibana family, she decides to stay with Shôgo:

Nobuko has finally reconciled herself to the "way of the wife," knowing that it is not right to blame one's husband, but rather, true love is self sacrifice. What matters is her husband's happiness. Even if she

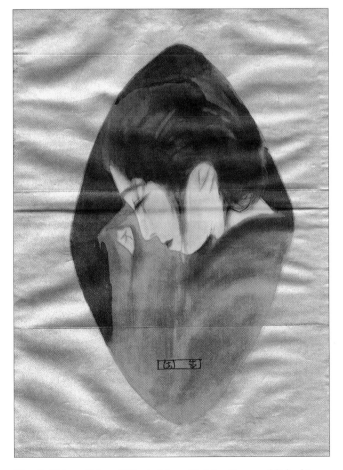

Fig. 6. *Shima Seien. "Hisako" from* Golden Fan, *published in* Shufunotomo, *June 1920.*

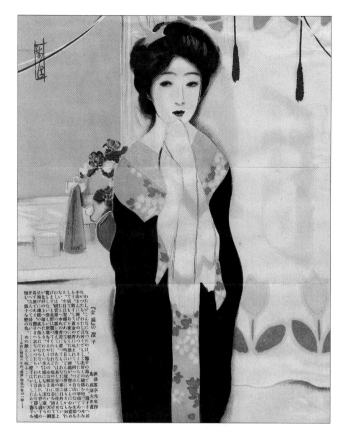

Fig. 8. *Shima Seien. "Sumiko" from* Golden Fan, *published in* Shufunotomo, *September 1920.*

> should lose a home to return to and clothes to wear, if her husband is successful and happy, this is a wife's happiness—it is true love.

In stark contrast, the picture of the coolly calculating Sumiko (Fig. 8) reveals her selfish personality and her own "back story." While Kanji suffers in captivity and Tazuko's blindness worsens, even as Nobuko and Oetsu begin to unravel the abduction plot, Sumiko seeks only to justify her life of pleasure. The text reads:

> Sumiko is thinking, "I became like this because of Hisako. If Hisako didn't exist, I could give my life to Koyama, getting rid of Kitano. In that case I would be so happy. Even if I had a good life, with the fragrance of gold, and could do anything, a feeling of guilt would haunt my mind every night. So I am never at peace; even if today is good, I fear for tomorrow. Even if I don't say anything, cutting off my own head for him, still Kitano made me a promise that I can't trust. If someone discovered what Kitano did, my shame would be exposed, and I would fall to the bottom of hell. It's all because of Hisako."

In these contexts, subtle details suggest character. Nobuko's large eyes and upward gaze signal nobility, while Sumiko's small eyes and oblique glance suggest deviousness. These types of character are underscored by elements of setting and clothing—understated for Nobuko, luxurious for Sumiko.

The subtlety of Seien's *kuchi-e* is most evident in her illustrations for the final two chapters. The *kuchi-e* for chapter twenty-three (Fig. 9), "Surprise Reunion," abjures the happy recognition of Kanji by Hisako in the basement, but instead shows the maid who carried the food to Kanji. The text synopsizes the plot development, but the viewer must imagine Kanji and Hisako in the maid's field of vision. In the final chapter, "Full Moon" (Fig. 10), Seien similarly avoids Nobuko's triumph or even nobility. Instead, Nobuko is reflective. Likely Seien captures the key moment when Nobuko, having heard from Shôgo that her father-in-law wants her to leave the family, steps into the street, where she is mesmerized by the sound of koto music. She had always played the koto to

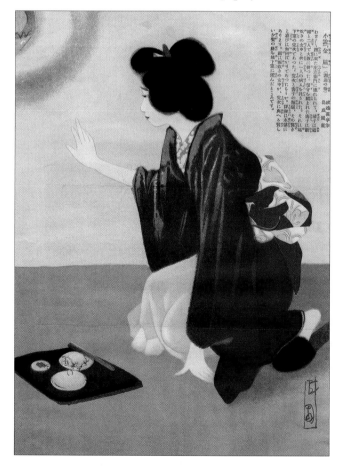

Fig. 9. *Shima Seien. "Surprise Reunion" from* Golden Fan, *published in* Shufunotomo, *November 1920.*

find self-composure. As she listens, a destitute young girl nearly runs into her. When the girl apologizes, Nobuko recognizes her voice as that of the missing Shizue (aka Tazuko). They embrace in tears. Thus, the ultimate image is of the *bijin* heroine as a model of goodness as much as an icon of fashion. Her physical appeal expresses her internal beauty.

Embodying the *Bijin* in *Kuchi-e:* Mass-Printing Technologies

To fully appreciate Taisho *kuchi-e*, we need not only know their literary content and social context but also understand the technologies used in their production. These technologies were not simply expedient means of mass production, but, in fact, were part of a visual revolution that included the desire to reproduce perfectly the images created by designers, the skilled artistry of master printers, and the creation of luxury prints meant to function as de facto works of art. For instance, in the 1910s some luxury lithographs utilized thirty metal plates to create saturated colors that were as vivid as, if not brighter than, the original painting. On average, about twenty color plates were employed for advertising posters; presumably, slightly fewer were utilized for *kuchi-e* prints.[20]

The Japanese had used stone lithography since 1874, and copperplate intaglio printing soon afterward. Zinc plate lithographic processes were deployed in the 1880s and 1890s, with photographic collotype printing developed around 1890. By 1902 three-color (red, yellow, blue) chromolithography was deployed, beginning in *Bungei Kurabu.* Kiyokata adapted it for his *kuchi-e* in 1905. In that same year, the Marinono rotary magazine printing machine was imported to Japan, allowing for much faster printing. Soon after, the American Rubel rotary press using a rubber sheet was also imported, producing high-quality color printing even on the coarse paper commonly used for mass-circulation magazines. A version of the rotary offset press was manufactured in Japan in 1913, making the technology more affordable. From around 1914 planographic offset lithography using lighter zinc and aluminum plates, rather than heavy, brittle stone plates, made printing easier and cheaper. When the Ichida Offset Printing Company started business in 1916, polychrome photographic offset printing became popular, causing a further decline in lithographic printing.

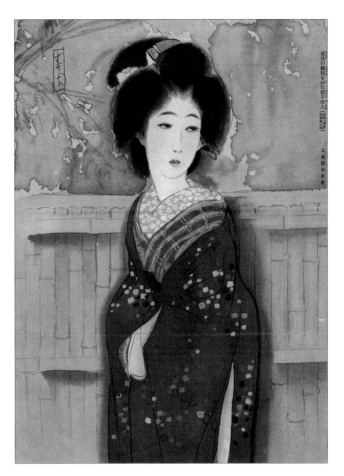

Fig. 10. *Shima Seien. "Mrs. Nobuko" from* Golden Fan, *published in* Shufunotomo, *December 1920.*

Among the *kuchi-e* reproduced here where the printer is noted in the margin, the Mitsuma Printing House (Mitsuma insatsusho) was the most prolific, producing seventeen of the prints. The company, under the leadership of Mitsuma Takatsugu, who toured America and Europe to study the latest technology, installed the latest and largest presses in 1914, eventually adding photogravure printing to its three-color process. Mitsuma produced *kuchi-e* for *Fujin sekai* and *Fujokai* from 1920 to 1924. Nearly as common here are the fourteen *kuchi-e* produced by Koshiba Photoengraving Printing (Koshiba seihan insatsu) for *Fujin gahô* in 1915 and 1916. The diffusion of the printing business is evidenced by the eight other companies whose names appear in this selection.

Economics and Female Artists

Producing *kuchi-e* provided artists with a way of honing their skill and message by developing themes and methods of expression relevant to their paintings. More immediately—along with illustration, cover art,

and other design work—it offered a consistent source of income. Data on fees paid to rank-and-file *kuchi-e* artists in Taishô is scarce, but there is some information about the economics of late-Meiji illustration for top artists. Kiyokata reported that he earned from three to seven yen per *kuchi-e* between 1901 and 1906 for his work for *Shin shôsetsu*, but, in 1906, got twelve yen from *Bungei kurabu*, and fifteen yen in 1907. According to Eihô, *Shin shôsetsu* paid him around fifteen yen for *kuchi-e* in 1902, a very high rate compared to the low fees for *sashi-e* from other magazines and newspapers. In 1907 an issue of *Bungei kurabu* or *Shin shôsetsu* sold for 50 sen, the same cost for one entrée in the restaurant at the upscale Mitsukoshi department store. [21]

As a result of these relatively low fees, artists took on numerous assignments. If not disciplined, they were forced to work frantically to meet their deadlines. In an undated note detailing the schedule for one such day, Eihô reveals that he produced two sheets of drawings for *Osaka Mainichi* newspaper in one hour; one *kuchi-e* in an hour and a half; an illustration in one hour for *Goraku sekai*; a *kuchi-e* for *Engei gahô* in five hours; and he finished with an illustration for *Bungei kurabu* that occupied two hours.[22]

Female artists are disproportionately better represented in *bijin kuchi-e* than they are in other areas of the Taishô art world. The albums purchased for this book include designs by eleven female artists from a period when women rarely had careers as artists. This remarkable figure has two causes. First, since many female artists found it impossible to make a living by selling their painting, work for magazines was essential. Second, because consumers of *bijin kuchi-e* were primarily women, female artists were thought to have a special affinity with both the subject and the audience. The female artists included here are Uemura Shôen, Ikeda Shôen, Kawasaki Rankô, Shima Seien, Kitani Chigusa, Kakiuchi Seiyô, Kurihara Gyokuyô, Kasai Hikono, Suzuki Kenko, Shiizuka Shôka and Kiriya Tenkô. There seems little doubt that *bijin kuchi-e* provided female artists with a critical social space, as well as an economic base.

The opportunities furnished by magazines matched those provided by the government with its propagation of *bijinga* at Bunten. Of the *kuchi-e* artists shown here, more than half had their work exhibited at Bunten between 1907 and 1918, with Shimazaki Ryûu, Kawasaki

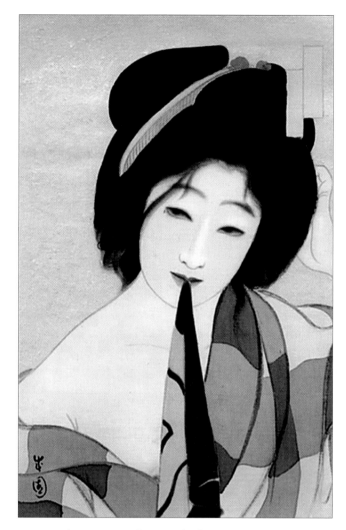

Fig. 11. *Shima Seien.* After a Bath, *from* Collection of New Ukiyo-e Beauties, c. 1924. *Collection of Darrel C. Karl.*

Rankô, Ikeda Shôen, Uemura Shôen, and Shima Seien winning prizes, awards of special selection (*tokusen),* or certificates *(hôjô).* This remarkable fact, given the tenor of the times, suggests that the rise of *bijin* pictures in all formats coincided with a brief florescence of female artists, some of whom were noted as *bijin.* In Kyoto, Uemura Shôen was making a name as one of the great artists of the age, and, in nearby Osaka, Seien became a media star for her skill as a painter of haunting *bijin* scrolls (Fig. 11), her success at Bunten in 1912 at the age of twenty, and her striking looks. By 1914 she had about ten female students, and nearly thirty by 1918, some coming from around Japan and others simply wealthy wives and daughters from the area.[23] Although Seien continued to work actively in illustration after her marriage in 1920, her fame declined as suddenly as it had risen.[23] As such, Seien's career paralleled that of several other female

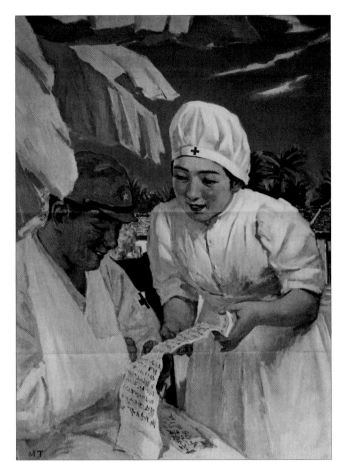

Fig. 12. *Terauchi Manjirô. "Field Hospital," published in* Shufunotomo, *September 1940. Collection of the author.*

artists in Osaka who achieved youthful notoriety in early Taishô, then quickly faded. In Tokyo, the early deaths of Ikeda Shôen in 1917 and Rankô in 1918 ended the careers of two of the most accomplished female artists, though others like Seiyô and Gyokuyô had careers teaching at Tokyo Women's Art School.

The Decline of *Bijin Kuchi-e*

The great majority of the *kuchi-e* gathered here were made between 1914 and 1921, the "golden age" of *bijin kuchi-e* reproduced by lithographic and photo-offset printing. It is hard to pinpoint any one reason for the decline of the genre, but *bijin kuchi-e* well may have been the victim of their own earlier success. Once nearly every magazine featured them, *bijin kuchi-e* became overly familiar and their appearance marked a magazine as old-fashioned and unfashionable. Best-selling *Shufunotomo* stopped including monthly *bijin kuchi-e* in 1922, and soon after started to employ more *yôga* painters to design covers. *Bijin kuchi-e* appeared in the new year's edition and

other special issues, a practice that continued through World War II (Fig. 12). *Fujokai* also stopped producing *kuchi-e* in 1922. After the Great Kantô earthquake of September 1, 1923, *bijin kuchi-e,* when still found, seemed like relics of a previous epoch.

This trend was foreshadowed in the case of *Fujin kôron,* the most progressive popular women's magazine of the era. It included *bijin kuchi-e* in its inaugural year of publication, 1916, but changed to genre scenes of modern women by oil painter Ishii Hakutei in 1917. It then featured *kuchi-e* sketches of Tokyo in the 1918 and 1919 issues, and from 1920 reproduced European oil paintings. In the competitive world of publishing in which companies sought to keep up with social trends, by the last years of Taishô, *bijin kuchi-e* were considered staid at best, retrograde at worst.

This is not to say that pictures of *bijin* went out of fashion. On the contrary, the *bijin* genre continued as the leading category of *nihonga* through the 1930s. Moreover, when publisher Watanabe Shôzaburô established the Shin hanga (new print) movement in woodblock prints in 1915, *bijinga* initially formed the bedrock of the new genre. Numerous publishers and artists worked in the *bijin* area, and it was only surpassed in popularity by landscape prints in the 1930s. Artists such as Itô Shinsui (Fig. 13) who designed *bijin kuchi-e* were also major figures in *bijin* painting and prints, their work in magazine frontispiece pictures providing both a source of inspiration and a point of departure.

Representing *Bijin Kuchi-e*

This book evolved from a pair of mysterious scrapbook albums bearing the stamp Tanakaya ("Tanaka Shop"; alternately, Tanakake, "Tanaka family"), acquired by Dover Publications in 2008. Pasted on the left-hand album pages are the woodblock-printed covers from a series of adventure novels (*kôdan*) produced by Okamoto Igyôkan in Osaka between 1898 and 1903. (These are published in the volume *Japanese Warriors, Rogues and Beauties,* Dover Publications, Inc., 2010.) The facing pages feature *bijin kuchi-e* from various magazines issued between 1917 and 1923. Because many of the Tanakaya *bijin* images were from marginal periodicals, Dover Publications purchased an album of seventy-seven *bijin kuchi-e* from a wider range of journals and, with two exceptions, produced between 1911 and 1923.

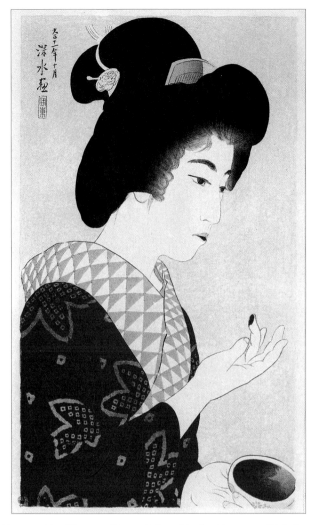

Fig. 13. *Itô Shinsui. "Rouge," from* Twelve Figures of Modern Beauty, *1922. Pacific Asia Museum.*

The *kuchi-e* are organized by region and the professional affiliation of the artist, with works arranged chronologically for each artist. We begin with the famous Hirezaki Eihô, grand student of Yoshitoshi. Next are various late-Meiji illustrators, including Kajita Hanko, Kondô Shiun, and Otake Kokkan—all of whom worked for *Bungei kurabu*. Following them are students of the illustrious Terasaki Kôgyô (1866–1919), including Kurihara Gyokuyô, Kasai Hikono, Kawasaki Rankô, and Ishiyama Taihaku, followed by the first generation of disciples of the equally renowned Mizuno Toshikata (1866–1908), including Ikeda Terukata, his wife, Ikeda Shôen, and Shiizuka Shôka. The subsequent major grouping consists of Kiyokata, a Toshikata student, and Kiyokata's followers: Ishii Tekisui, Itô Shinsui, and Kakiuchi Seiyô. Seiyô links to a group of teachers and students at Joshi bijutsu gakkô (Women's Art School), including Masuda Gyokujô, Kurihara Gyokuyô, and Kasai Hikono. Concluding the Tokyo group are Eihô's disciple, Ishii Hôshô, and the ubiquitous Igawa Sengai, a student of Tomioka Eisen. Moving to Western Japan, we show Uemura Shôen, the leading *bijin* painter from Kyoto and most famous female artist of the prewar period, and then the circle of Osaka artists around Kitano Tsunetomi, including Hata Tsuneharu, Shima Seien, Shima Gyofû, and Kitani Chigusa. The penultimate group is *yôga*-trained artists, including the former Takarazuka stage designer Morita Hisashi and the cartoonists Hosokibara Seiki and Kitazawa Rakuten. The book concludes with artists whose biographies are not yet known.

All of the images include signatures or seals, disclosing (potentially) the artist's identity. Many also have titles printed on the margin, in some cases along with the artist's name. However, the magazine from which each *kuchi-e* came is never noted on the print itself. Thus, once a frontispiece picture is detached from its publication (as was the case with the *kuchi-e* in these scrapbook albums), the origin of the images is lost. In order to rediscover the date and publication for each image, we looked at the issues of about three dozen magazines for the years 1905 to 1925. Finding the original source of an image not only provided basic publication information, but in many cases the table of contents of the magazine also gave the work's title and the artist's full name. Because *kuchi-e* were often removed from magazines, and since even the best library collections of old journals are missing issues, about fifteen

In keeping with the status of *kuchi-e* as part of mass culture, the works selected for inclusion here represent the diversity of artists, styles, subjects, and levels of sophistication. Resisting a "high art" emphasis on images by the best-known artists who are closest to their paintings, these images range from the visual poetry of famous painters to the prosaic products of unknown designers. For artists who produced prodigious numbers of *bijin kuchi-e,* we reproduce numerous examples; conversely, for the relatively infrequent contributor, we show one or two samples. To represent the diversity and relative distribution of *bijin kuchi-e,* most images come from women's magazines (*fujo zasshi),* but we reproduce some from girls' magazines (*shôjo zasshi),* and a few from literary magazines (*bungei zasshi),* entertainment magazines (*goraku zasshi),* and even one theater magazine (*engei zasshi)*—the primary genres in which *bijin kuchi-e* appeared.

percent of the *kuchi-e* in the Dover albums have yet to be identified. A handful of these "unknowns" conclude the book to indicate the on-going nature of this research and the obscurity of some artists working in this genre.

Notwithstanding this wide sample of *kuchi-e* artists, some major figures are not included, as their work was not found in the albums. Most noticeably missing is Takehisa Yumeji (1884–1934), who designed *bijin kuchi-e* for *Jogaku sekai* in 1912. Despite his small *kuchi-e* output, Yumeji was the most distinctive artist of the last years of Meiji and first years of Taishô, his impact felt in the simply drawn, large-headed, thin-shouldered beauties of his follower and lover, Kasai Hikono. Most of the *kuchi-e* artists absent here are students of the prolific Kiyokata. They include Terajima Shimei (1896–1975), Yamakawa Shûhô (1898–1944), Torii Kotondo (1900–1976), Iwata Sentarô (1901–1974), Tateishi Harumi (1908–1994), and Shimura Tatsumi (1907–1980). Many of these talented third-generation *kuchi-e* artists were published in *Kôdan zasshi*, represented here with only two works, but perhaps the Taishô equivalent of *Bungei kurabu*, the periodical that set the standard for *bijin kuchi-e* in its age. Also missing from late Taishô is the work of Takabatake Kashô (1888–1966), the most renowned illustrator of girls' magazines.

Conclusion: *Bijin* for Their Age

The fictive *bijin* who grace the *kuchi-e* of Taishô magazines are icons of their time. Printed in the newest techniques, these beauties are calibrated to mass production and mass consumption, yet they echo the basic form and broad appeal of woodblock prints of earlier generations. Their fashions are carefully a la mode, new enough to excite, and familiar enough to comfort. In character, these beauties seem to be modeled on the ostensible verities of the past in order to suggest the ideals of the present. Yet, they hint at other, more complex qualities of the human heart that link women of every historical age. In pictorial style, too, they are equally complex hybrids with the resulting sense of cultural transcendence. In words used to laud the basic spirit of the conservative art of the era, the approach is "neo-idealistic . . . expressing the Japanese characteristics by combining Eastern and Western fine art." [24]

Neither superficial fashion plate nor hollow moral exemplar, the *kuchi-e bijin* hovers between noble ideal and hazy reality. She suggests both the aspirations and the mundane truths of her audience. This *bijin* was the product of a largely male world of publishers and artists but was intended for an audience composed largely of women. She combines the sense of fine art and the sensibilities of popular illustration. She is meant to exist between the pages of an ephemeral magazine and to be detached from it, set free in an album of her peers or perhaps framed for special display. The *kuchi-e bijin* may be pinned up, but she cannot easily be pinned down.

Created at a time of growing female political and economic consciousness, at first blush these *bijin* pictures seem disconnected from their age, or, more precisely, to counteract its most progressive ideas. Arguably, they are models of feminine passivity and comfortable domesticity at a time of women's increasing assertiveness in education, in professional work, and even in politics. They present dreams of quiet contentment in an era of rising conflict. To look at these pictures at the front of women's magazines, and then read articles in those same magazines about rice riots in 1918 or suffragist rallies in 1919, may well induce a kind of cognitive dissonance. For those who champion progress, Taishô *kuchi-e* may represent a visual sedative or a cultural vaccine meant to inoculate women against modern ills.

Yet, these relatively de-eroticized images of women who appear independent from men may also be seen as invoking a kind of new female self-awareness that is resolute and affirming even while unprovocative. This realm of graceful and "natural" feminine beauty may be interpreted as an antidote, or a gentle rebuke, to the masculine domain of military aggression, mercantile struggle, and mechanical advance. As such, in the totality of their styles, themes, and presence in magazines, these *bijin kuchi-e* balance modernity and modesty to create a complex world. There, good wives, wise mothers, and aspiring daughters—with the rare dangerous beauty thrown in as spice and a negative model—stand as sentinels of family and household, the foundation stones of a modern state. For all their social utility, these *bijin* possess sufficient beauty, variety, and mystery to make these paper images compelling models for the women who consumed them and, in some ways, desired to become them.

Kendall H. Brown
Professor of Asian Art History
Department of Art
California State University, Long Beach

NOTES

1. For recent studies of inter-war Japanese *bijin* painting, see Kendall H. Brown, et al., *Taisho Chic: Japanese Modernity, Nostalgia and Deco* (Honolulu: Honolulu Academy of Art Deco, 2002); Doris Croissant, "Icons of Femininity: Japanese National Painting and the Paradox of Modernity" in Joshua Mostow, et al. eds., *Gender and Power in the Japanese Visual Field* (Honolulu: University of Hawai'i Press, 2003); for *bijin* woodblock prints, see Hamanaka Shinji and A. R. Newland, *The Female Images: 20th Century Prints of Japanese Beauties* (Tokyo: Abe Publishing, 2000); for *bijin* posters, see *Bijin no tsukurikata: sekihan kara hajimaru kôkoku posutâ* (Tokyo: Printing Museum, 2007); for postcards, see Anne N. Morse, ed., *Art of the Japanese Postcard* (Museum of Fine Arts, Boston, Massachusetts, 2004).

2. Julia Meech devotes the final dozen pages to frontispiece illustrations in *The World of the Meiji Print, Impressions of a New Civilization* (New York: Weatherhill, 1986). Helen Merritt and Nanako Yamada investigate the topic in depth in *Woodblock Kuchi-e Prints, Reflections of Meiji Culture* (Honolulu: University of Hawai'i Press, 2000), and Yamada further explores it in *Bijinga kuchi-e saijiki* (Tokyo: Bunseishoin, 2008). Miya Mizuta Lippit investigates debates over the definition, status of, and social utility of the *bijin* in literature and art in her doctoral dissertation, *Figures of Beauty: Aesthetics and the Beautiful Woman in Meiji Japan* (Yale University, 2001). The entry on *kuchi-e* in *The Hotei Encyclopedia of Japanese Woodblock Prints* does not mention that the genre continued beyond Meiji in media other than woodblock prints.

3. For a discussion of "decorated spaces" of magazines, as well as reprographic technologies, see John Clark, "Indices of Modernity, Changes in Popular Reprographic Representation," in Elise K. Tipton and John Clark, eds., *Being Modern in Japan, Culture and Society from the 1910s to the 1930s* (Honolulu: University of Hawai'i Press, 2000).

4. Kaburaki Kiyokata, "Kuchi-e hanayaka narishi koro 1" in *Koshikata no ki* (Tokyo: Chûo kôron bijutsu shuppan, 1961), 181–183.

5. Timon Screech, *Sex and the Floating World* (Honolulu: University of Hawai'i Press, 1999), 16-31.

6. See "bijinga" in Amy Reigle Newland, ed., *The Hotei Encyclopedia of Japanese Woodblock Prints* (Amsterdam: Hotei Publishing, 2005), vol. II, 423.

7. See Yamada Nanako, *Bijinga kuchi-e saijiki*.

8. Kajita Hanko, "Shôsetsu no sashie oyobi kuchi-e ni tsuite," *Waseda bungaku* (June 1907). See also Yamada Nanako, *Mokuhan kuchi-e sôron* (Tokyo: Bunseishoin, 2005) and Yamada Nanako, *Kuchi-e meisaku monogatari-shû* (Tokyo: Bunseishoin, 2006).

9. Itô Shinsui, "Sashi-e oyobi kuchi-e ni tusite," *Chûo bijutsu* 107 (October 1924), 199.

10. For extended discussions of the concept bijusu and its connection to national exhibitions, see Satô Dôshin, *"Nihon bijutsu" tanjô: kindai Nihon no "kotoba" to senryaku* (Tokyo: Kôdansha, 1996) and *Meiji kokka to kindai bijutsu–bi no seijigaku* (Tokyo: Yoshikawa kôbunkan, 1999).

11. Hamanaka Shinji, "Bijinga: the portrayal of beauties in modern Japan" in Hamanaka and Reigle, *The Female Image,* 13.

12. The controversy is discussed in Alice Tseng, "Kuroda Seiki's *Morning Toilette* on Exhibition in Kyoto," *Art Bulletin* (2009).

13. See Miriam Wattles, "The 1909 Ryuto and the Aesthetics of Affectivity" in *Art Journal* (1996), ?–? (Autumn 1996), 48–56.

14. Miya Mizuta Lippit's dissertation, *Figures of Beauty: Aesthetics and the Beautiful Woman in Meiji Japan*, is an indispensable source for the discussion of *bijin* in late Meiji literature and art theory. Much of the discussion in this section is drawn from it. Also see her article "Reconfiguring Visuality: Literary Realism and Illustration in Meiji Japan" in *Review of Japanese Culture and Society* XIV (December 2002), 9–24.

15. Karatani Kojin, "The Discovery of Landscapes" in Brett de Bary, ed. *Origins of Modern Japanese Literature* (Durham: Duke University Press, 1993), 30.

16. Julia Meech, *The World of the Meiji Print,* 217.

17. Kiyokata, *Gendai sakka bijinga zenshû* vol. I:2, paraphrased in Merritt and Yamada, *Woodblock Kuchi-e Prints,* 126.

18. The phrase is used by Kabayama Koichi in "The Age of the Magazines: From Nation to Citizen." Unless otherwise noted, the material in this section comes from that essay, and from Shinozawa Minako, "The Birth of the Million Seller: Magazines as Media in the Meiji-Taishô Era," in *Mirionserâ tanjô e, Meiji Taishô zasshi media* (Tokyo: Printing Museum, 2008).

19. Barbara Hamill Sato, "An Alternate Informant, Middle-Class Women and Mass Magazines in 1920s Japan" in Tipton and Clark, *Being Modern in Japan,* 141. Most of the information in this and the following paragraph comes from this essay or from Sato's book, *The New Japanese Woman: Modernity, Media, and Women in Interwar Japan* (Durham: Duke University Press, 2003).

20. The following information on printing techniques is from Teramoto Minako, "Technical Innovation in Lithography" in *Making Beauties—Early Japanese Lithographic Posters* (Tokyo: Printing Museum, 2007), 186–190.

21. Yamada Hajime, ed., *Kaburaki Kiyokata bunshû vol. II, Meiji tsuikai* (Tokyo: Hakuhôsha, 1979), 172. The information on Eihô is found in Matsumoto Shinako, *Sashi-e gaka Eihô—Hirezaki Eihô den* (Tokyo: Sukaidoa, 2001), 77. For further discussion of the economics of illustration, see "Binbô gaka no meshi no tane wa nan datta no ka?" *Geijutsu shinchô* (March 1994), 40–44.

22. Matsumoto Shinako, *Sashi-e gaka Eihô—Hirezaki Eihô den* (Tokyo: Sukaidoa, 2001), 5.

23. For the biography of Seien, and her work, including some *kuchi-e,* see Ogawa Tomoko, ed., *Shima Seien to Naniwa no joseigaka* (Osaka: Tôhô shuppan, 2006).

24. Fujitani Misao, *2,600 Years of Nippon Empire* (Osaka and Tokyo: Osaka Mainichi and Tokyo Nichi Nichi, 1940), 231.

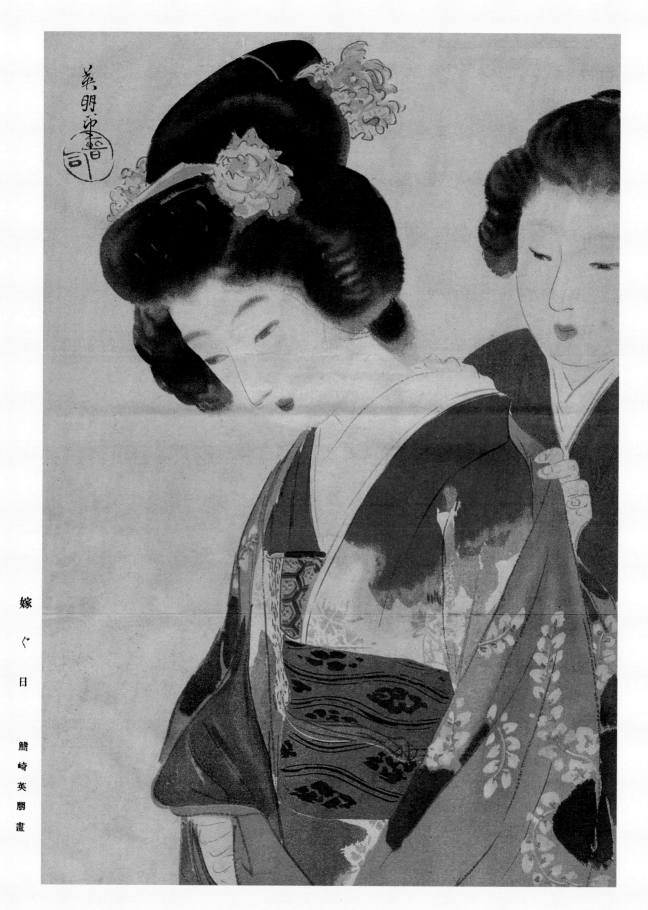

嫁　ぐ　日　鰭崎英朋畫

Hirezaki Eihô
"Wedding Day" *(Totsugu hi)*

PLATE 1

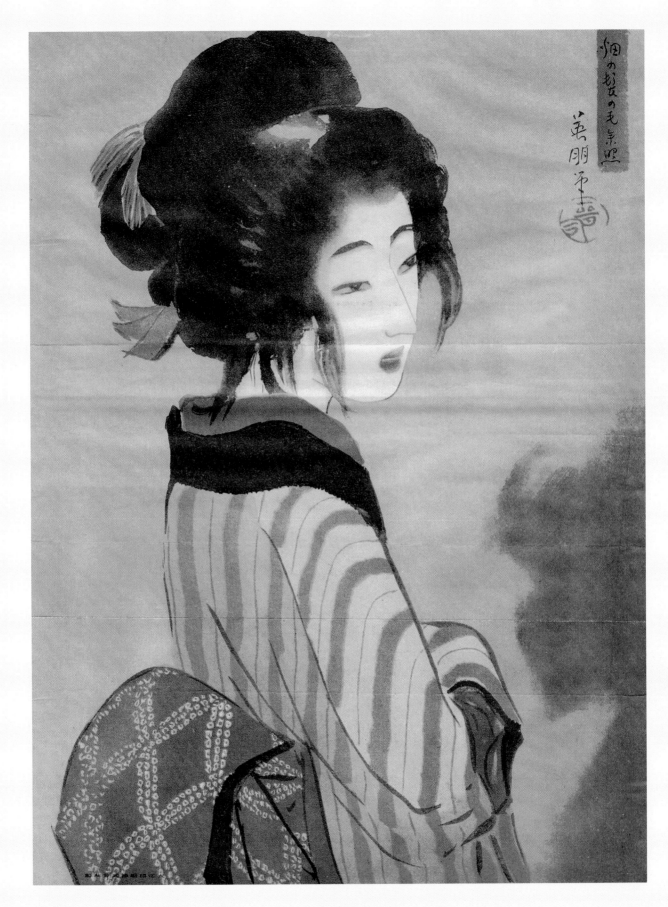

畑の髪の毛気耀

英朋市壽

Hirezaki Eihô
from *A Hair in a Field (Hatake no kami no ke)*
[a kôdan story by Chiyoda Kinkyô]

PLATE 2

夏　初

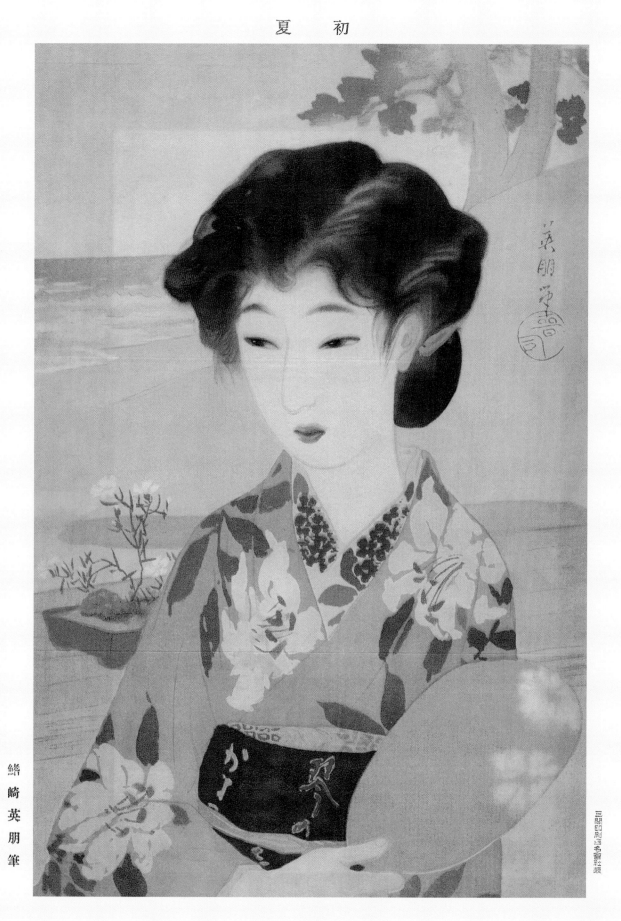

鰭崎英朋筆

Hirezaki Eihô
"Early Summer" *(Shoka)*

PLATE 3

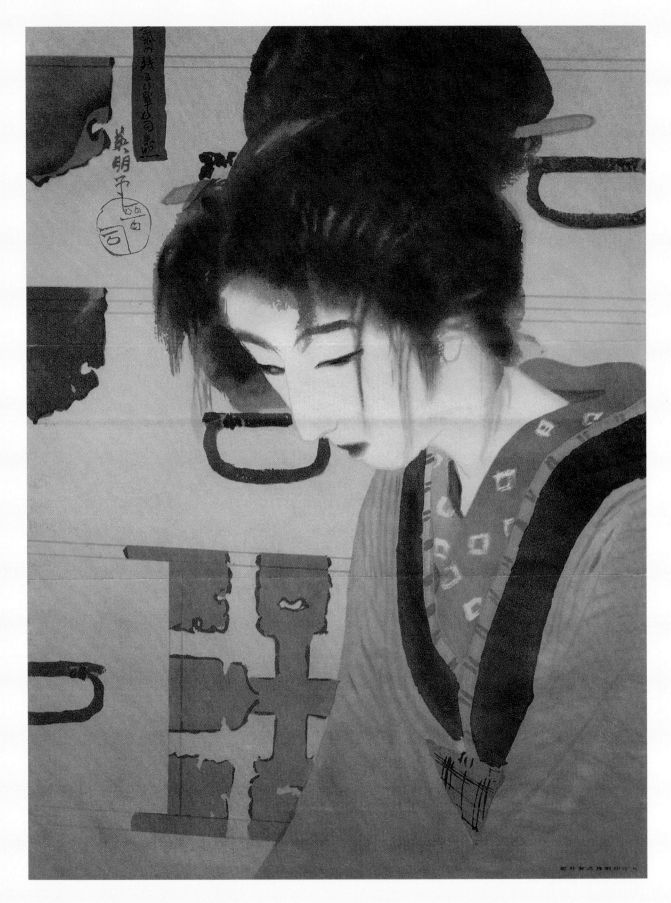

Hirezaki Eihô
from *A Chest of Drawers with a Lingering Spirit (Ki no nokoru tansu)*
[a kôdan story by Chiyoda Kinkyô]

PLATE 4

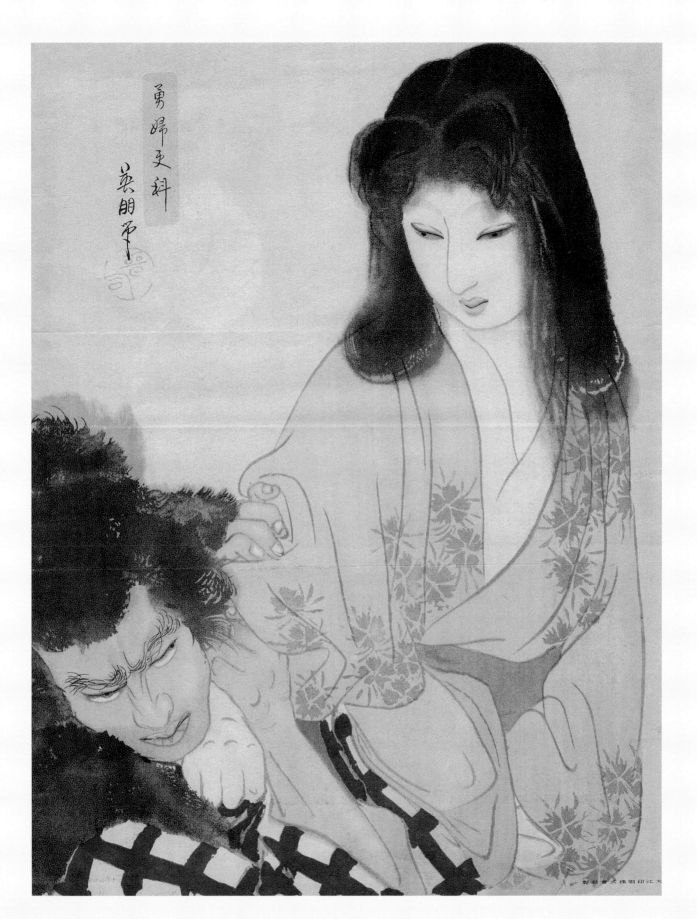

Hirezaki Eihô
from *The Courageous Woman Sarashina (Yûfu Sarashina)*
[a kôdan story by Murai Sadakichi]

PLATE 5

夜月朧

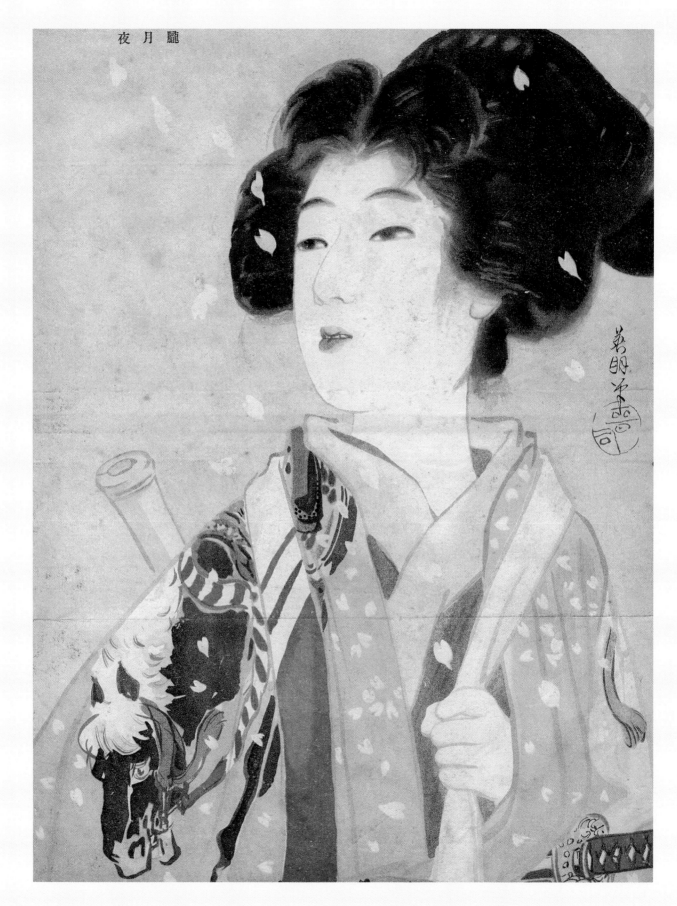

Hirezaki Eihô
"A Hazy Spring Moon Night" *(Oborozukiyo)*

PLATE 6

桃

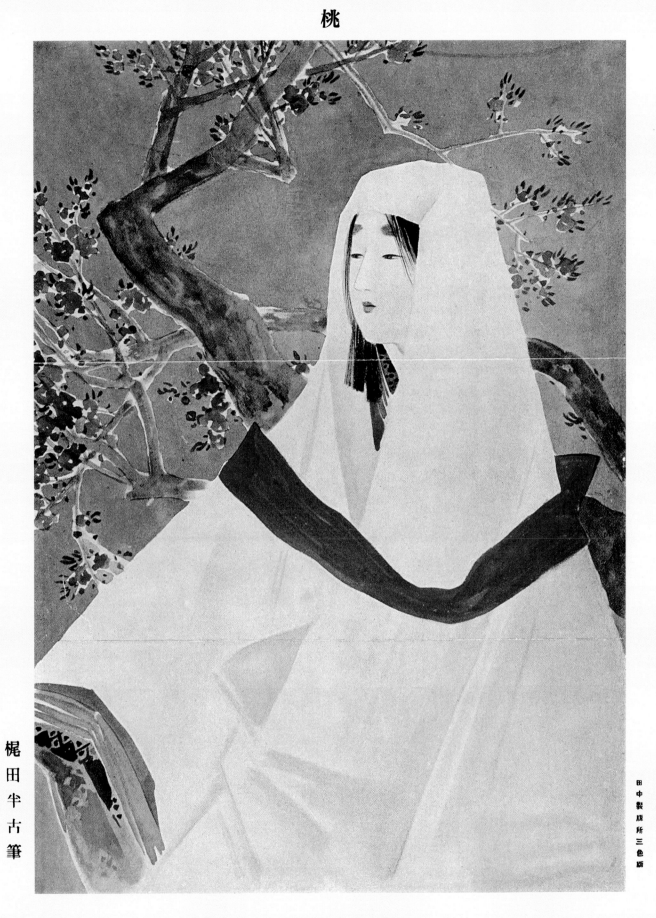

梶田半古筆

田中製版所三色版

Kajita Hanko
"Peach" *(Momo)*

PLATE 7

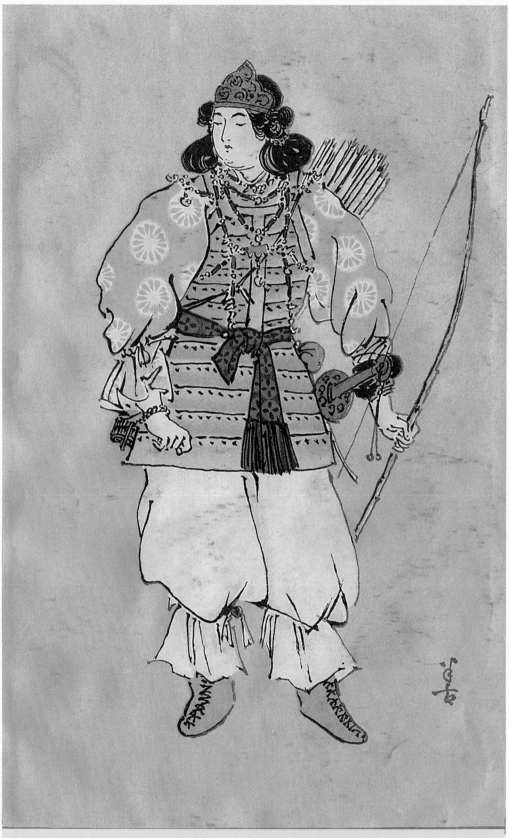

The Empress Jingo who conducted the Expedition to Korea in A. D. 200.

Kajita Hanko
"The Empress Jingû" *(Jingû kôgô)*

PLATE 8

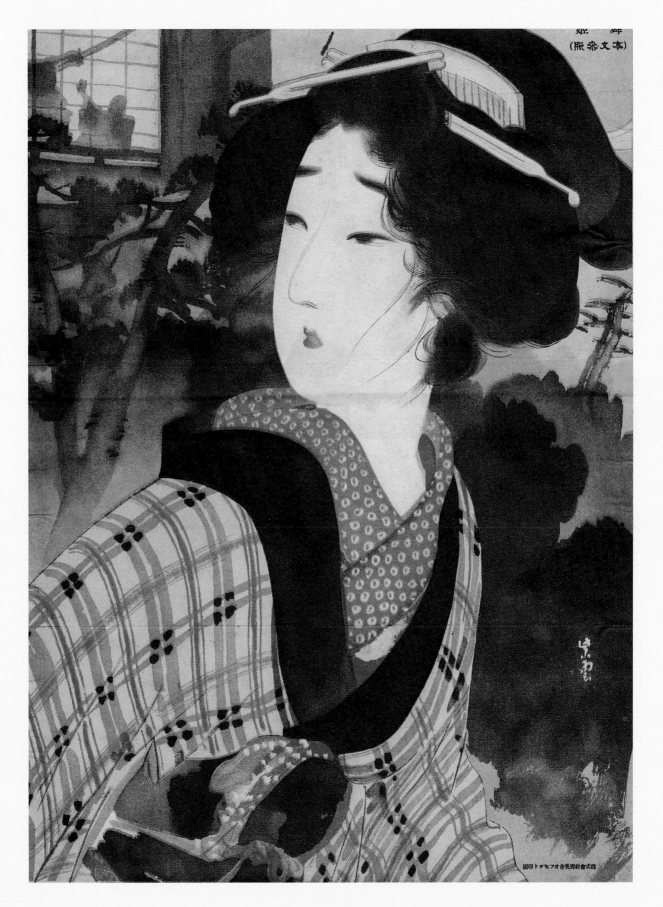

Kondô Shiun
from "Dancing Girl" *(Maihime)*

PLATE 9

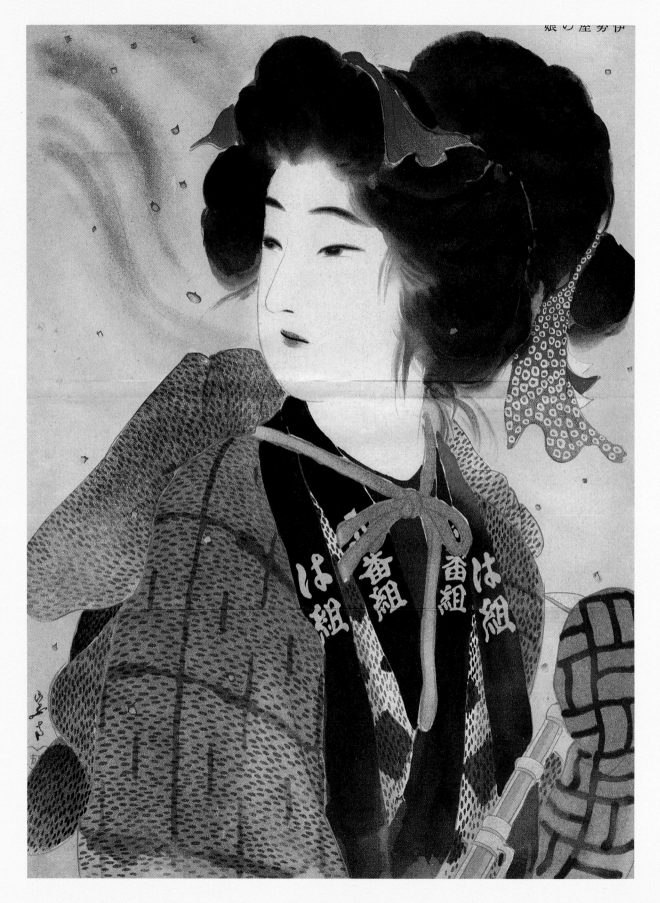

Sudô Munekata
"A Daughter of the Iseya" *(Iseya no musume)*

PLATE 10

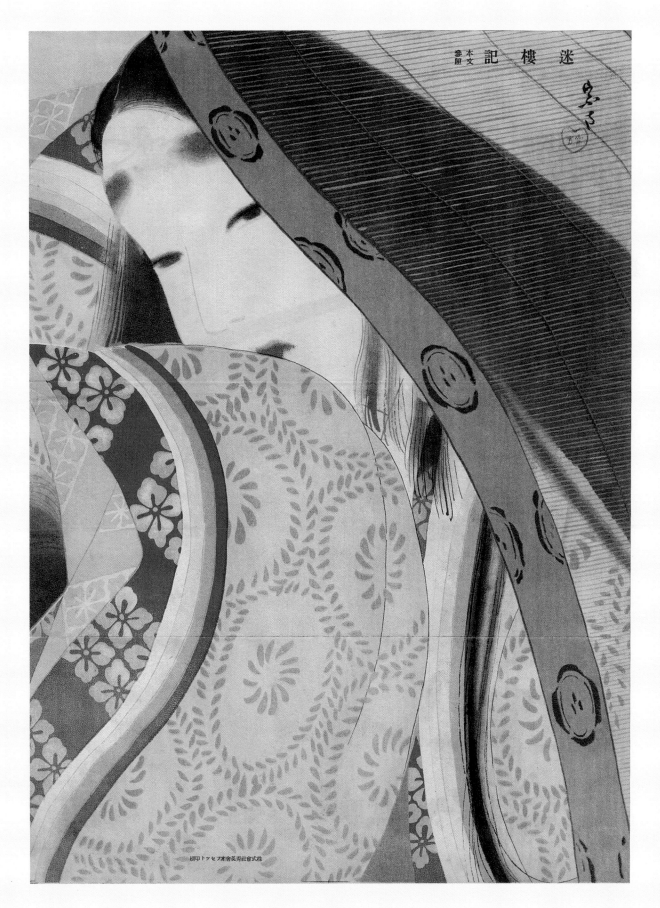

Sudô Munekata
from "Story of the Labyrinth Pavilion" *(Meirôki)*

PLATE 11

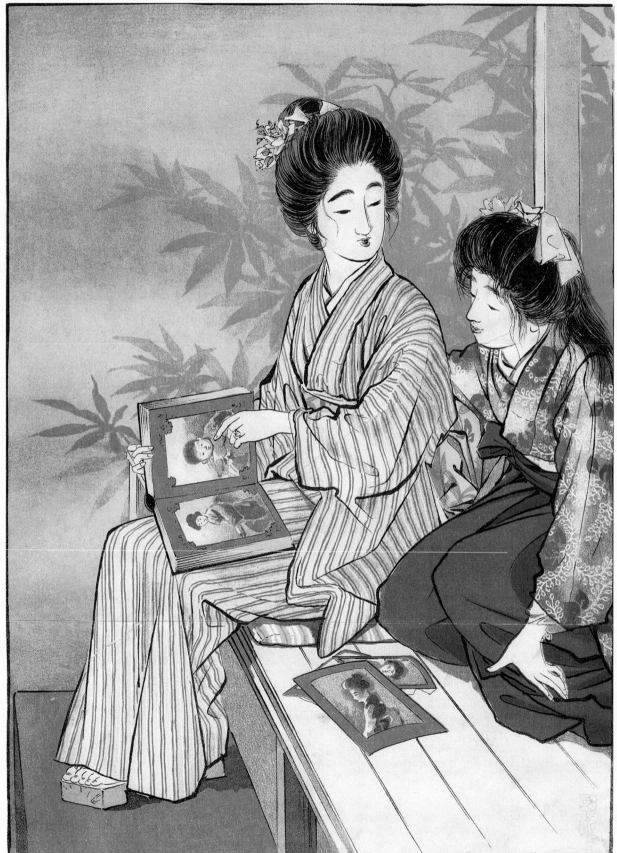

今年今月は博文館の創業二十週年に富る、二十年以前には茲に現はれし佳人も一歳なりしが、今は妙齡正に二十、花の如き姿となり、往時の寫眞を見てニッコリほゝ笑む顏の如何に美はしき！

Otake Kokkan
"Reaching Womanhood" *(Myôrei masani hatachi)*

PLATE 12

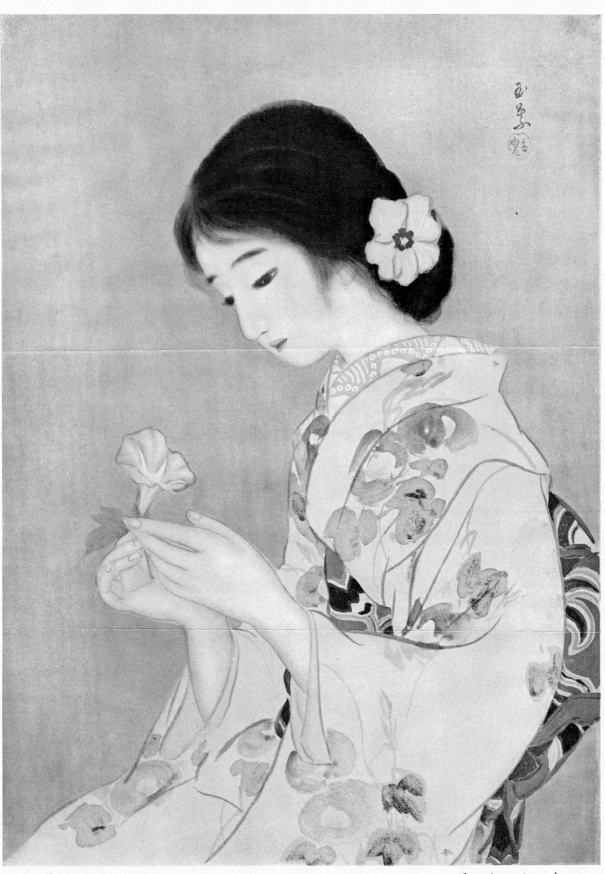

筆史女葉玉原栗 　　　　　　　ほがさあ

Kurihara Gyokuyô
"Morning Glory" *(Asagao)*

PLATE 13

小梁裂版印刷

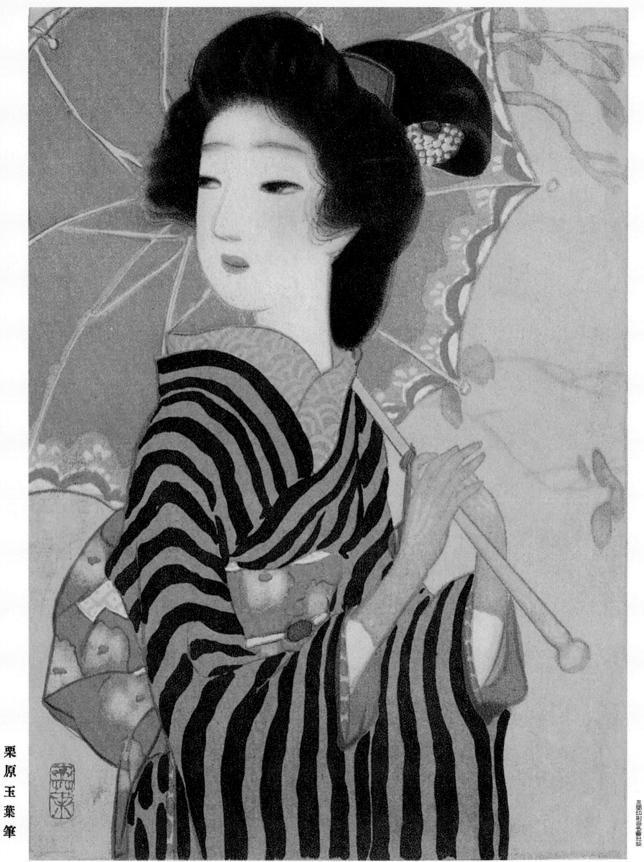

栗原玉葉筆

Kurihara Gyokuyô
"The Beginning of the 11th Month" (*Shimotsuki hajime*)

PLATE 14

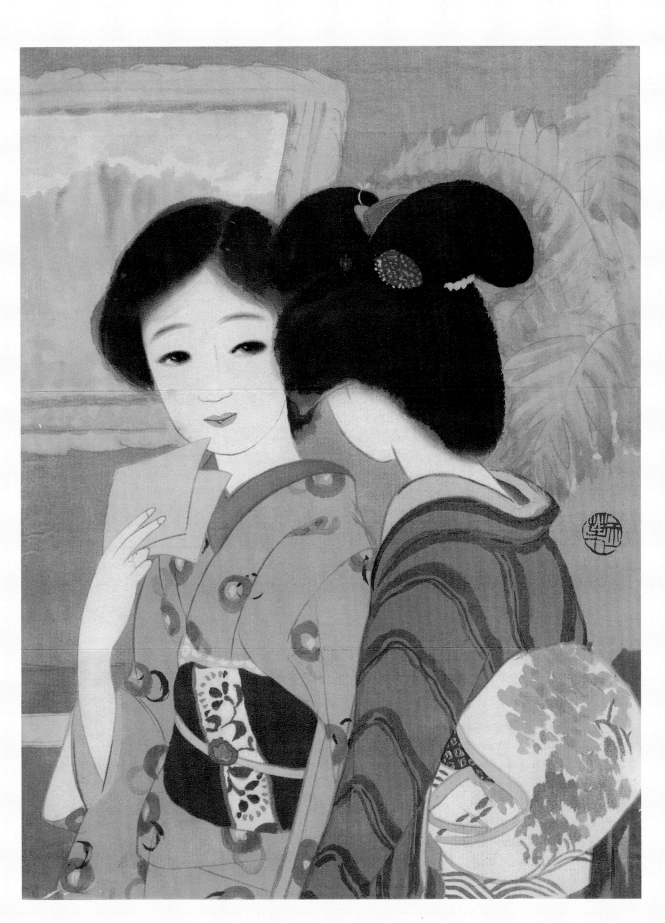

Kurihara Gyokuyô
"Autumn [Exhibition] in Ueno" *(Aki no Ueno)*

PLATE 15

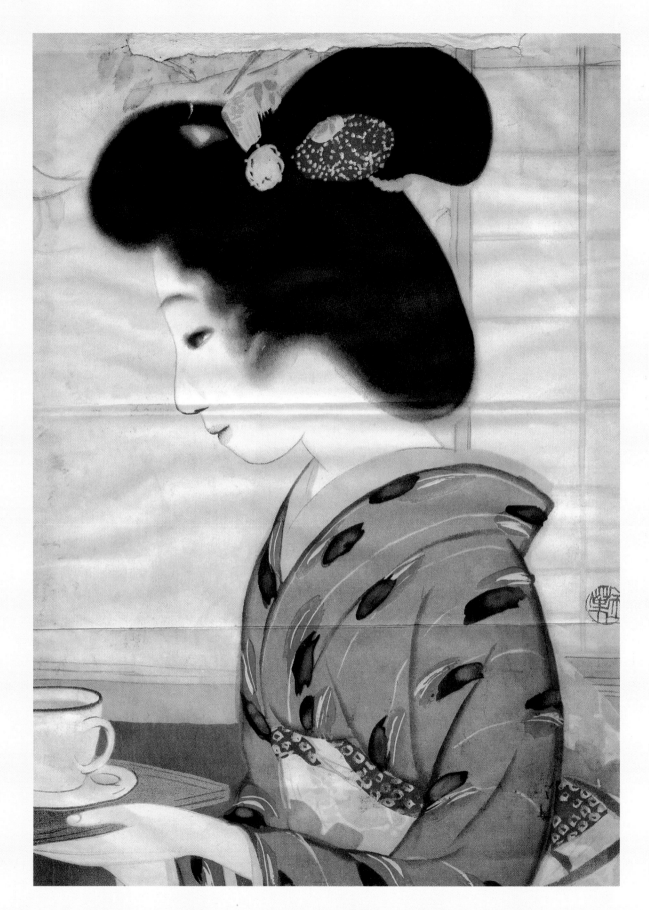

Kurihara Gyokuyô
"Morning" *(Asa)*

PLATE 16

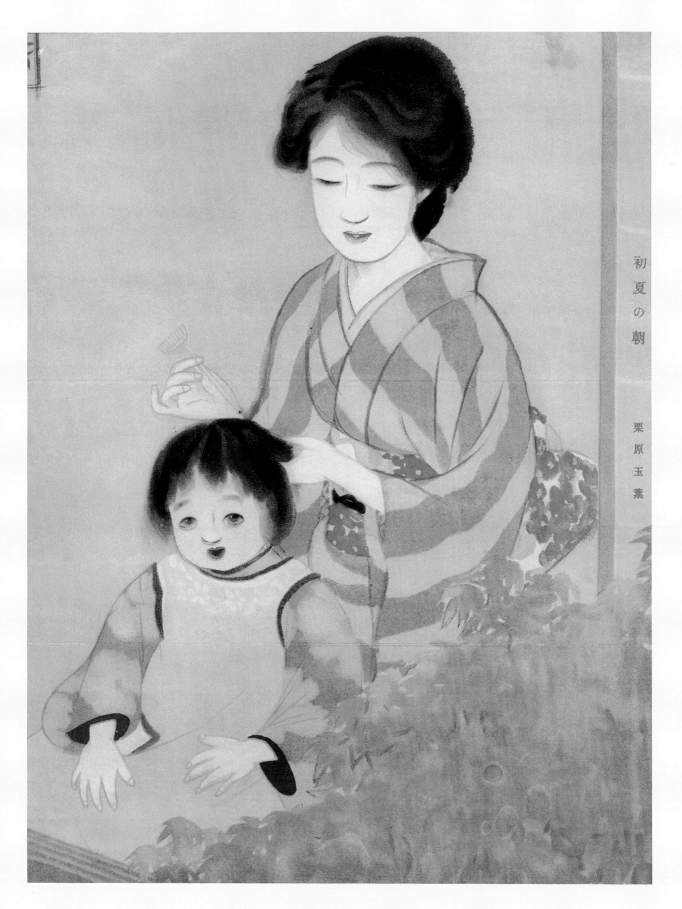

初夏の朝

栗原玉葉

Kurihara Gyokuyô
"Morning in Early Summer" *(Shoka no asa)*

PLATE 17

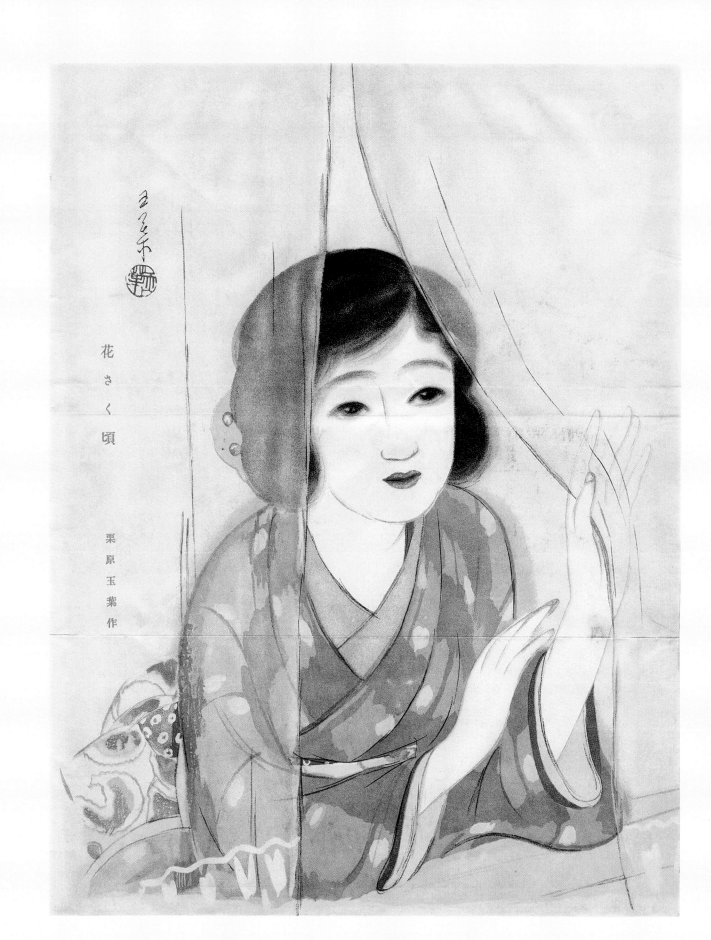

花さく頃

栗原玉葉作

Kurihara Gyokuyô
"Flower Blooming Time" *(Hana saku koro)*

PLATE 18

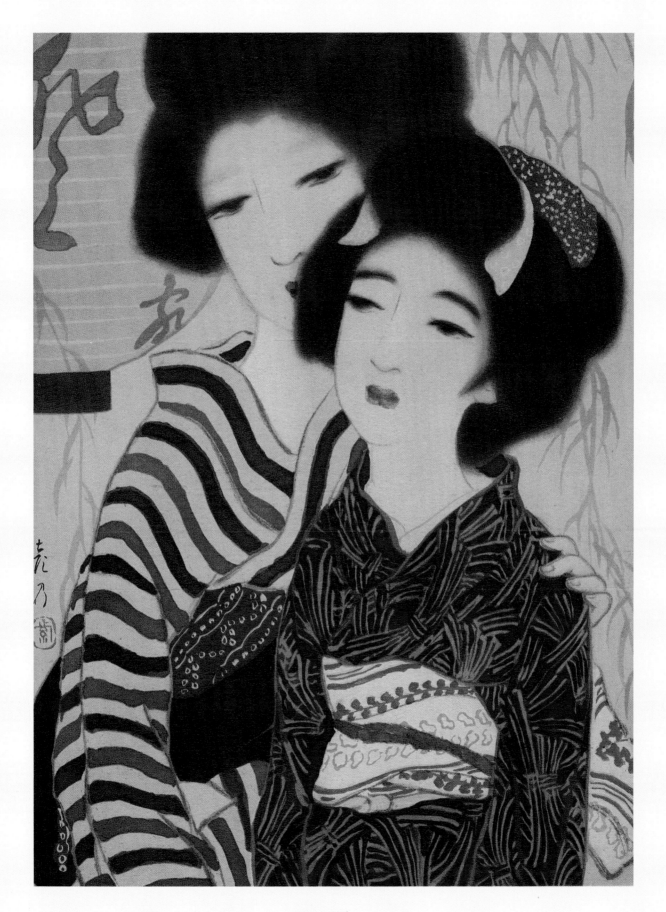

Kasai Hikono
"Early Summer" *(Shoka)*

PLATE 19

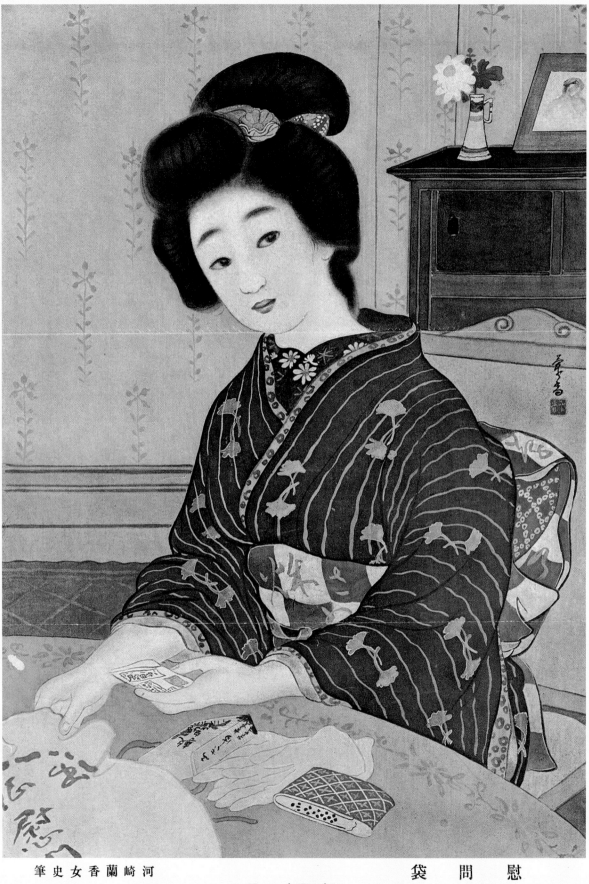

筆史女香蘭崎河　　　　　　　　　　　　袋　問　慰

Kawasaki Rankô
"[Soldiers] Comfort Bag" *(Imonbukuro)*

小柴製版印刷

PLATE 20

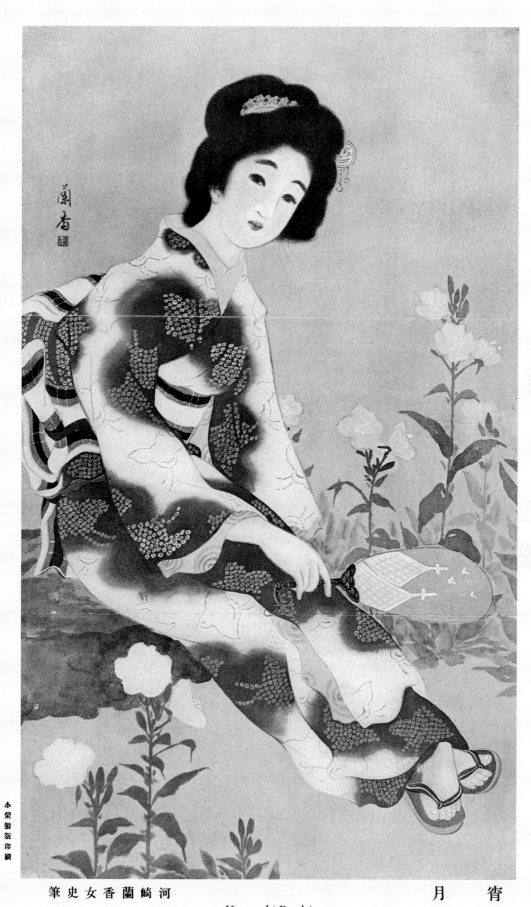

河崎蘭香女史筆　　　　　　　宵月

Kawasaki Rankô
"Evening Moon" (*Yoizuki*)

PLATE 21

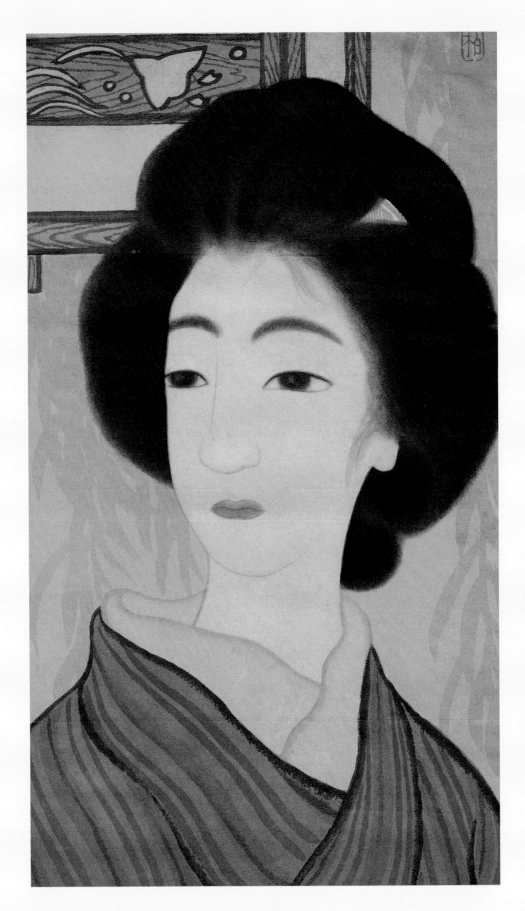

Ishiyama Taihaku
"Evening" *(Tasogare)*

PLATE 22

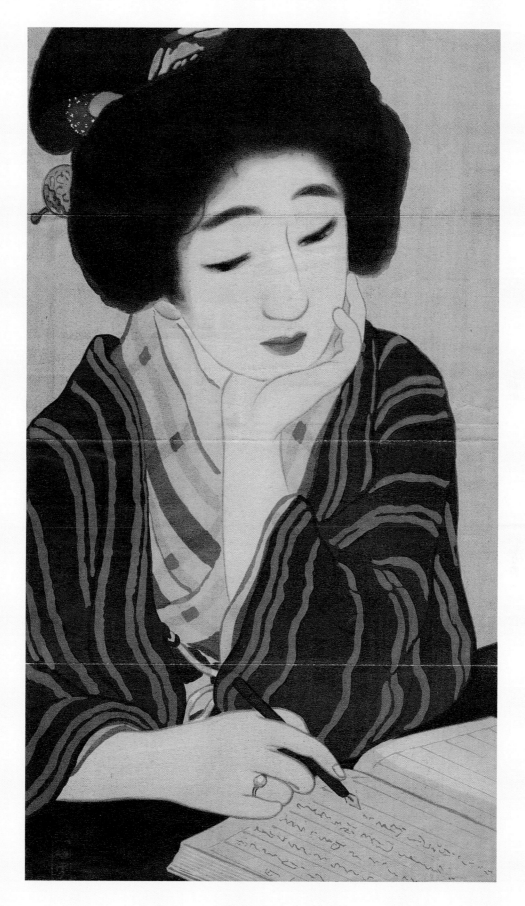

Ikeda Terukata
"An October Diary" *(Jūgatsu no nikki)*

PLATE 23

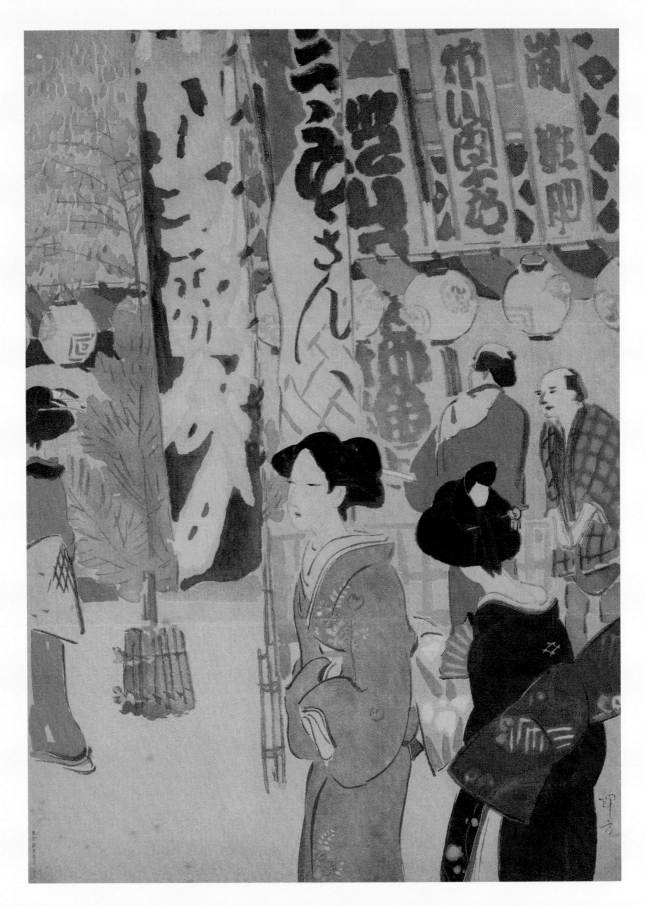

Ikeda Terukata
"Spring at Saruwakachô" *(Saruwakachô no haru)*

Plate 24

装 春

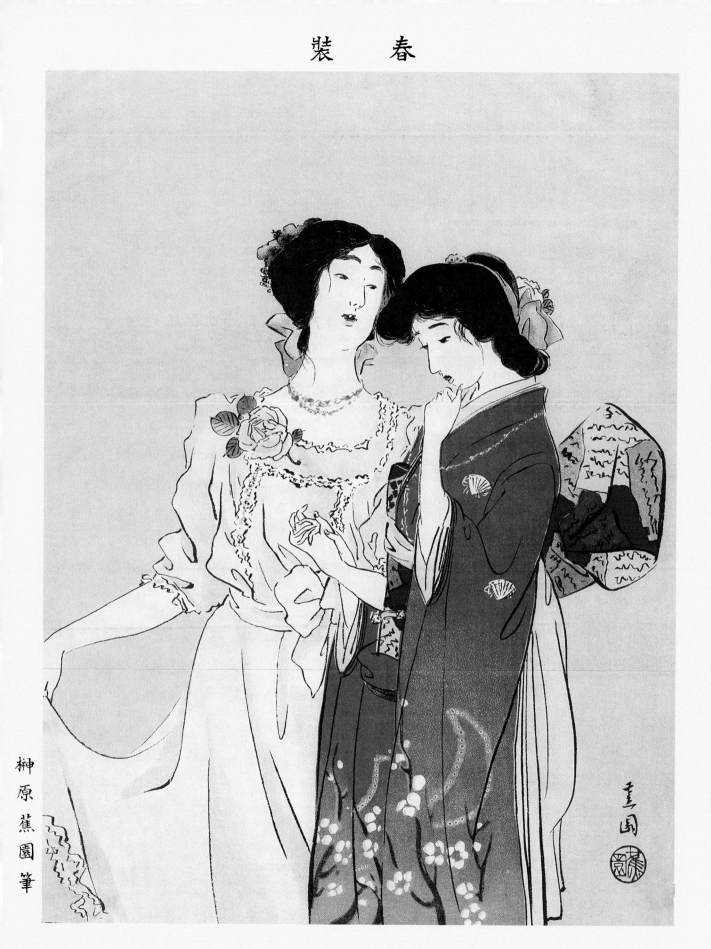

榊原蕉園筆

Ikeda (Sakakibara) Shôen
"Spring Dressing Up" *(Shunsô)*

PLATE 25

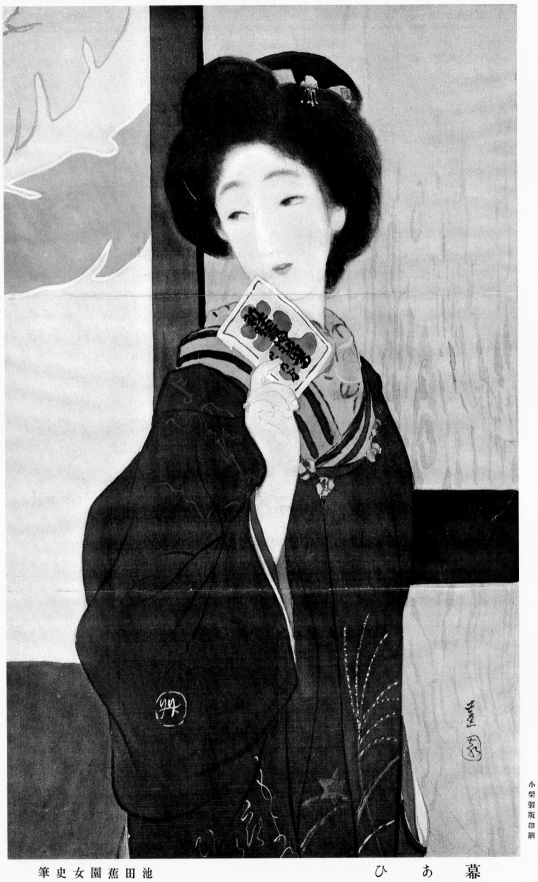

筆史女園蕉田池 ひあ幕

小柴製版印刷

Ikeda (Sakakibara) Shôen
"Intermission" *(Makuai)*

PLATE 26

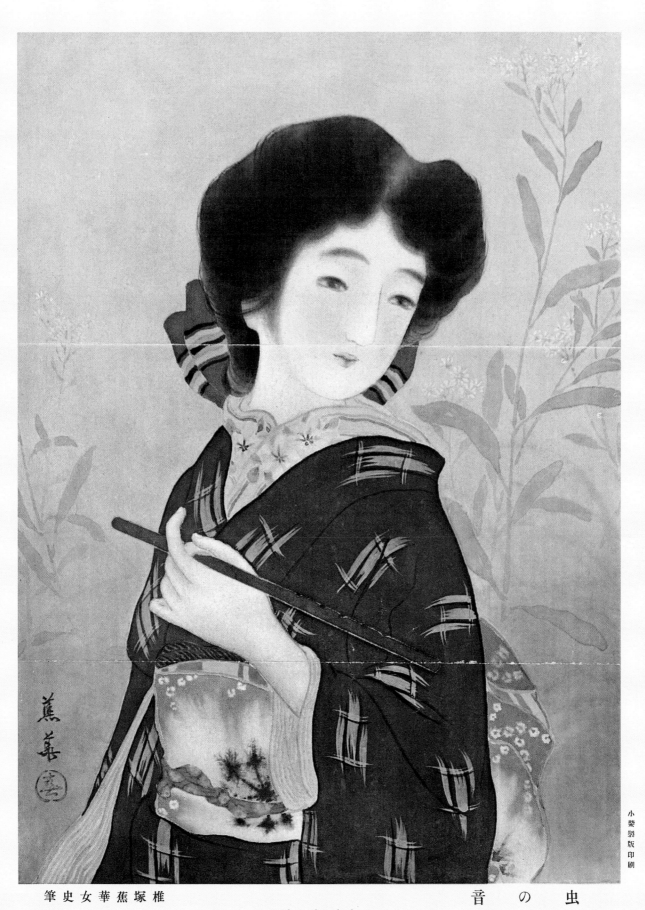

筆史女華蕉塚椎　　　　　　音　の　虫

Shiizuka Shôka
"The Chirping of Insects" *(Mushi no ne)*

PLATE 27

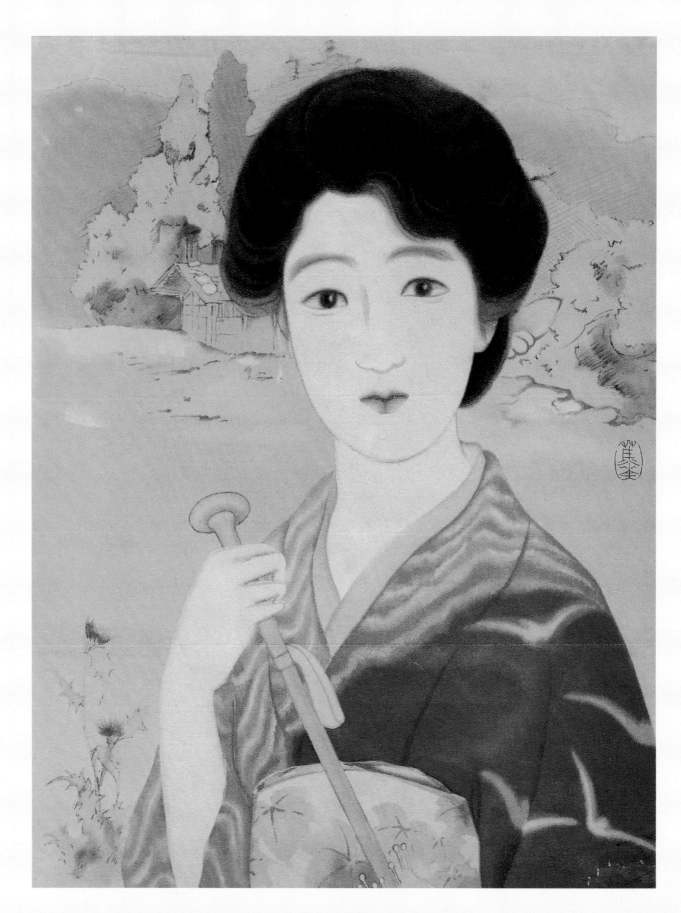

Shiizuka Shôka
"At a Summer Resort" *(Hishochi nite)*

Plate 28

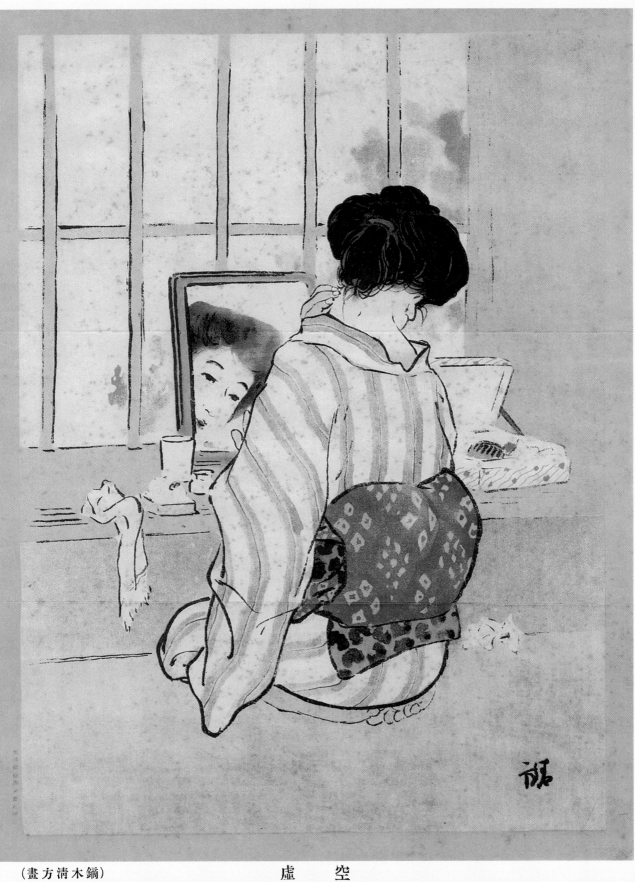

（畫方清木鏑）　　　　　　　　虚　空
Kaburaki Kiyokata
from *Empty (Kûkyo)*
[a novel by Mayama Seika]

PLATE 29

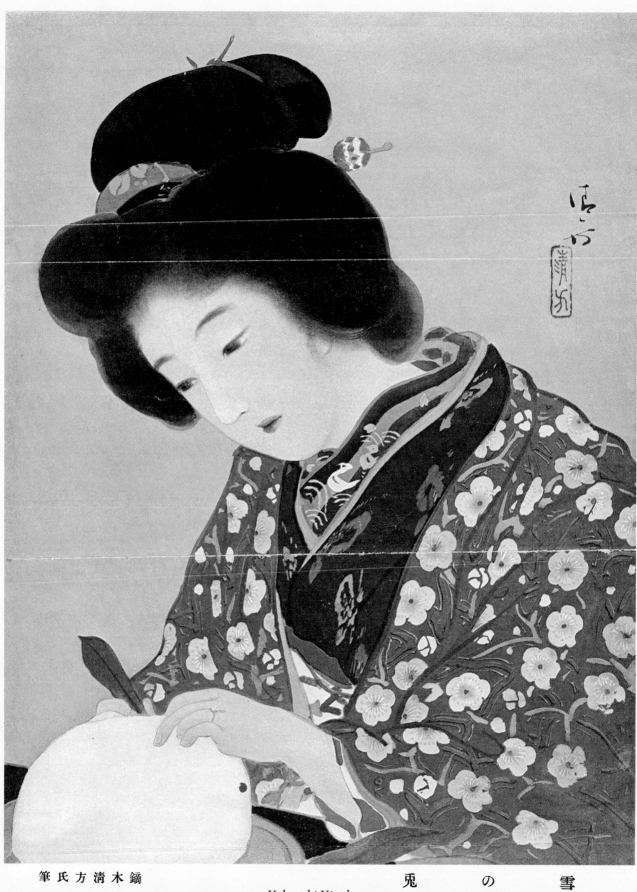

筆氏方清木鏑　　　　　　　兎　の　雪

Kaburaki Kiyokata
"Snow Rabbit" *(Yuki no usagi)*

PLATE 30

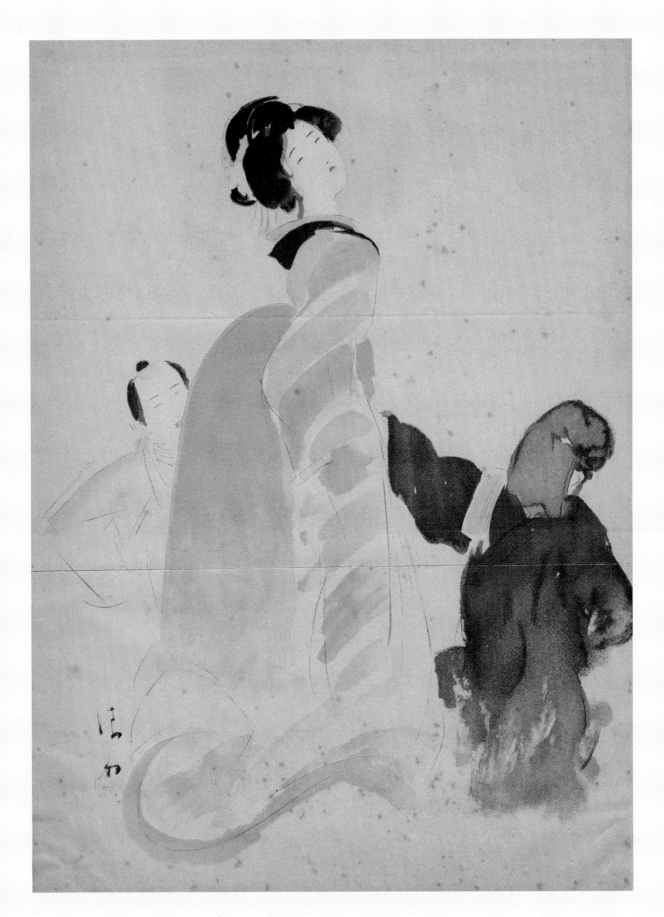

Kaburaki Kiyokata
"The Greengrocer Oshichi" *(Yaoya Oshichi)*

PLATE 31

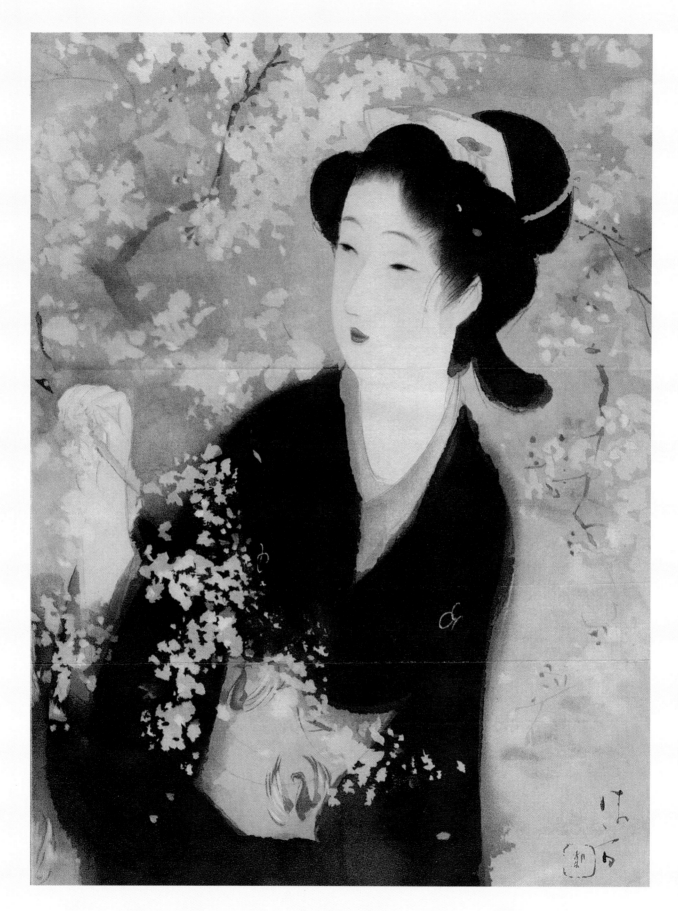

Kaburaki Kiyokata
"Plum Blossoms" *(Sumomo no hana)*

PLATE 32

女 の 門 將

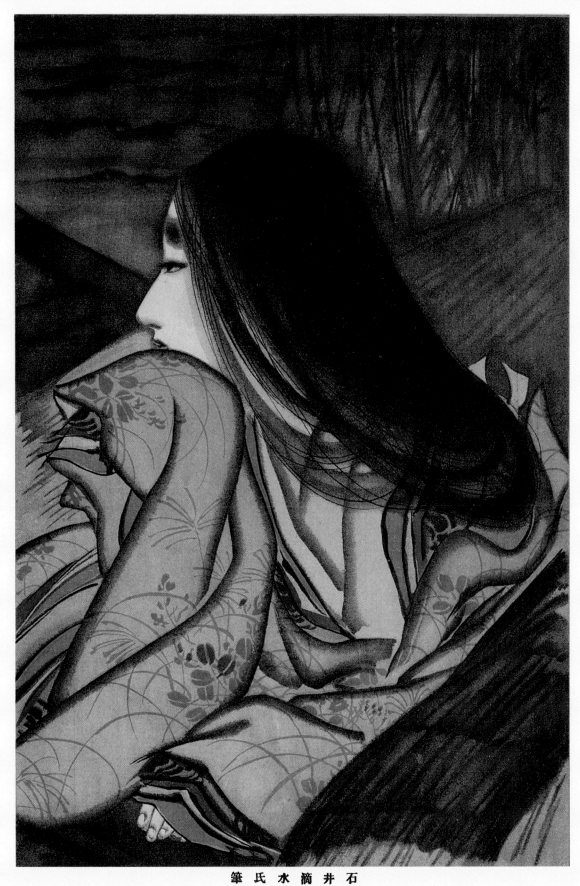

筆 氏 水 滴 井 石

Ishii Tekisui
from *A Woman of Masakado (Masakado no onna)*
[a novel by Ôhashi Seiha]

PLATE 33

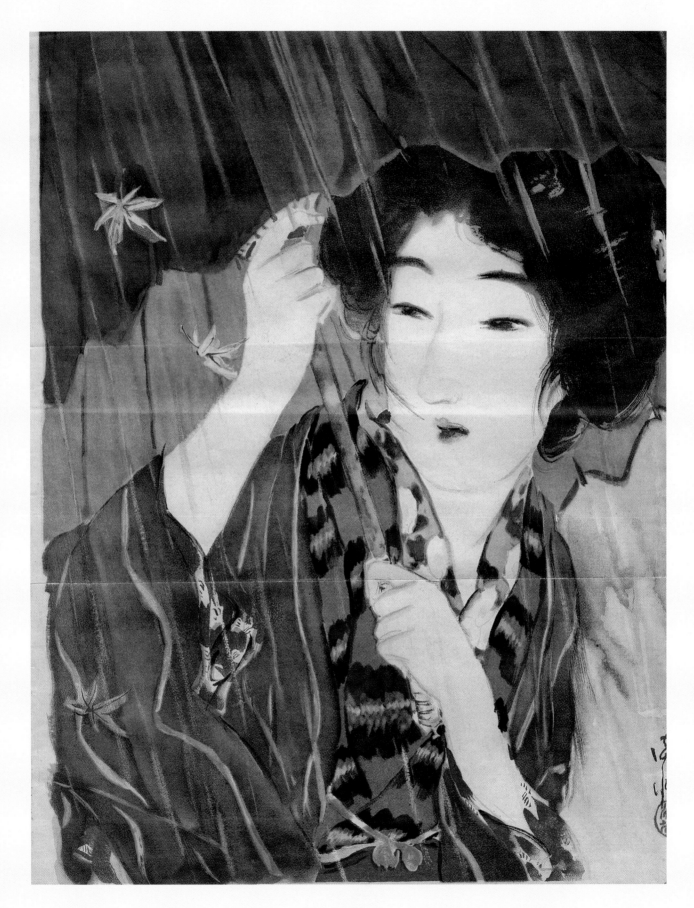

Ishii Tekisui
"Autumn Shower" *(Shigure)*

PLATE 34

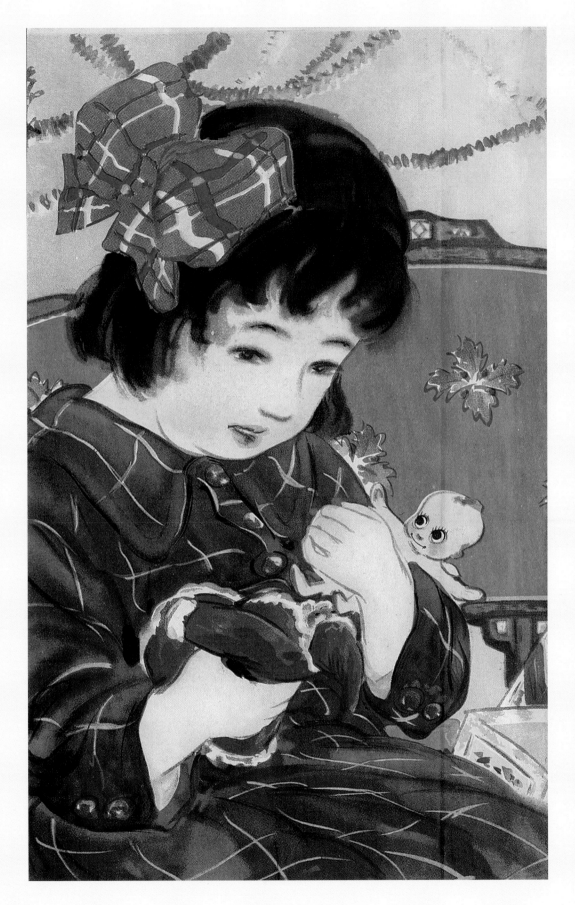

Ishii Tekisui
"Christmas Morning" *(Kurisumasu no asa)*

PLATE 35

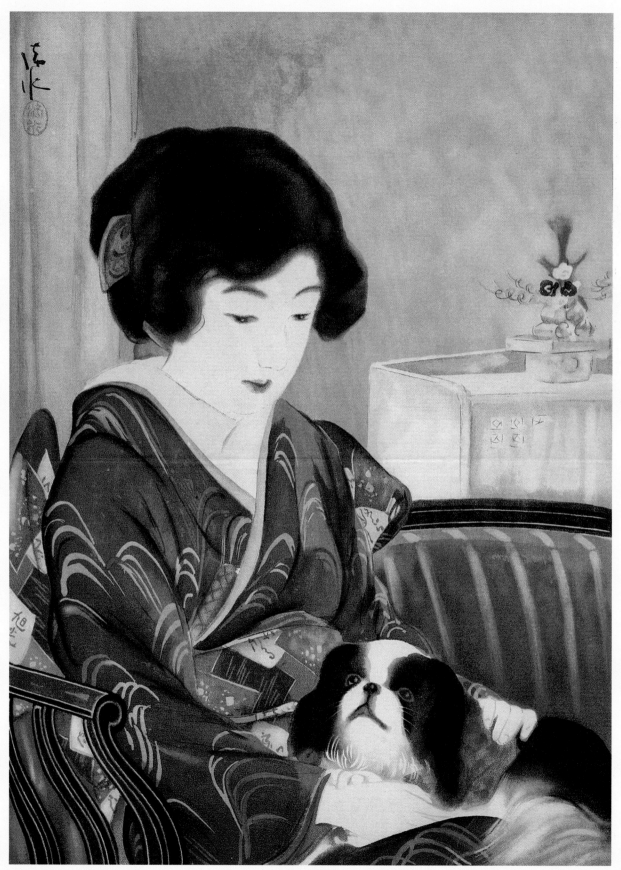

Ishii Tekisui
"New Year" *(Shinshun)*

PLATE 36

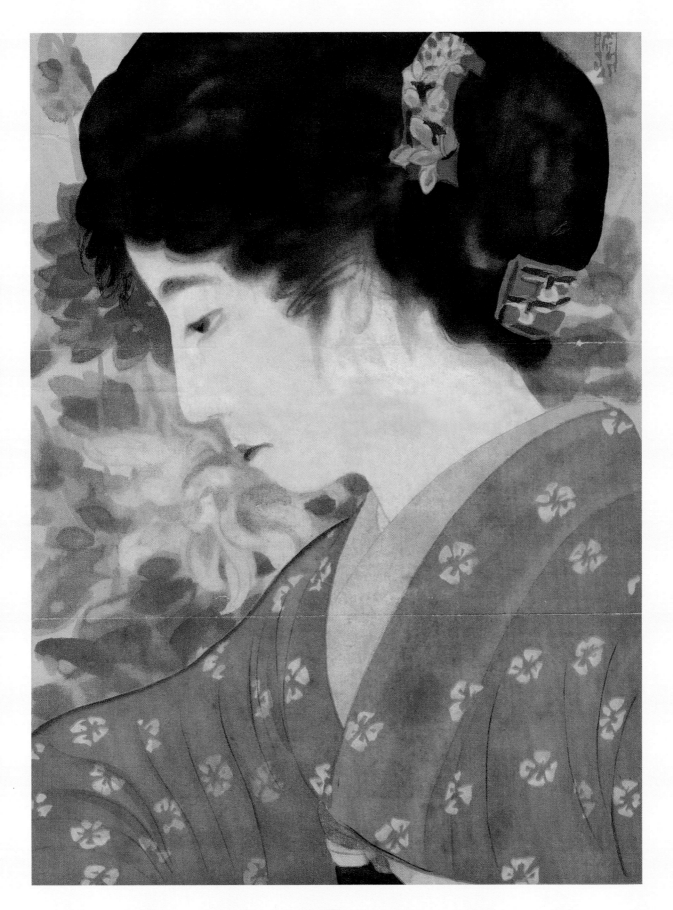

Itô Shinsui
"Dahlia" *(Dariya)*

PLATE 37

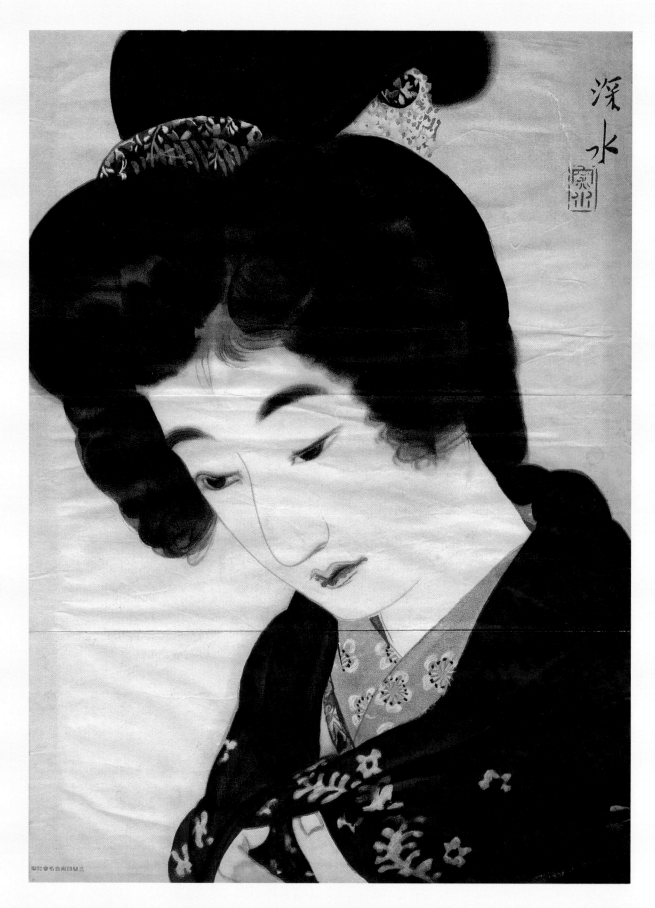

Itô Shinsui
"Frosty Morning" *(Shimo no asa)*

PLATE 38

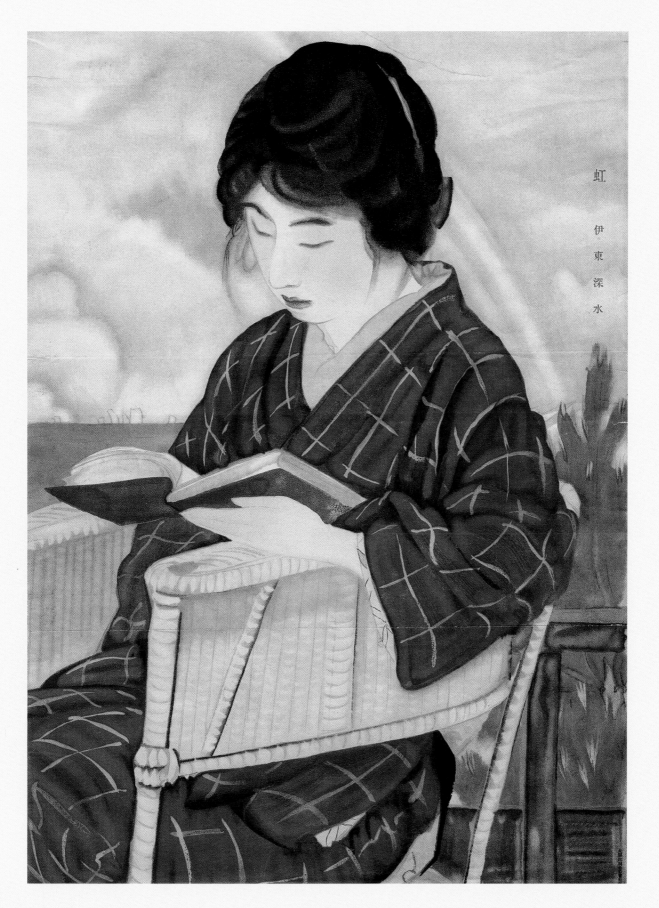

虹　伊東深水

Itô Shinsui
"Rainbow" *(Niji)*

Plate 39

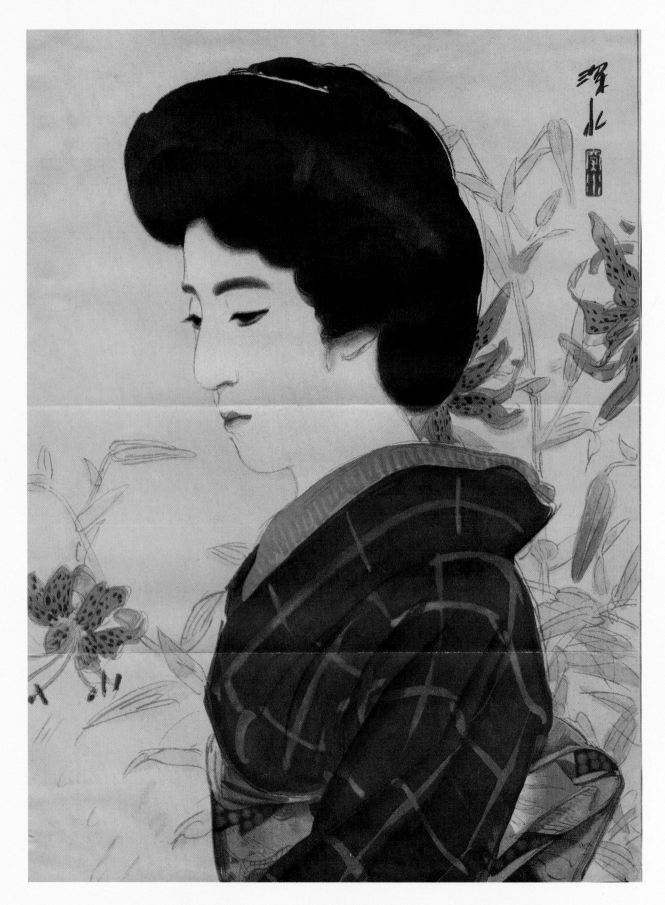

Itô Shinsui
[unknown title]

PLATE 40

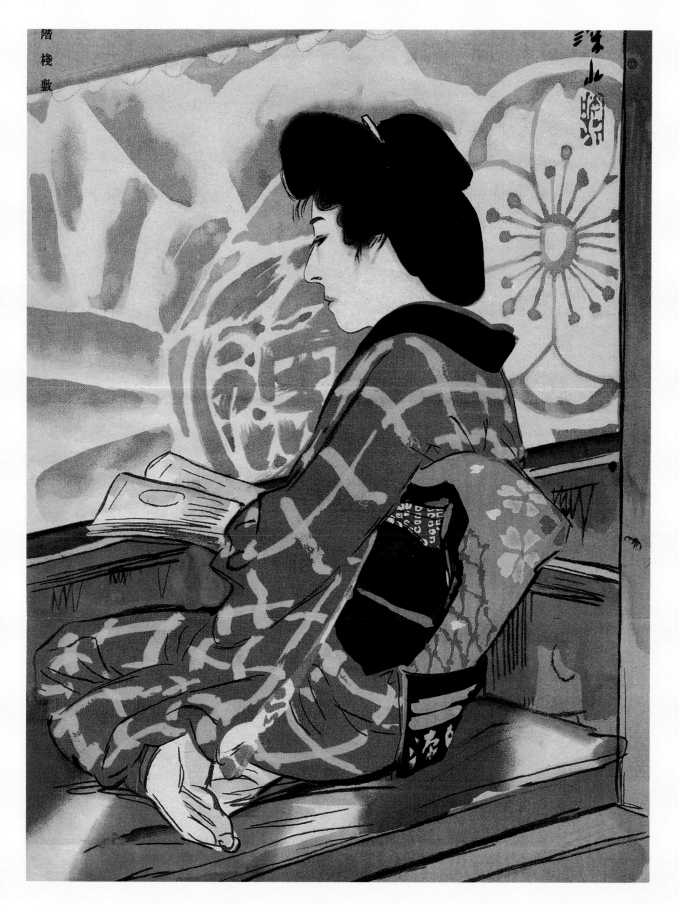

階棧敷

Itô Shinsui
"Balcony" *(Nikai sajiki)*

PLATE 41

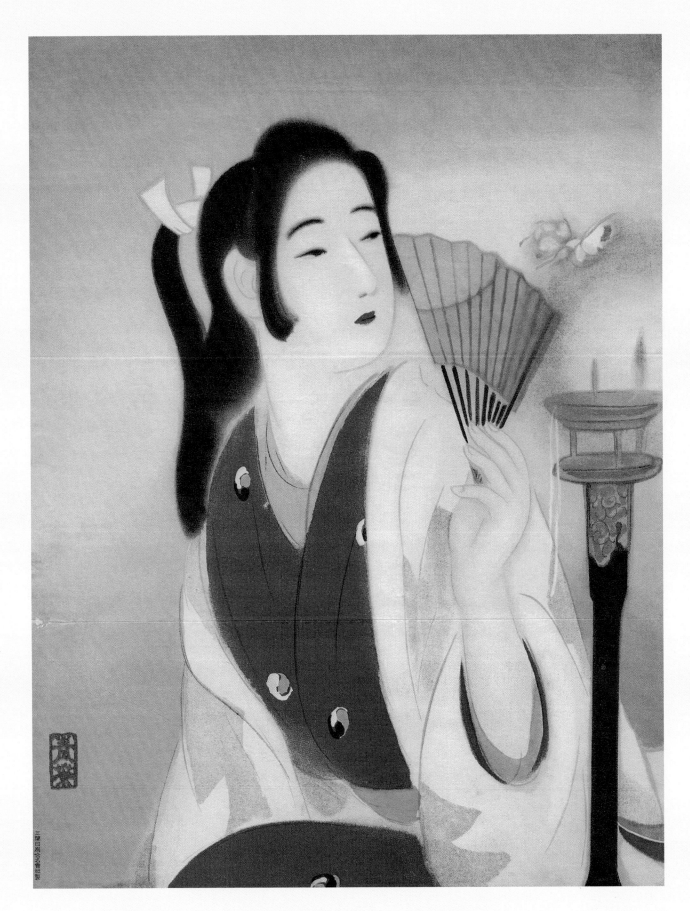

Kakiuchi Seiyô
"Moth" *(Ga)*

PLATE 42

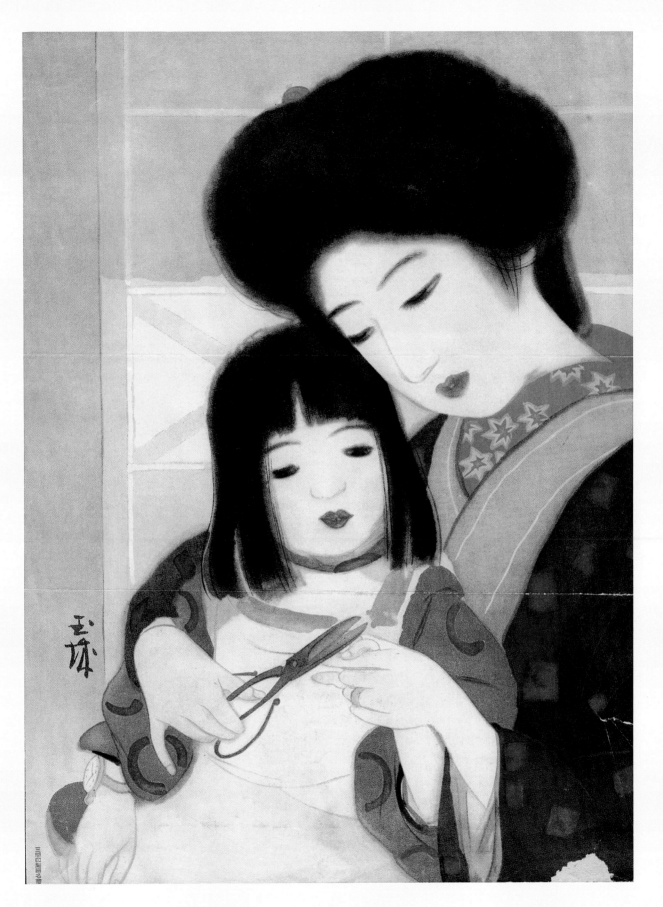

Masuda Gyokujô
"Nail Clipping" *(Tsumekiri)*

PLATE 43

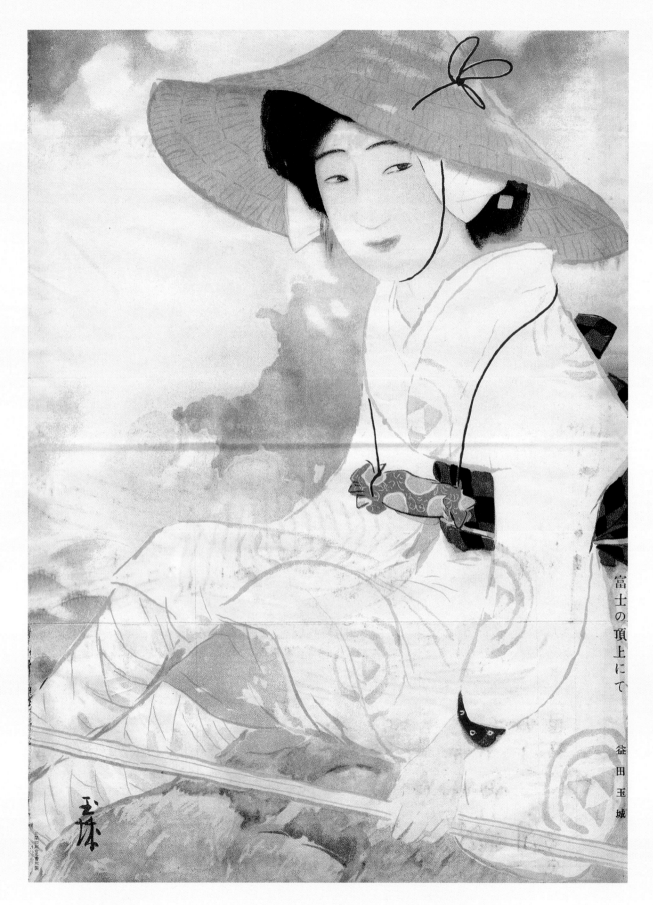

富士の頂上にて

益田玉城

Masuda Gyokujô
"At the Top of Mt. Fuji" *(Fuji no chôjô nite)*

PLATE 44

守 留 の 母

PLATE 45

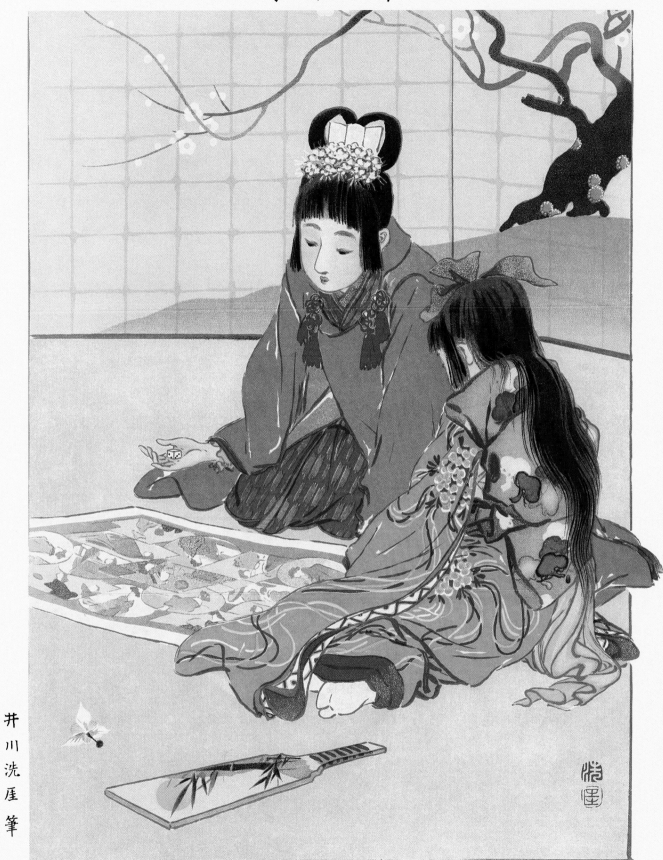

井川洗厓筆

Igawa Sengai
"Mother's Absence" *(Haha no rusu)*

PLATE 45

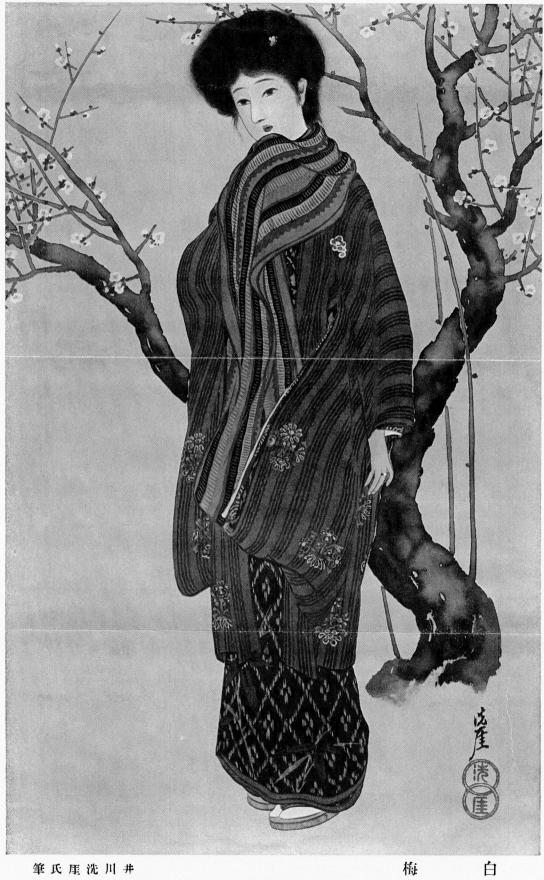

筆氏厓洸川井　　　　　　　　　　　　　　　　　梅 白

Igawa Sengai
"White Plum" *(Hakubai)*

PLATE 46

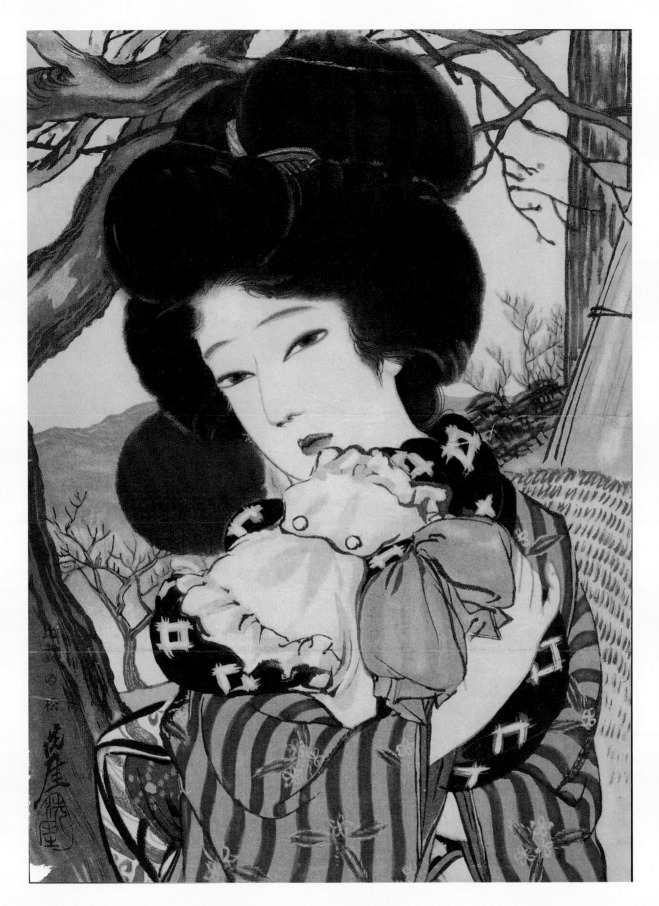

Igawa Sengai
from *A Pair of Pines (Hiyoku no matsu)*
[a novel by Gotô Chûgai]

PLATE 47

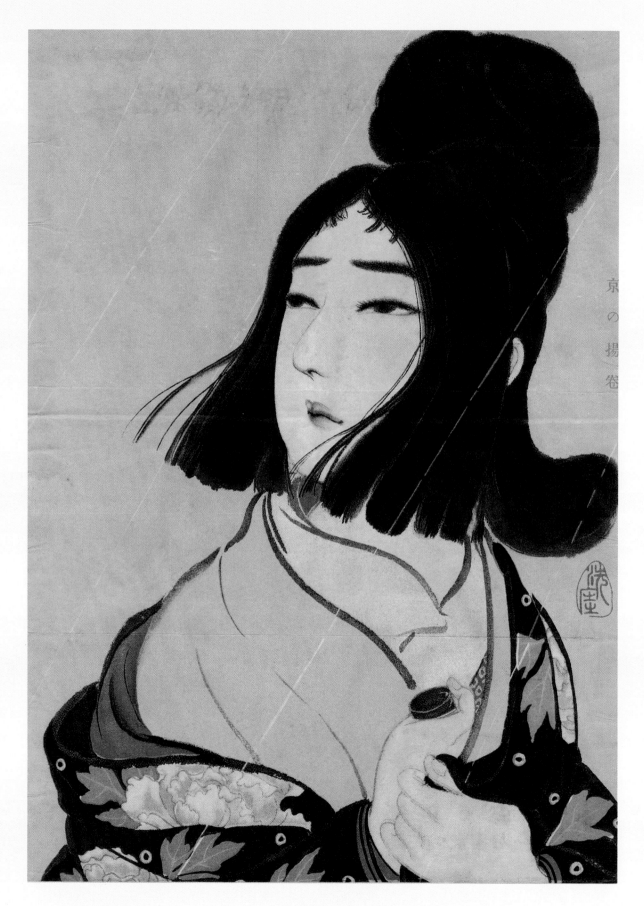

Igawa Sengai
from *Agemaki of Kyoto (Kyô no Agemaki)*
[a novel by Inaoka Nunosuke]

PLATE 48

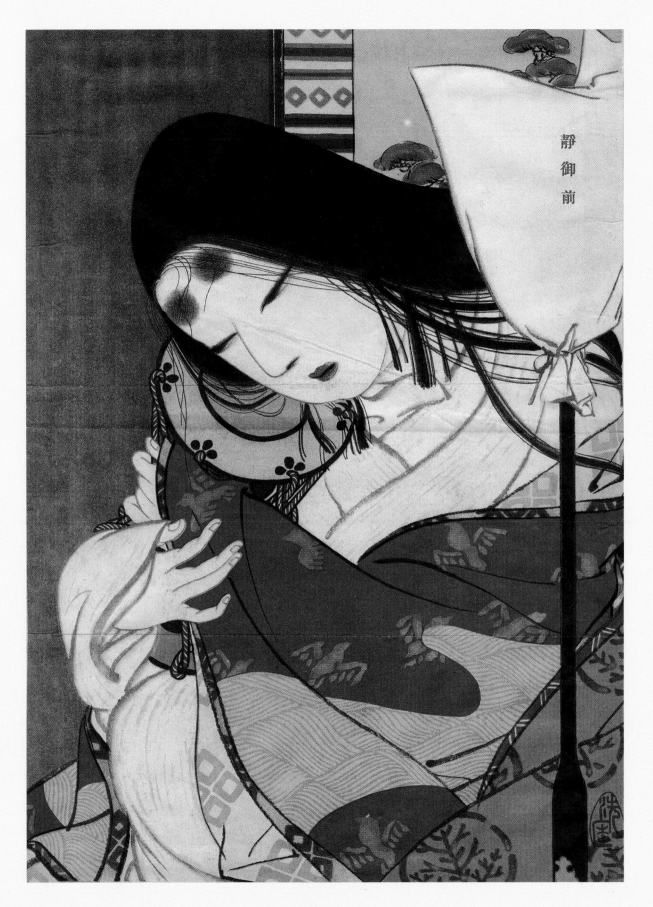

静御前

Igawa Sengai
from *Lady Shizuka (Shizuka gozen)*
[a novel by Hasegawa Shigure]

PLATE 49

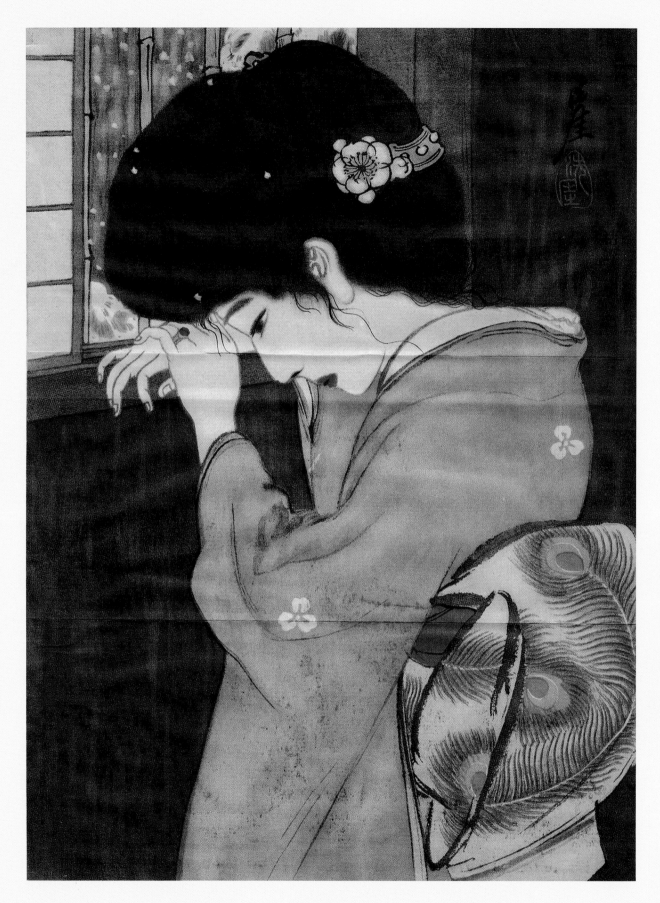

Igawa Sengai
from *Flower of a Wintry Field (Kareno no hana)*
[a novel by Hirai Banson]

PLATE 50

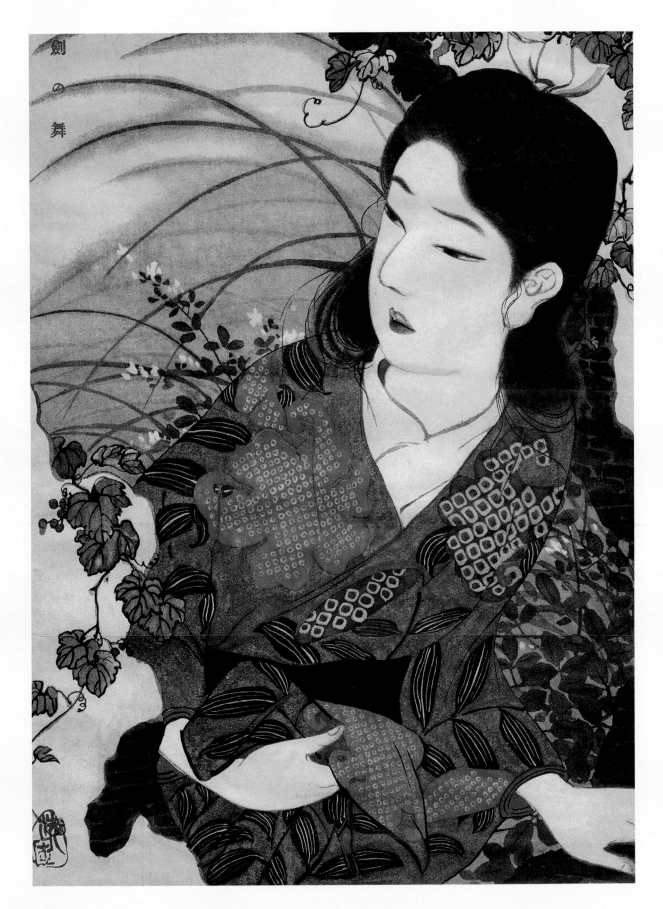

Igawa Sengai
from *Sword Dance (Tsurugi no mai)*
[a novel by Ôhashi Seiha]

PLATE 51

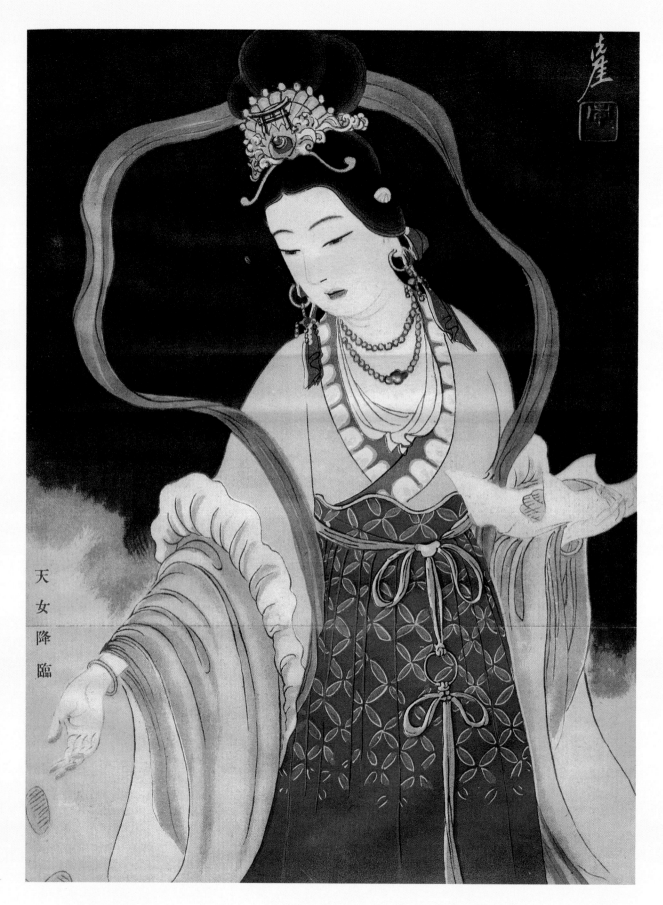

天女降臨

Igawa Sengai
from *The Descent of the Celestial Maiden (Tennyo kôrin)*
[a novel by Inaoka Nunosuke]

PLATE 52

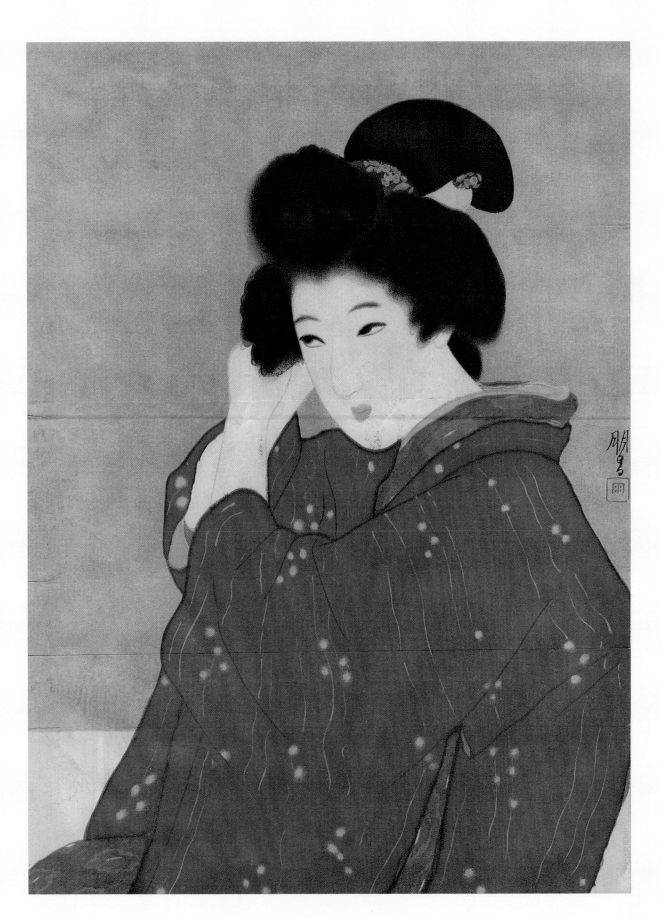

Ishii Hôshô
"Before the Mirror" *(Kagami no mae)*

PLATE 53

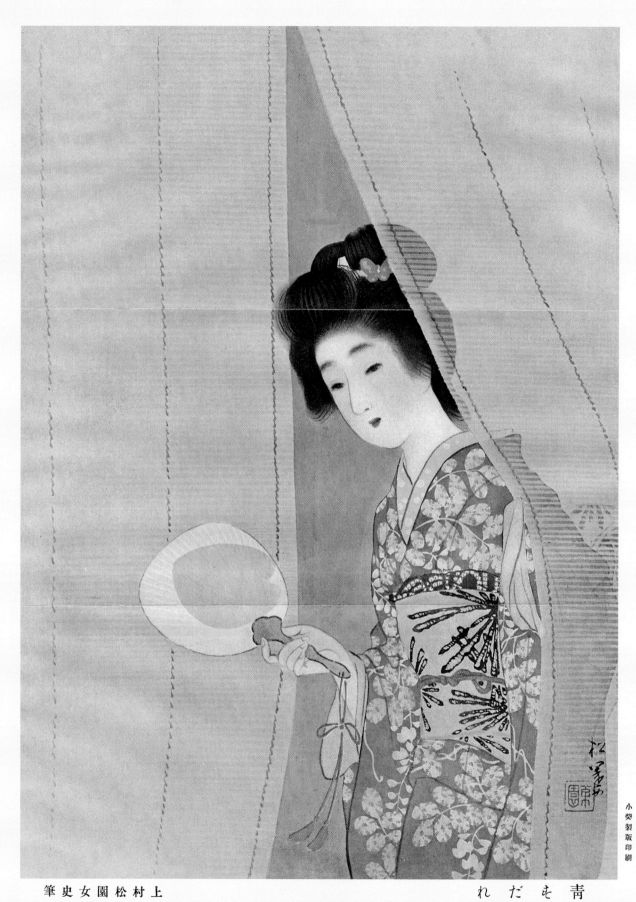

上村松園女史筆

青すだれ

Uemura Shôen
"Blue Bamboo Blind" *(Aosudare)*

PLATE 54

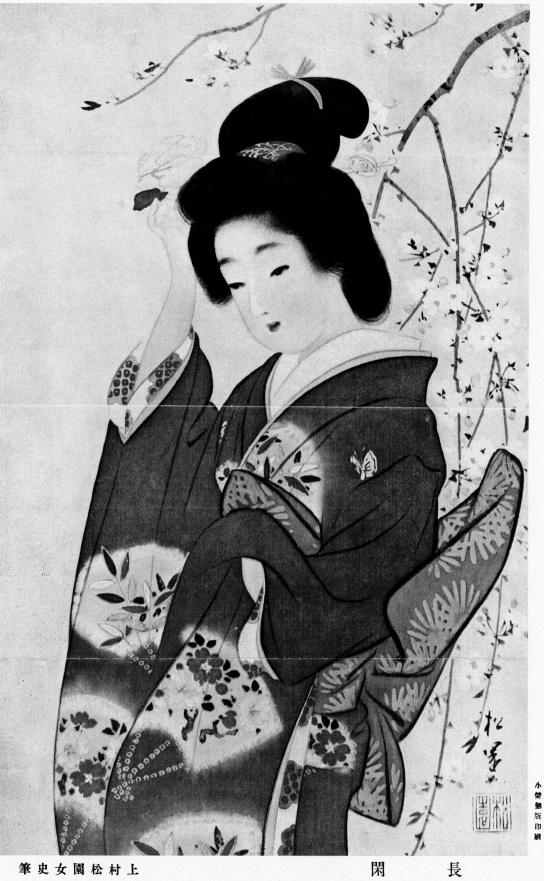

筆史女園松村上　　　　　　閑　長

Uemura Shôen
"Peaceful" *(Nodoka)*

PLATE 55

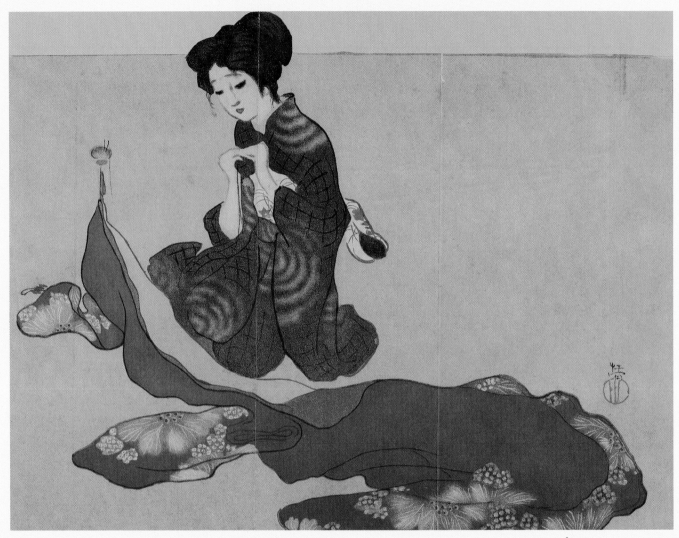

畫富恒野北

Kitano Tsunetomi
"Sewing a Bridal Cloth" *(Yomegoromo o nuu)*

PLATE 56

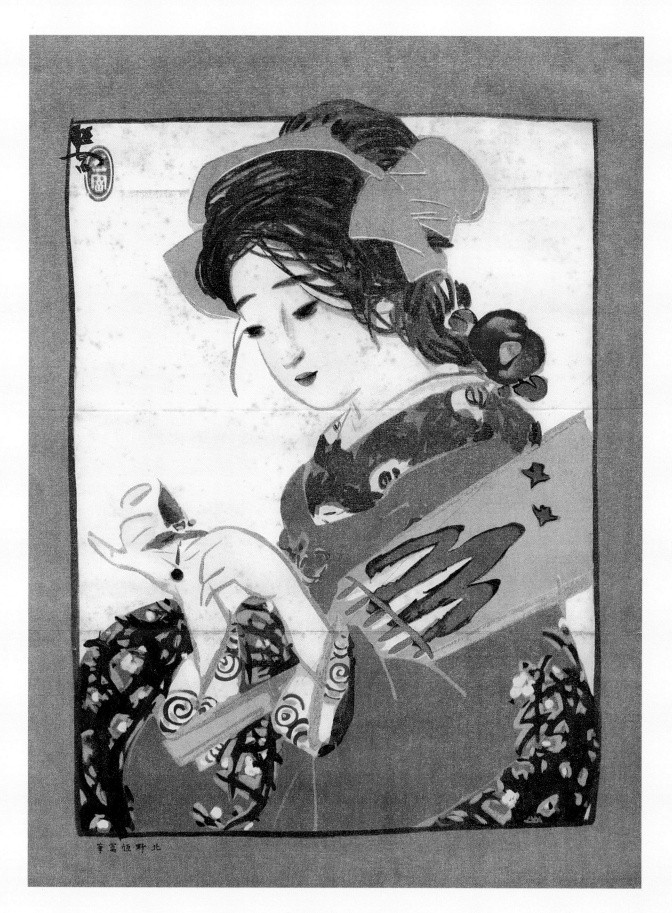

Kitano Tsunetomi
"Battledore" *(Hagoita)*

PLATE 57

子知美方緒

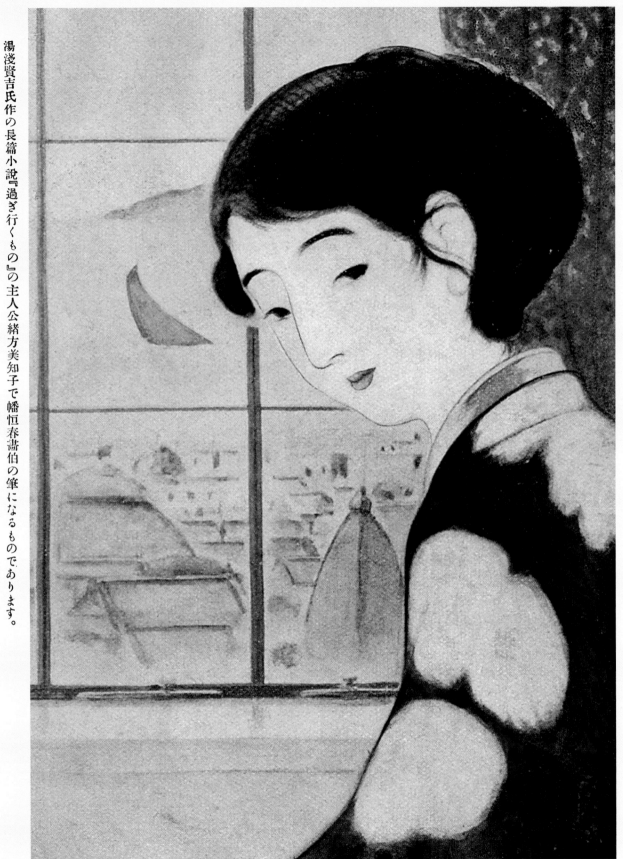

湯淺賢吉氏作の長篇小説『過ぎ行くもの』の主人公緒方美知子で幡恒春畫伯の筆になるものであります。

Hata Tsuneharu
Ogata Michiko from *Things Fleeting Away (Sugiyuku mono)*
[a story by Yuasa Kenkichi]

PLATE 58

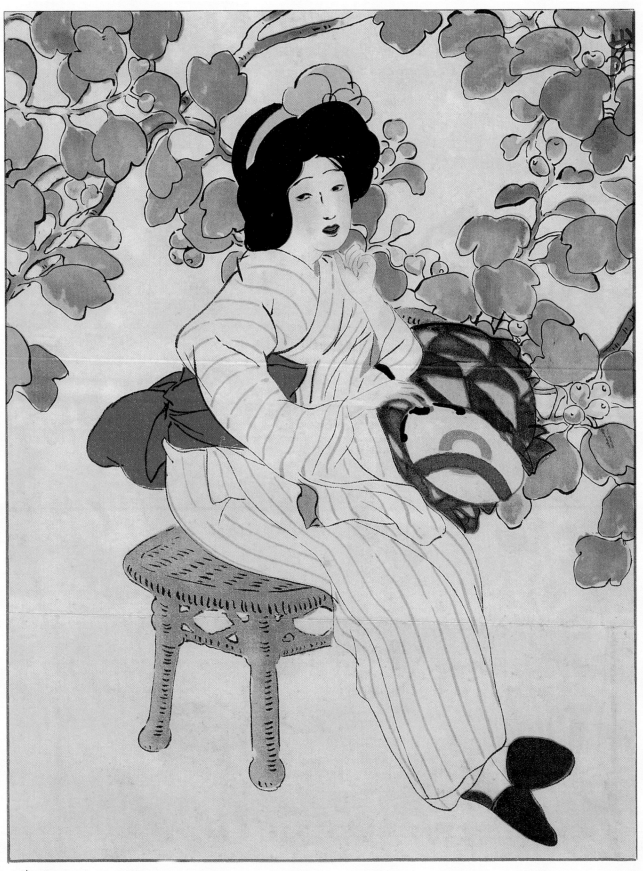

筆園成島　果花無

Shima Seien
"Fig" *(Ichijiku)*

PLATE 59

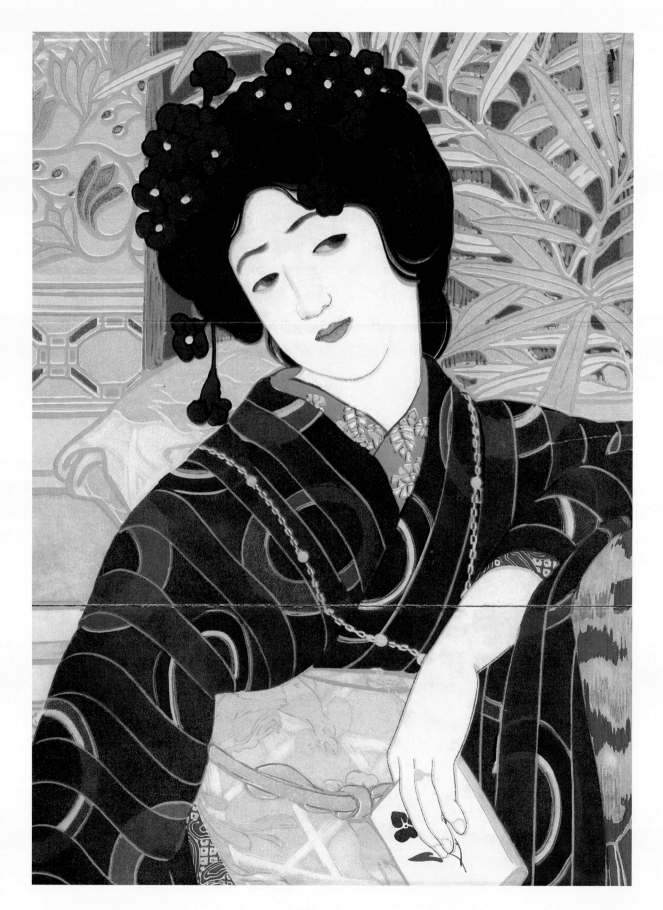

Shima Seien
"Utamaki" *(Utamaki)*

PLATE 60

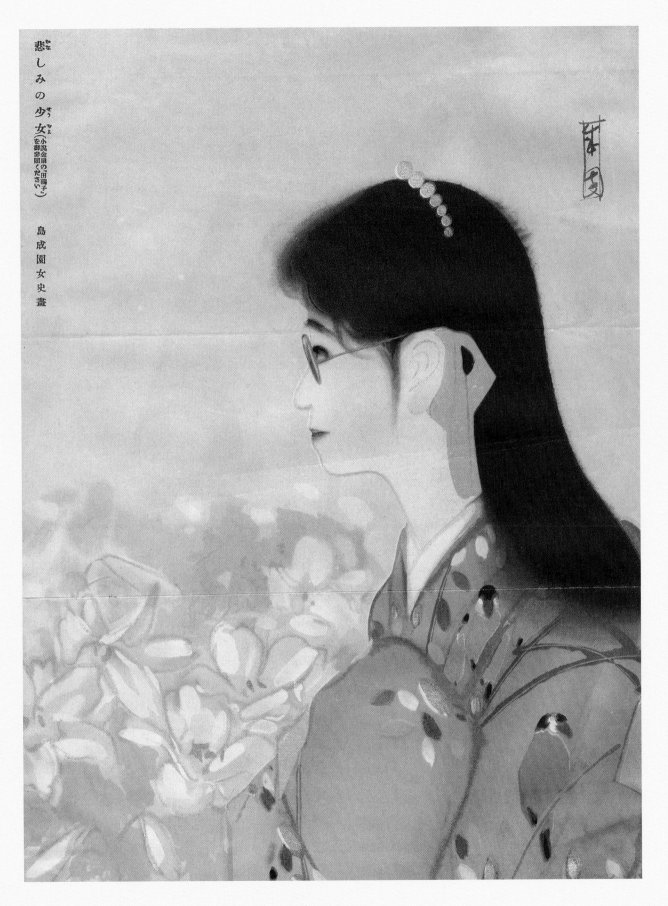

悲しみの少女（小説金扇の田鶴子を御参照ください）

島成園女史畫

Shima Seien
"A Girl in Sorrow" (*Kanashimi no shôjo*)
Tazuko from *Golden Fan (Kinsen)*
[a novel by Watanabe Katei]

PLATE 61

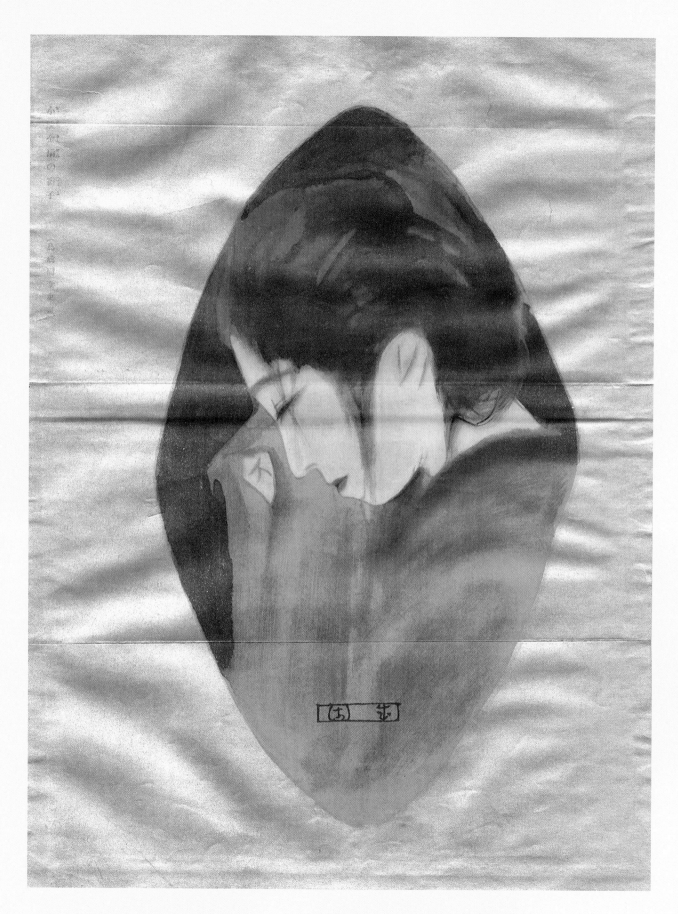

Shima Seien
"Hisako from *Golden Fan*" (*Kinsen no Hisako*)
[a novel by Watanabe Katei]

PLATE 62

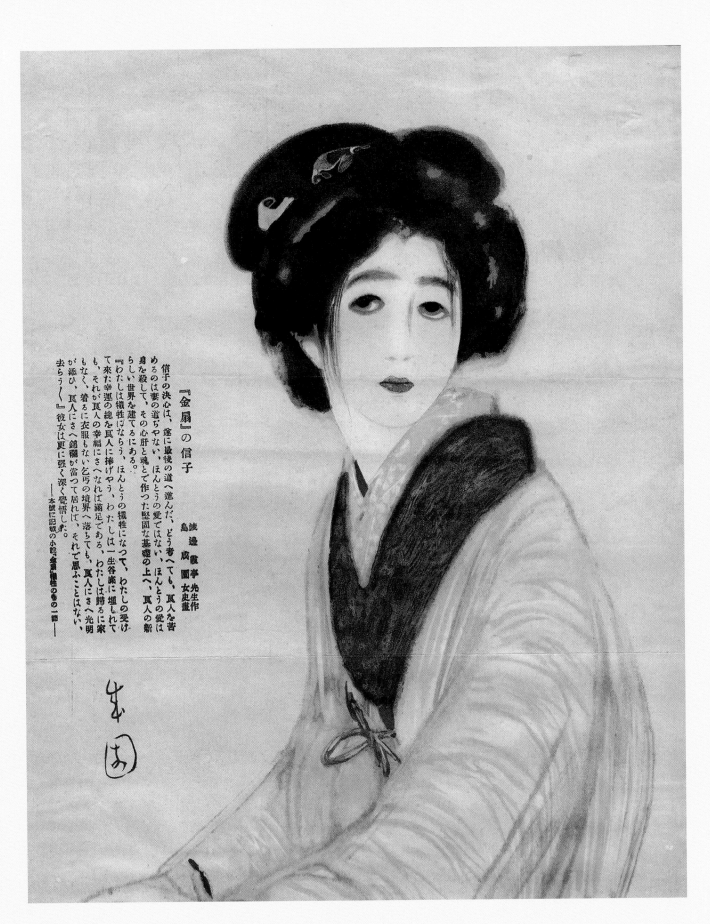

『金扇』の信子

渡邊 霞亭 先生作
島 成園 女史筆

信子の決心は、遂に最後の道へ進んだ、どう考へても、其人を苦めるのは妻の道ぢやない、ほんとうの愛ではない、ほんとうの愛は身を殺して、その心肝と魂とで作つた堅固な基礎の上へ、其人の新らしい世界を建てるにある。
『わたしは犠牲になつて、わたしの受けて来た幸運の總を其人に捧げやう、わたしは一生谷底に埋もれて、それが其人の幸福にさへなれば満足である、わたしは膀るに桑もなく、着るに衣服もない乞丐の境界へ落ちても、其人にさへ光明が添ひ、其人にさへ錦繍が當つて居れば、それで愚ふことはない、去らう〳〵』彼女は更に強く深く覚悟した。
——本誌に記載の小説『金扇』物語の卷の一百——

Shima Seien
"Nobuko from *Golden Fan*" (*Kinsen no Nobuko)*
[a novel by Watanabe Katei]

PLATE 63

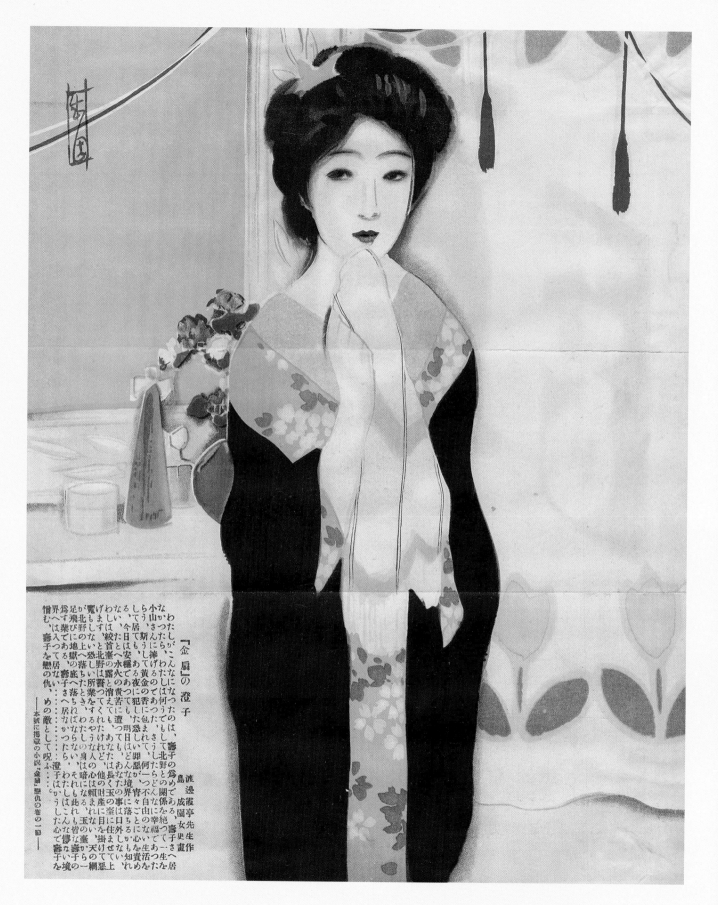

Shima Seien
"Sumiko from *Golden Fan*" (*Kinsen no Sumiko*)
[a novel by Watanabe Katei]

PLATE 64

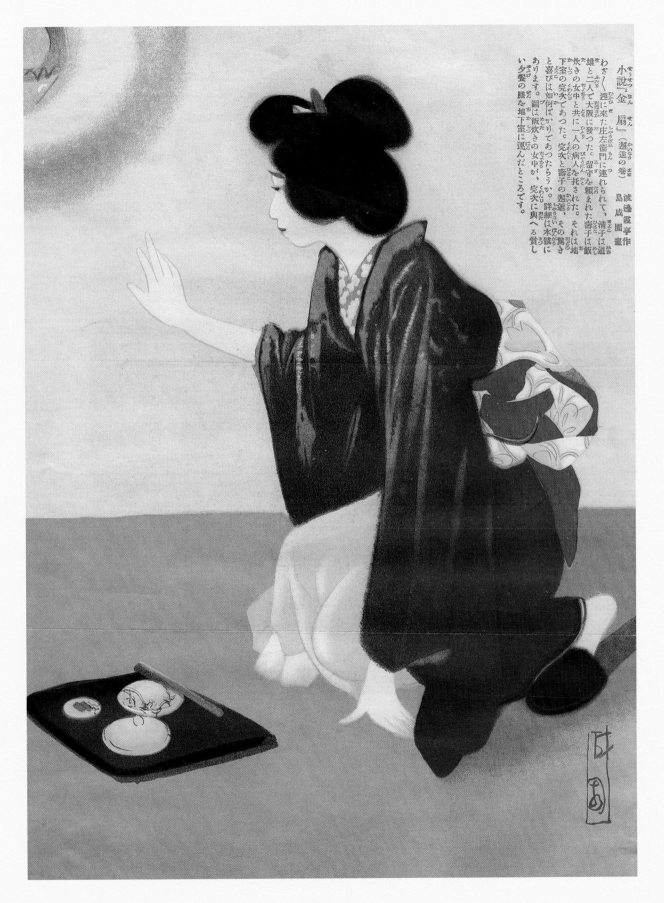

Shima Seien
"Surprise Reunion *(Kaikô no maki)*"; chapter from *Golden Fan (Kinsen)*
[a novel by Watanabe Katei]

PLATE 65

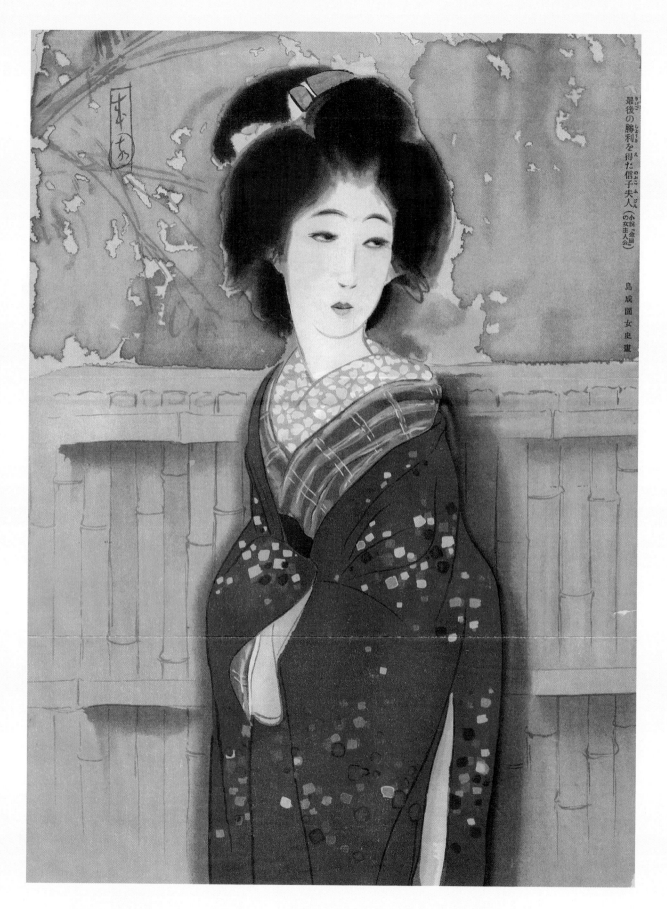

最後の勝利を得た信子夫人（小説「金扇」の女主人公）

島成園女史筆

Shima Seien
"Mrs. Nobuko from *Golden Fan*" (*Kinsen no Nobuko fujin*)
[a novel by Watanabe Katei]

PLATE 66

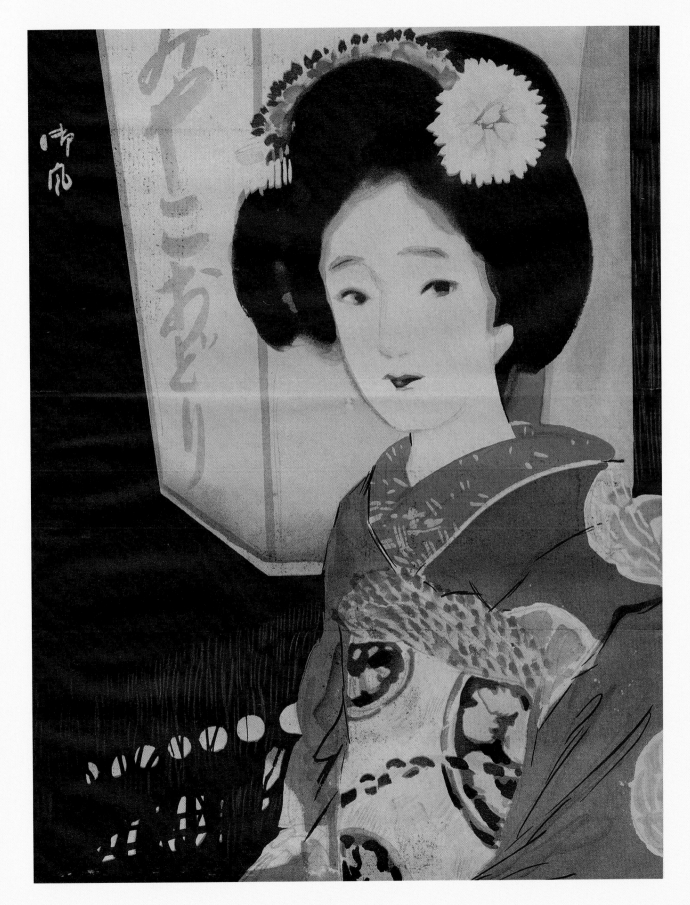

Shima Gyofū (or Issui)
[unknown title]

PLATE 67

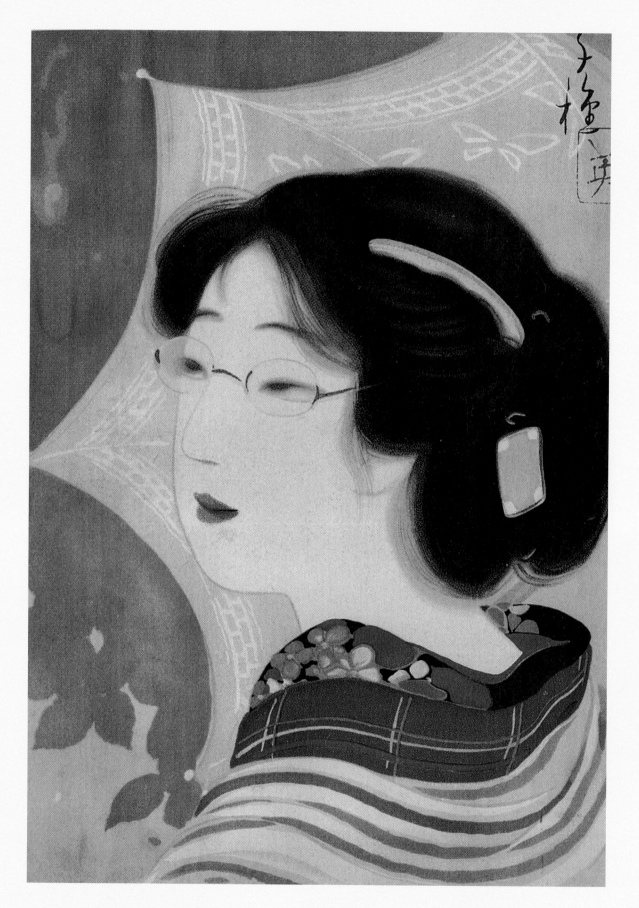

Kitani (Yoshioka) Chigusa
"Visit" *(Hómon)*

PLATE 68

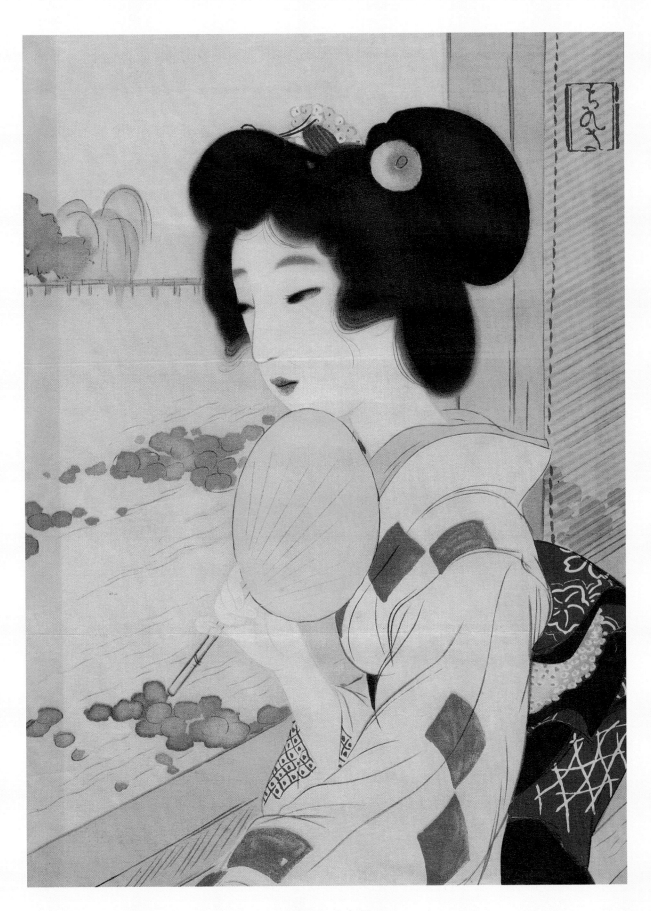

Kitani (Yoshioka) Chigusa
"Kamo River" (Kamogawa)

PLATE 69

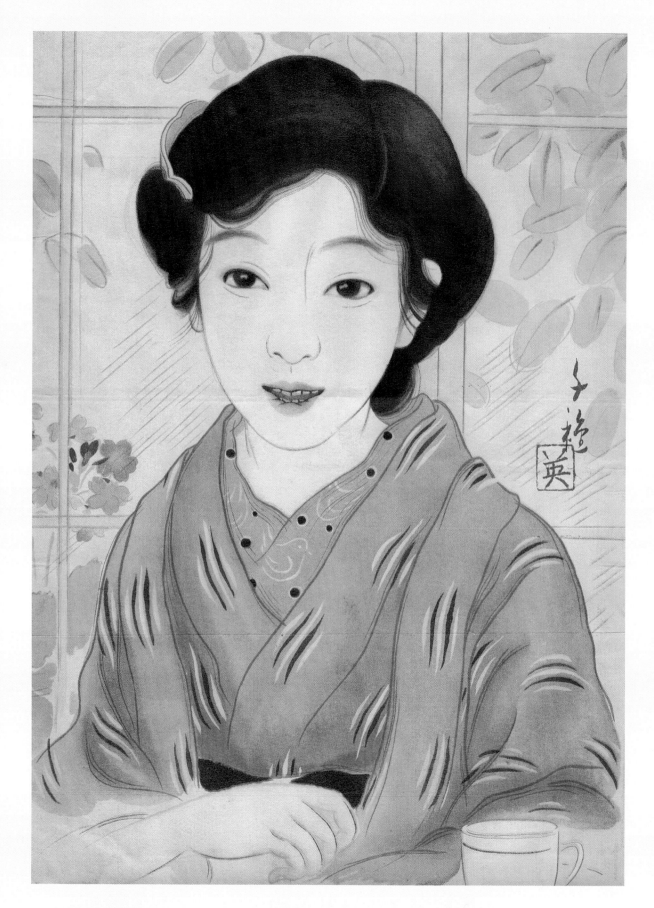

Kitani (Yoshioka) Chigusa
"Small Talk after a Meal" *(Shokugo shôwa)*

PLATE 70

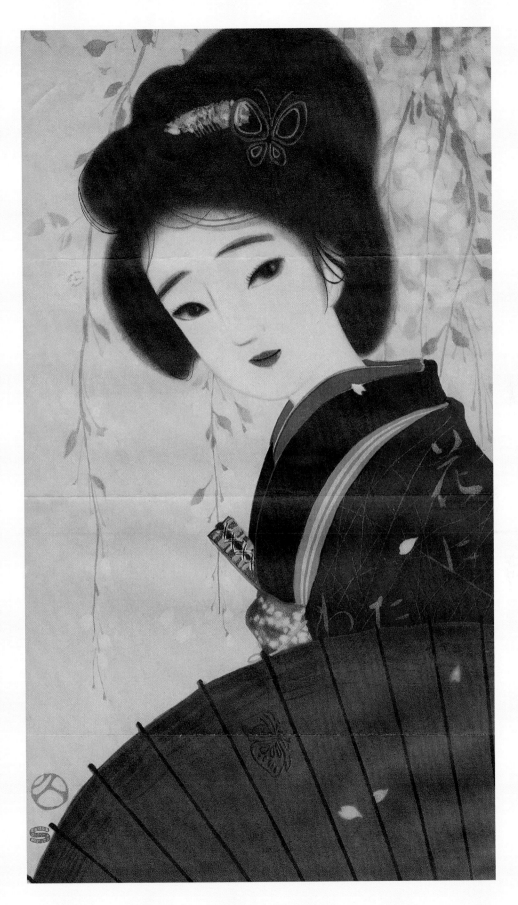

Morita Hisashi
"Under the Flowers" *(Hana no shita)*

PLATE 71

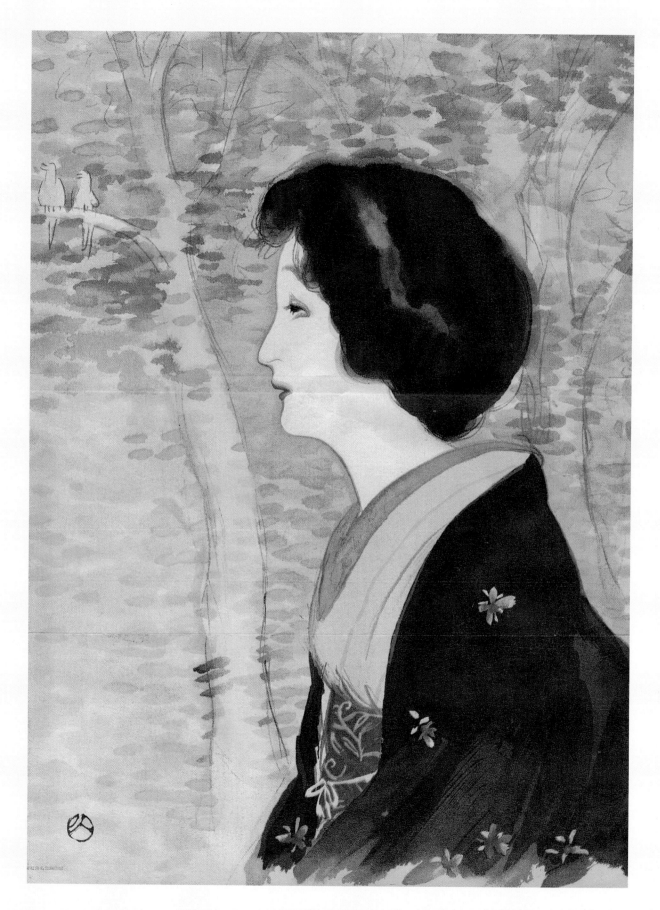

Morita Hisashi
"The Song of the Birds" *(Kotori no uta)*

PLATE 72

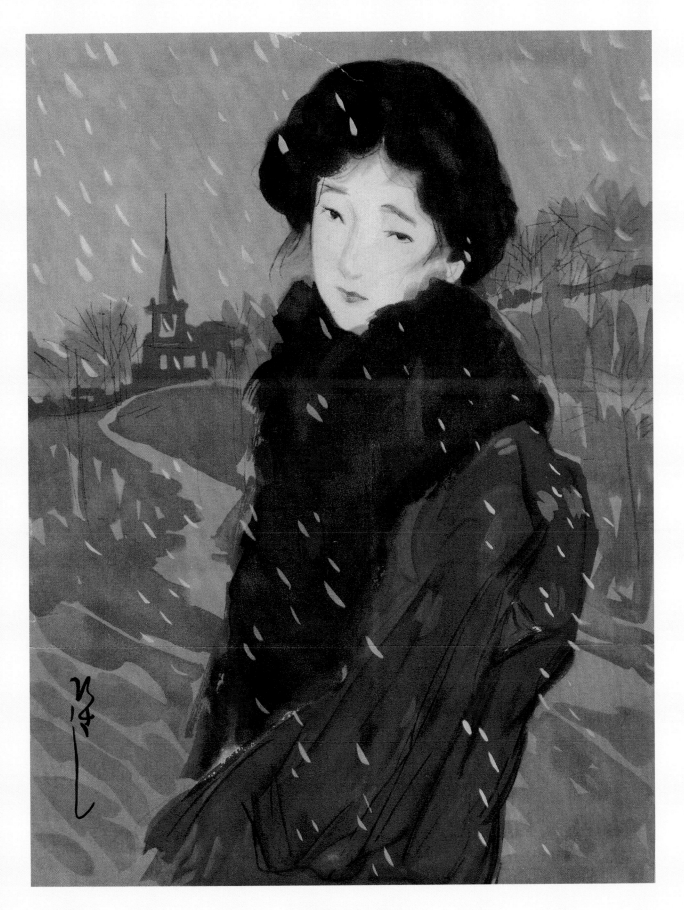

Morita Hisashi
"A Ringing Bell" *(Kane wa naru)*

PLATE 73

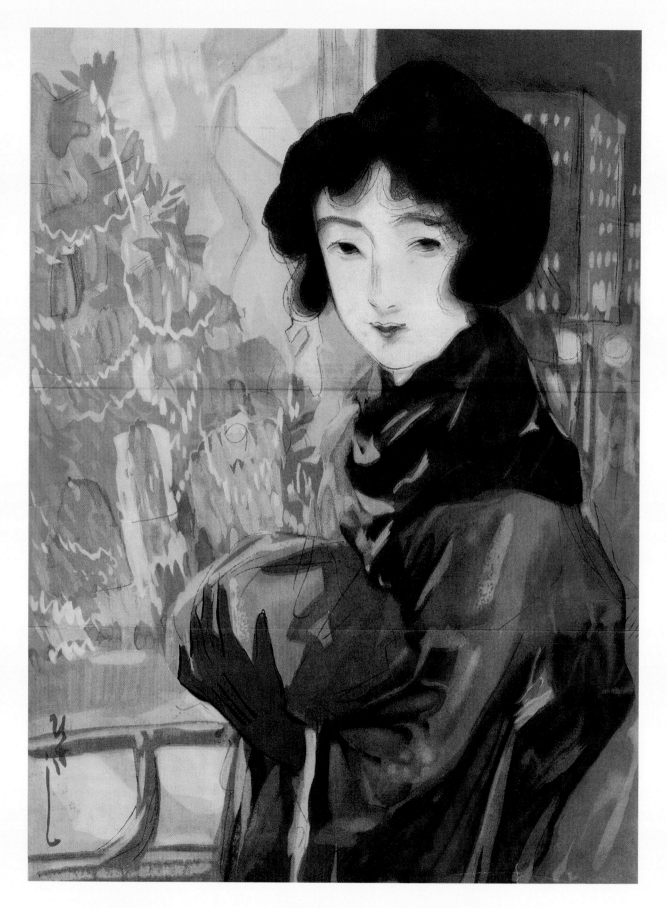

Morita Hisashi
"Christmas Night" *(Kurisumasu no yoru)*

PLATE 74

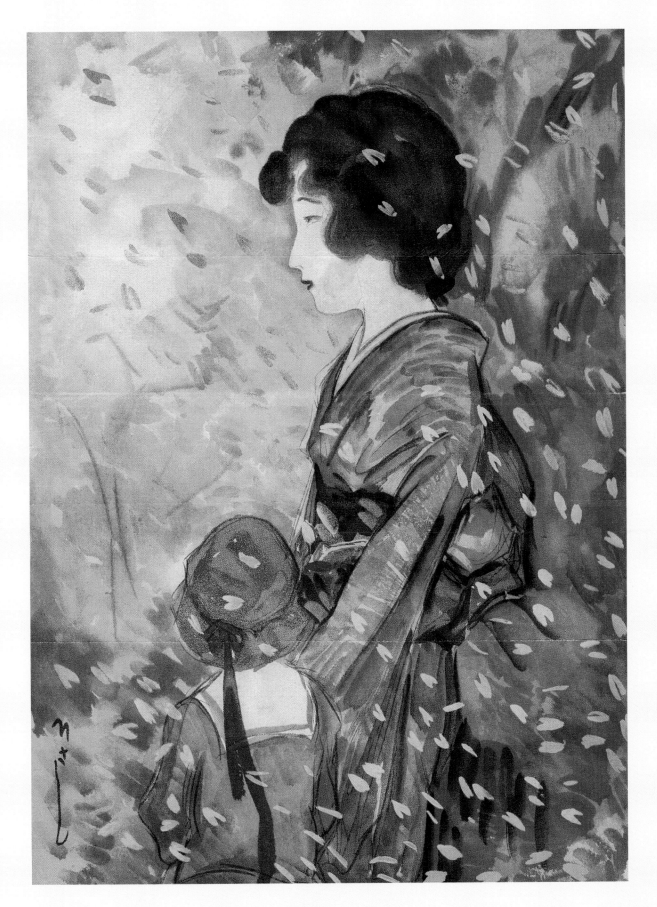

Morita Hisashi
"Flower Petal Blizzard" *(Hanafubuki)*

PLATE 75

宿 の 梅

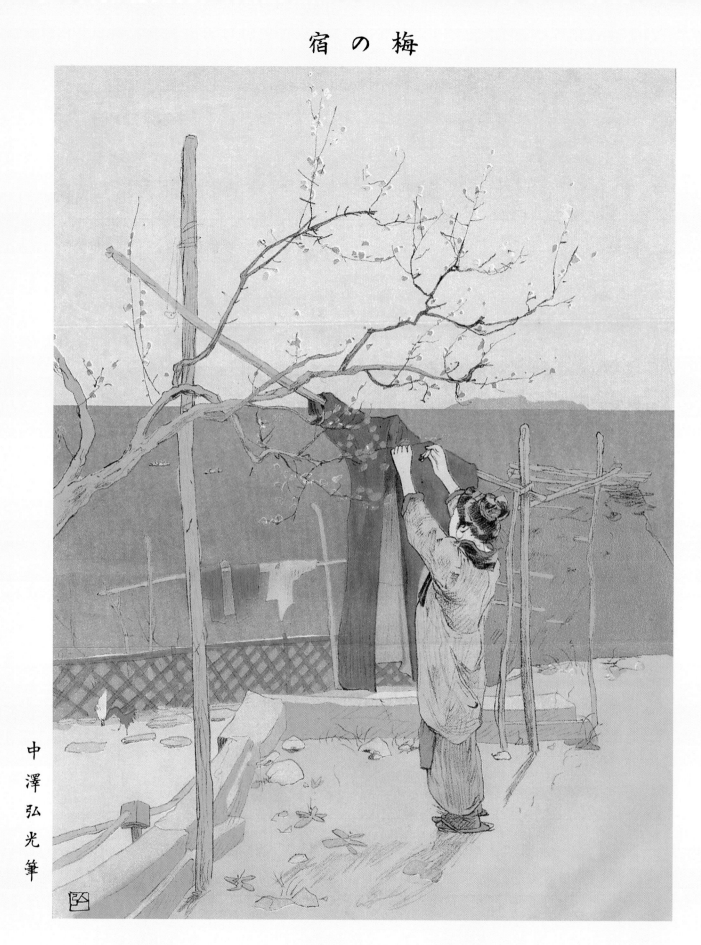

中澤弘光筆

Nakazawa Hiromitsu
"The Plum House" *(Ume no yado)*

PLATE 76

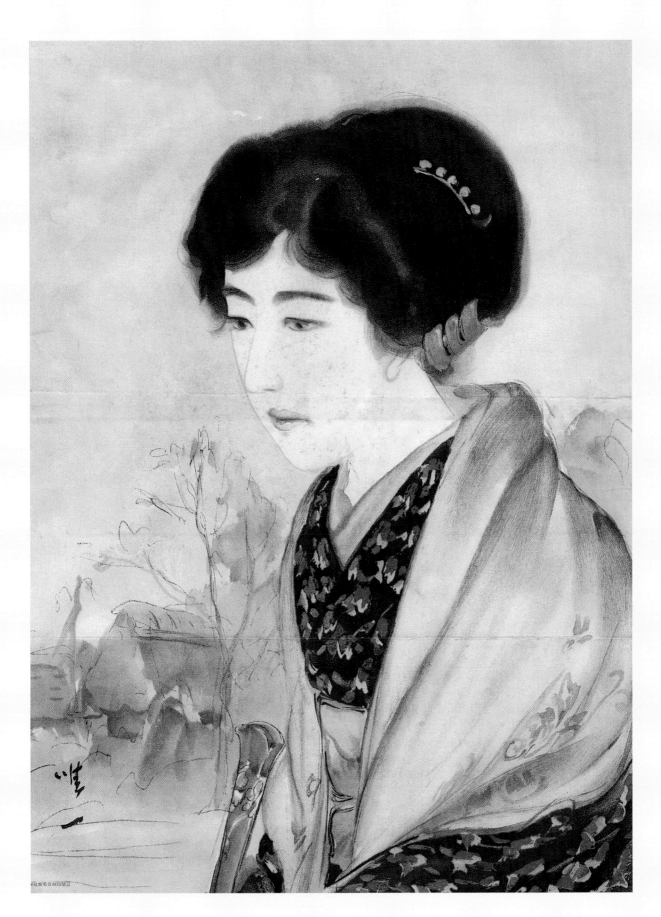

Hayashi Tadaichi
"A Fine Autumn Day" *(Akibare)*

PLATE 77

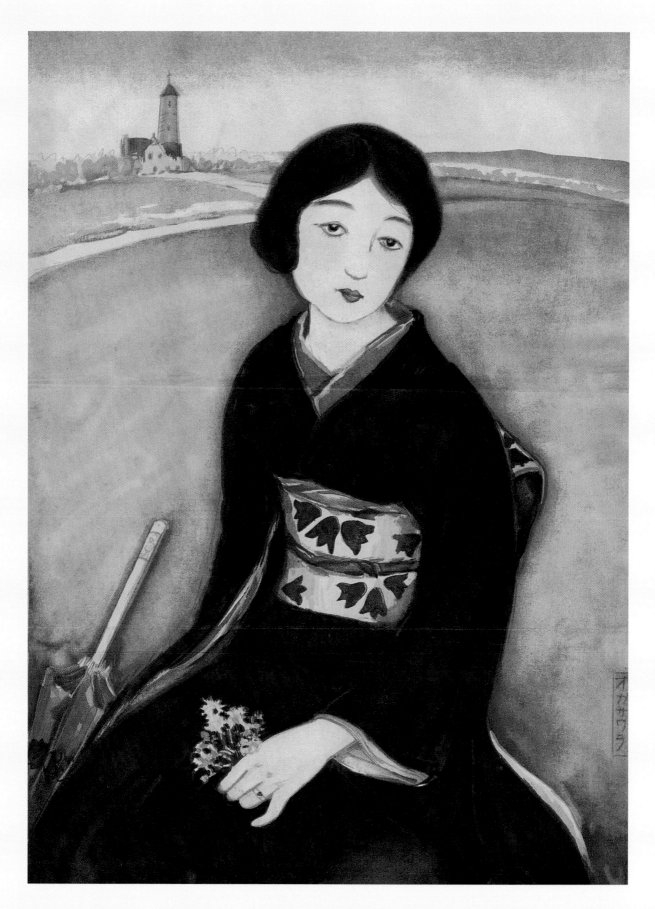

Ogasawara Kanzô
"Out to a Spring Field" *(Haru no no ni dete)*

PLATE 78

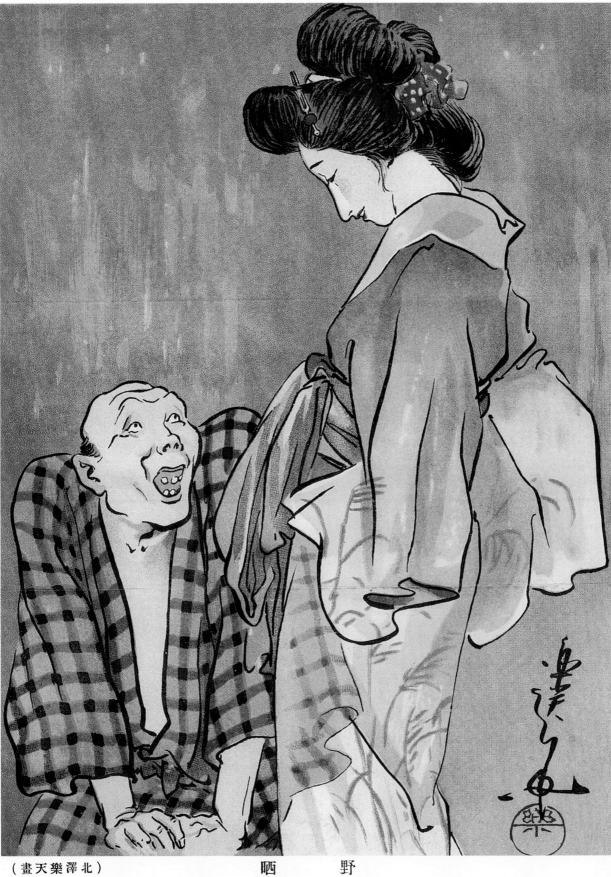

（畫天樂澤北）　　　　晒　　野

Kitazawa Rakuten
"Exposed in a Field" *(Nozarashi)*

PLATE 79

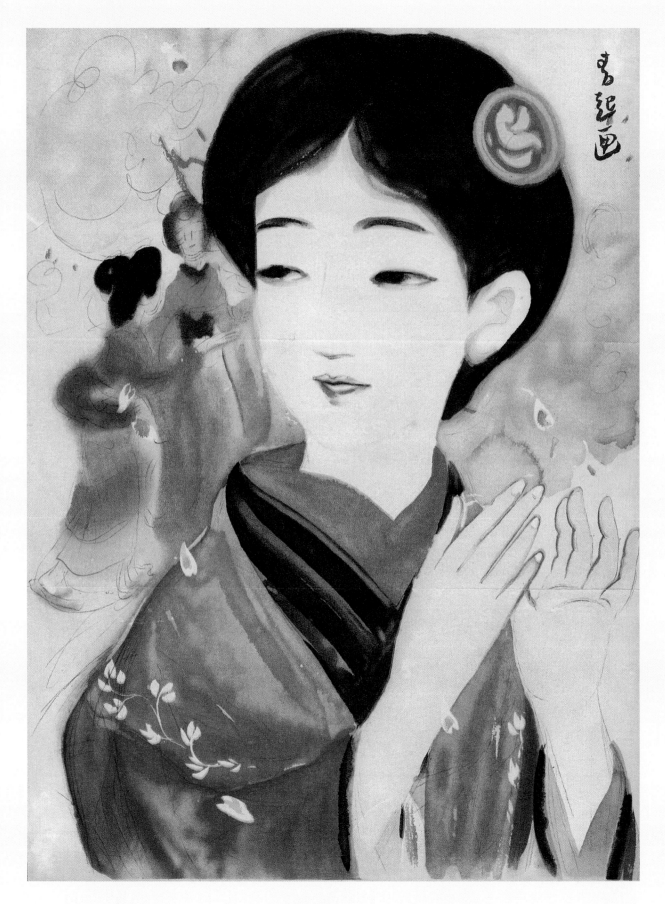

Hosokibara Seiki
[unknown title]

PLATE 80

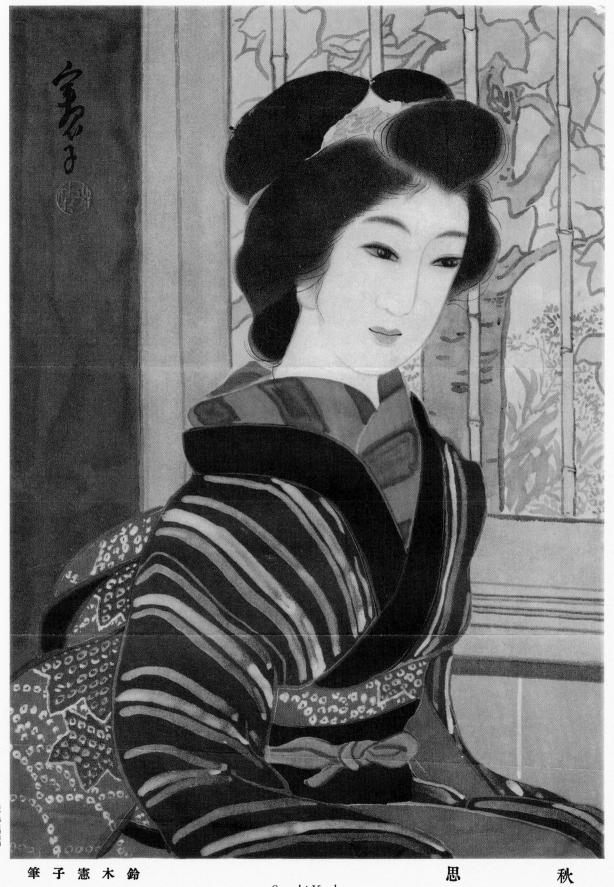

筆子憲木鈴　　　　　　　　　　　思　秋

Suzuki Kenko
"Autumn Thoughts" *(Shûshi)*

PLATE 81

げ か 鳥

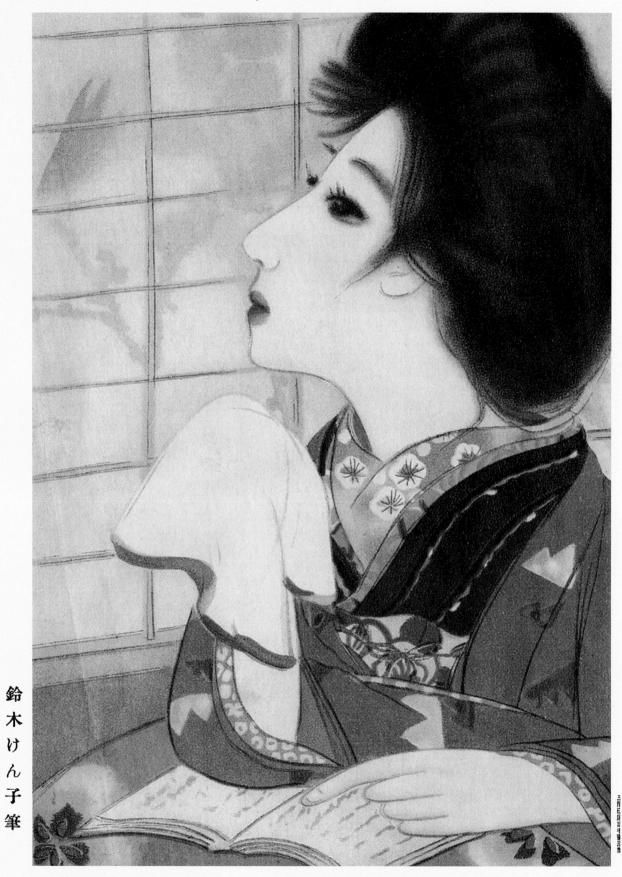

鈴木けん子筆

Suzuki Kenko
"Bird Shadow" *(Torikage)*

PLATE 82

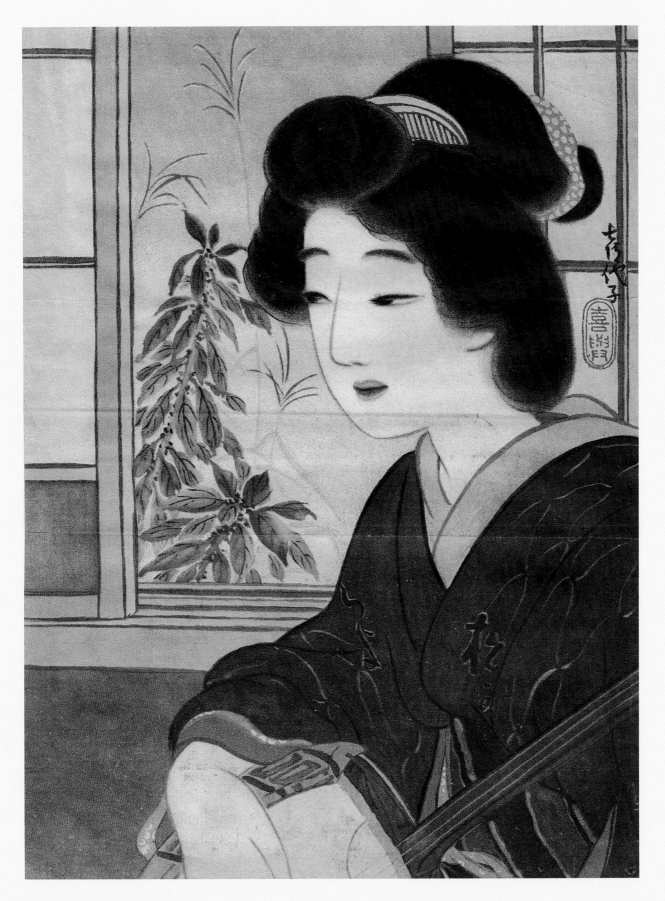

Anzai Kiyoko
[unknown title]

PLATE 83

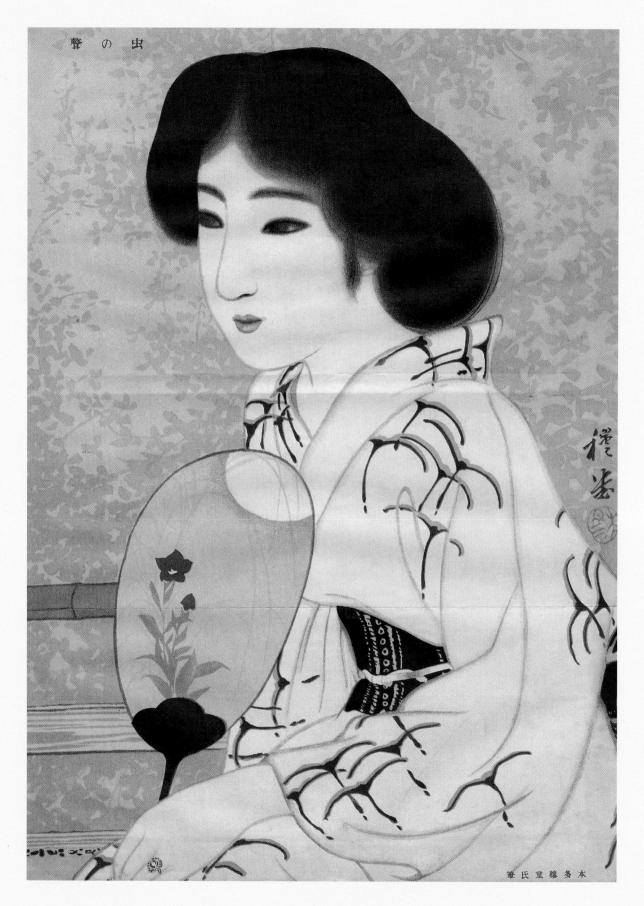

虫 の 聲

Honda Bokudô
"The Chirping of Insects" *(Mushi no koe)*

PLATE 84

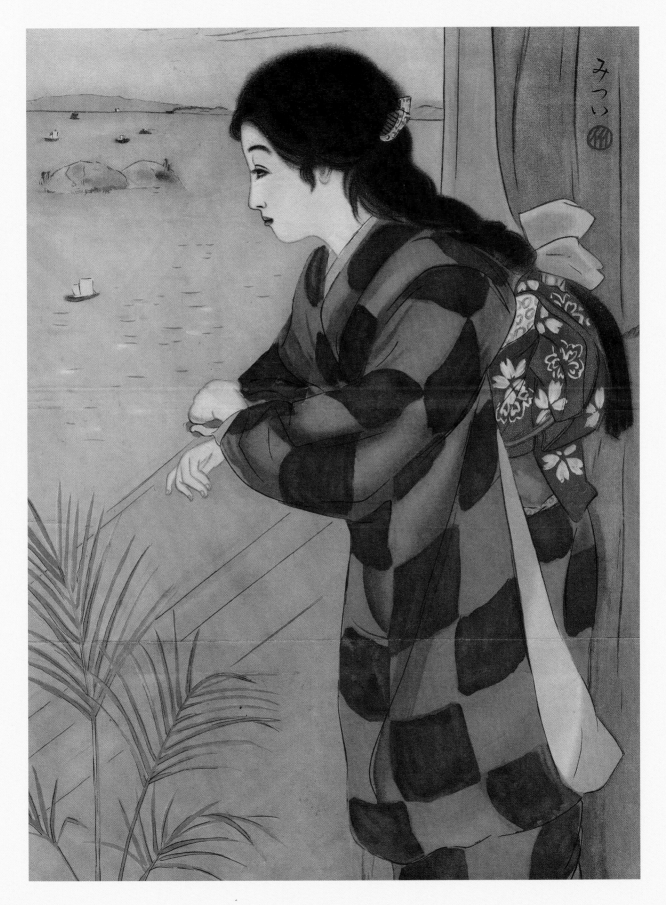

Asai Mitsui
"Looking at the Sea" *(Umi o nagamete)*

PLATE 85

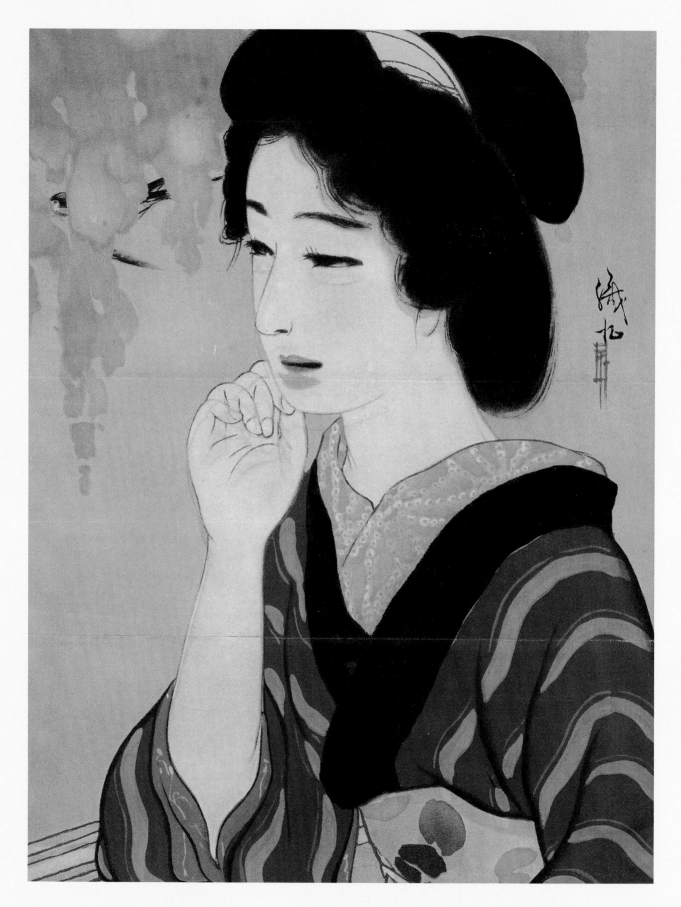

Hamaoka Orie
"Blurry Willow" (Yanagi kemuru)

PLATE 86

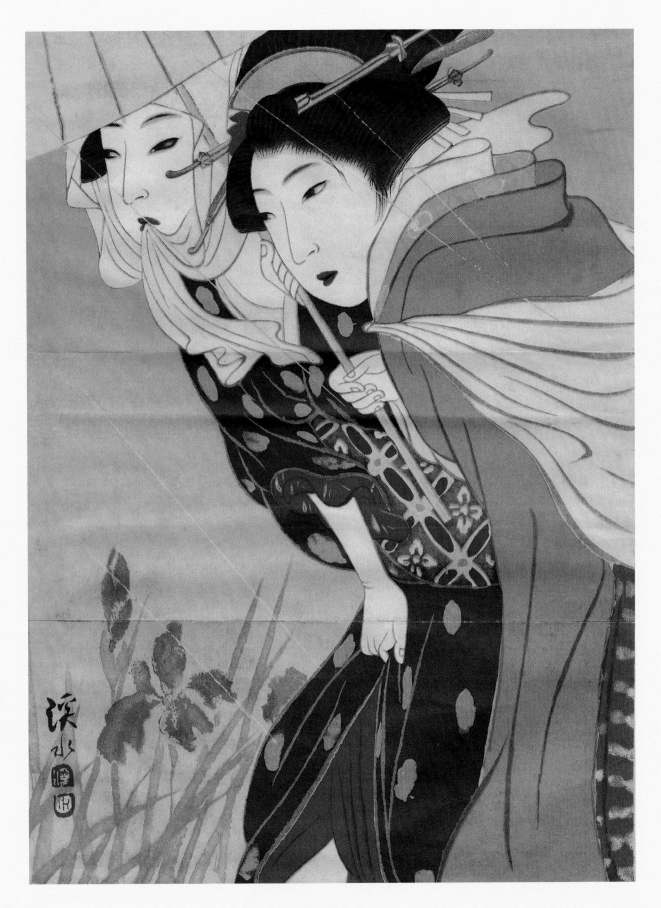

Ikari Keisui
"Early Summer Rain" *(Samidare)*

PLATE 87

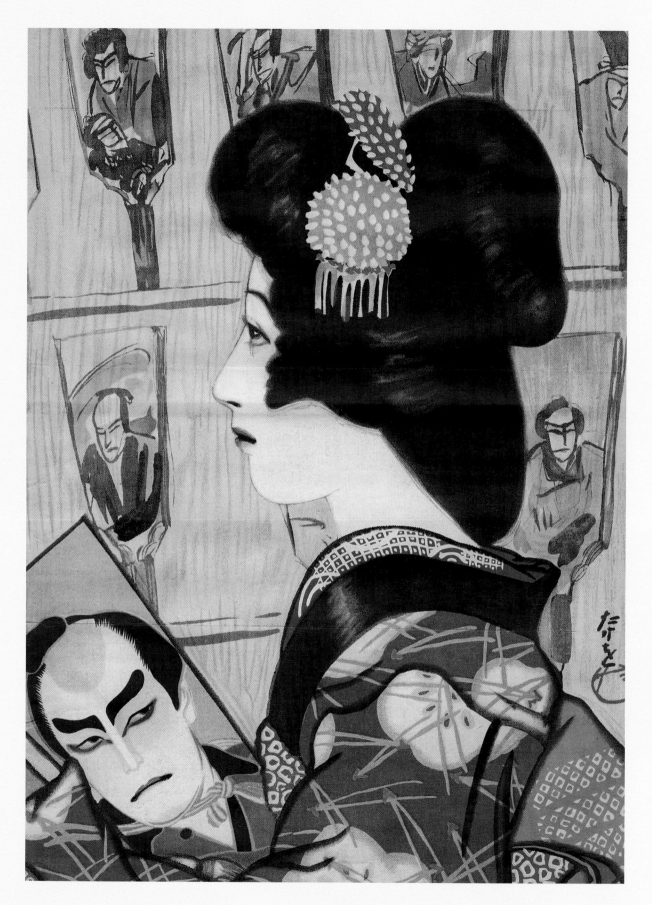

Inoue Takeo
"A Fan of Sadanji" *(Sadanji hiiki)*

PLATE 88

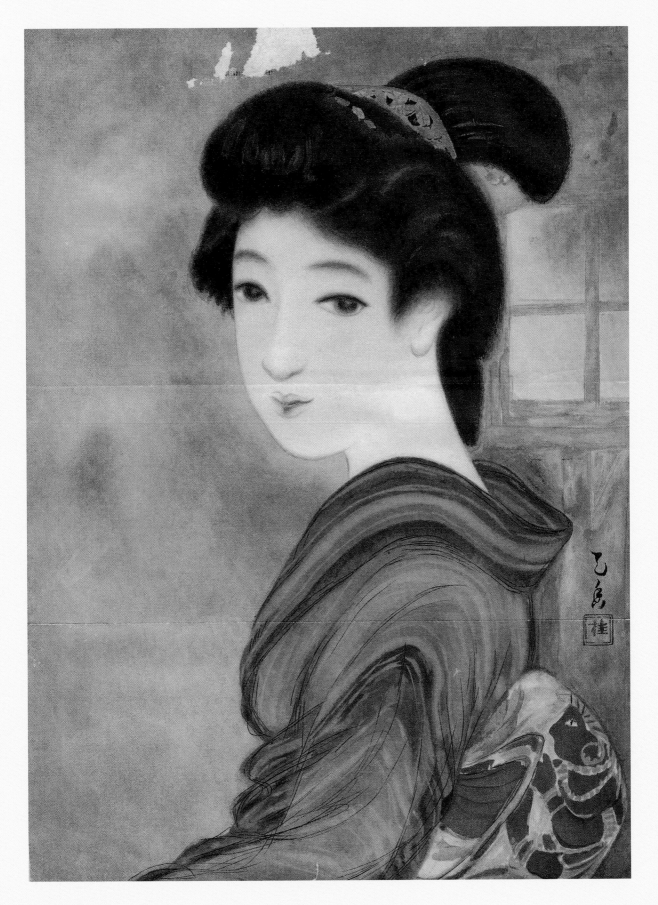

Kiriya Tenkô
"After an Evening Shower" *(Yûdachi no ato)*

PLATE 89

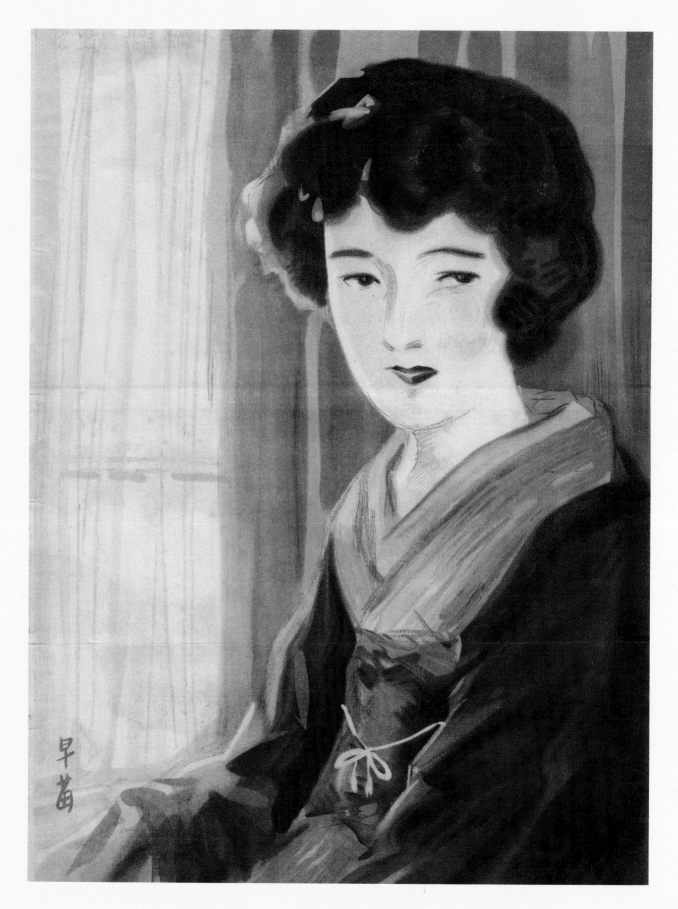

Morita Sanae
"First Sun Light of the New Year" *(Hatsuhikage)*

PLATE 90

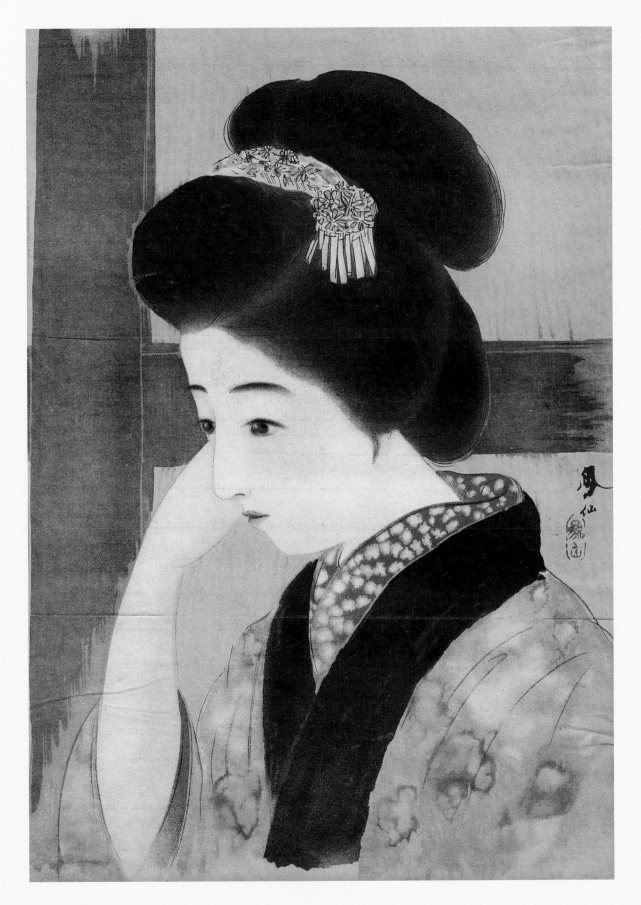

Nagai Hôsen
"A Box" *(Sajiki)*

PLATE 91

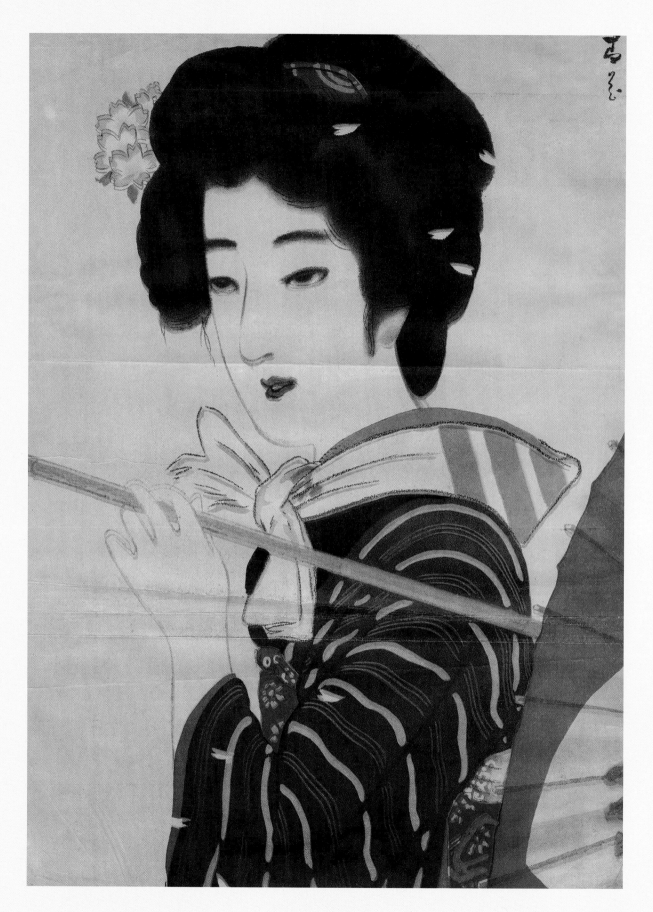

Niizeki Seika
"Tipsy" *(Horoyoi)*

PLATE 92

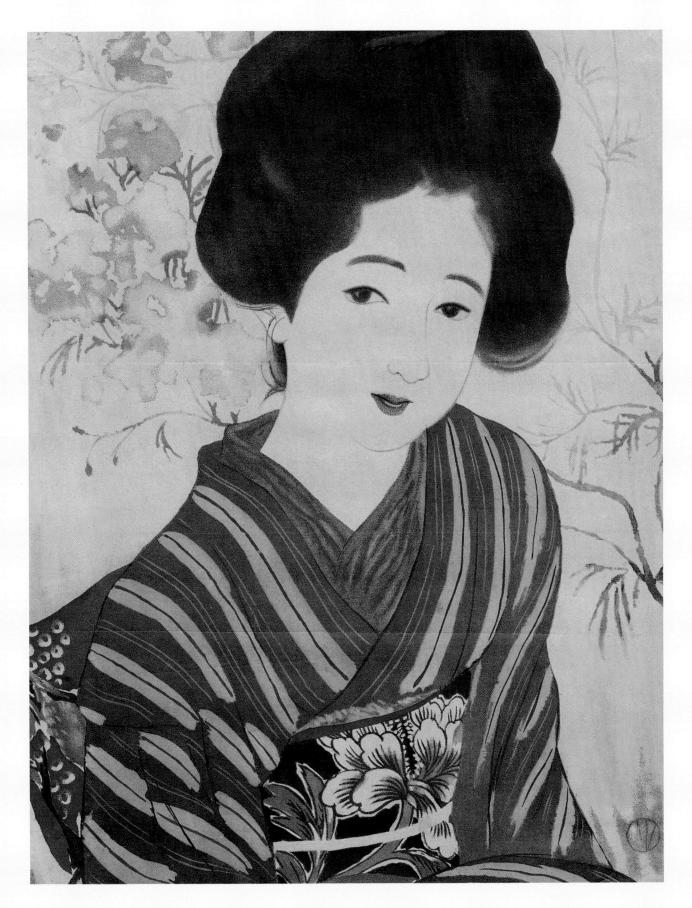

Okumura Ringyô
"Cosmos" *(Akizakura)*

Plate 93

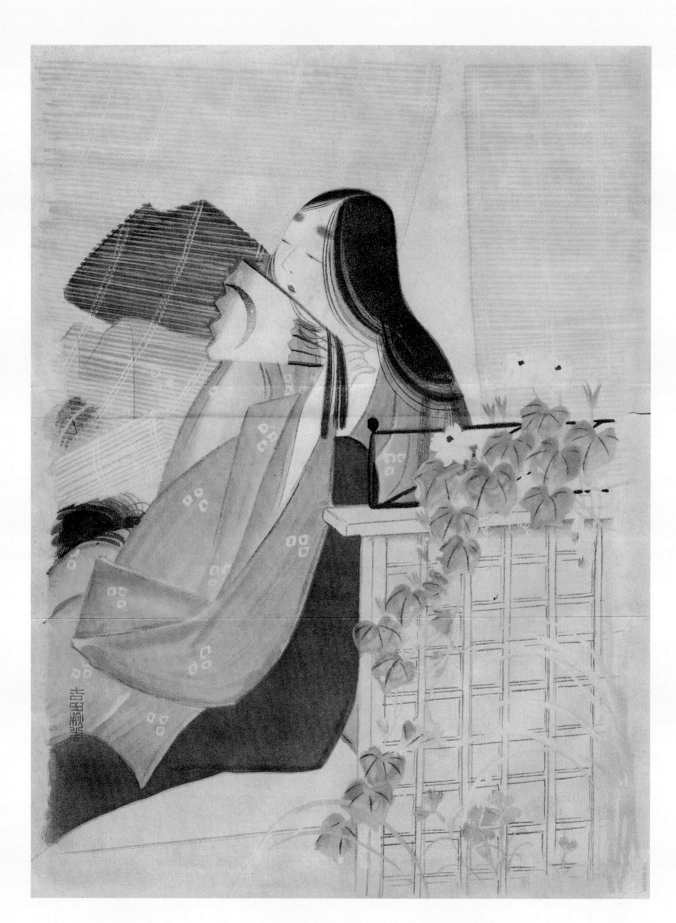

Yoshida Shûkô
"Morning Glory" *(Asagao)*

PLATE 94

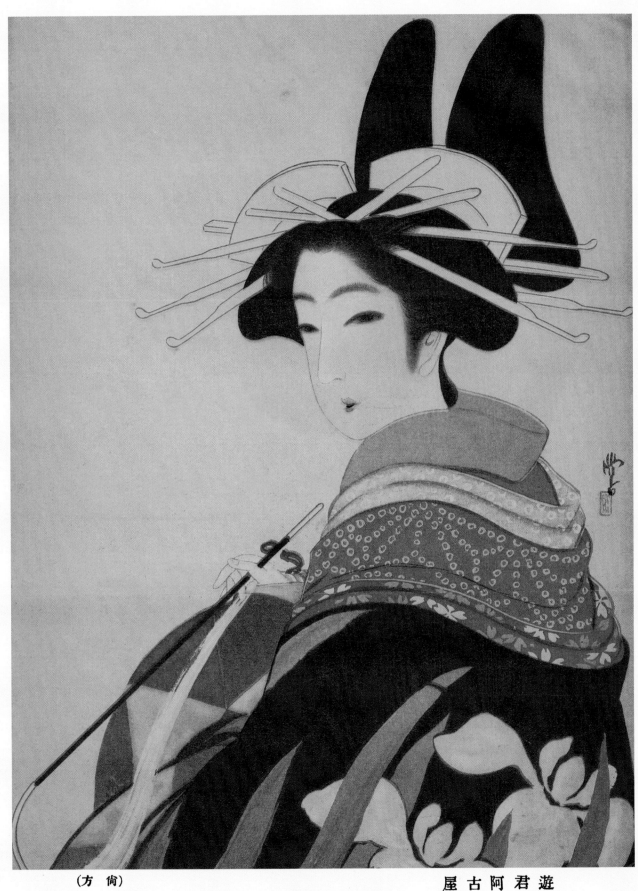

（方　伺）　　　　　　　　　　　　　　　　　屋 古 阿 君 遊

Yoshino Naokata
"The Courtesan Akoya" *(Yūkun Akoya)*

PLATE 95

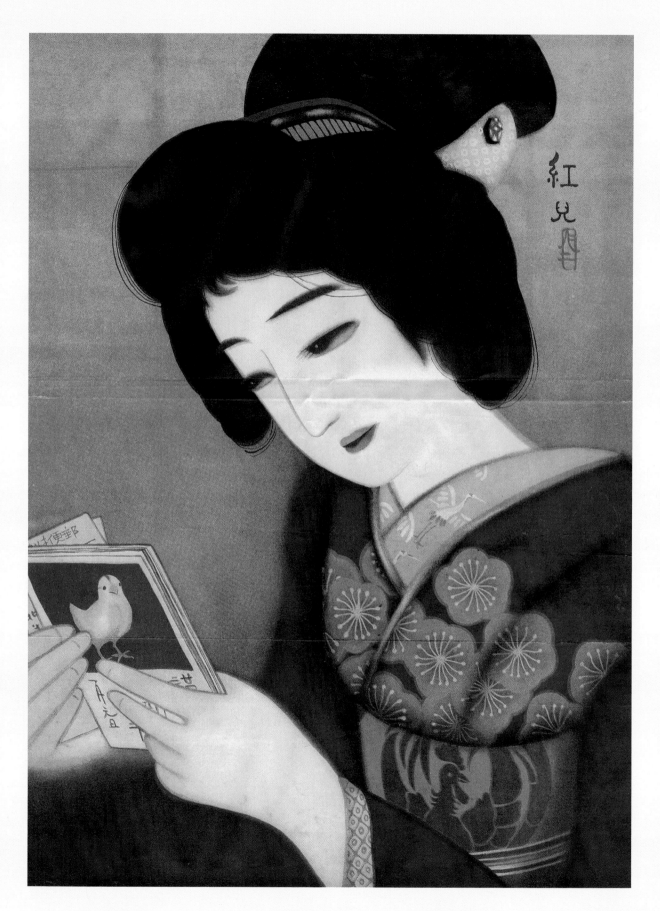

Fukiya Kôji
[unknown title]

PLATE 96

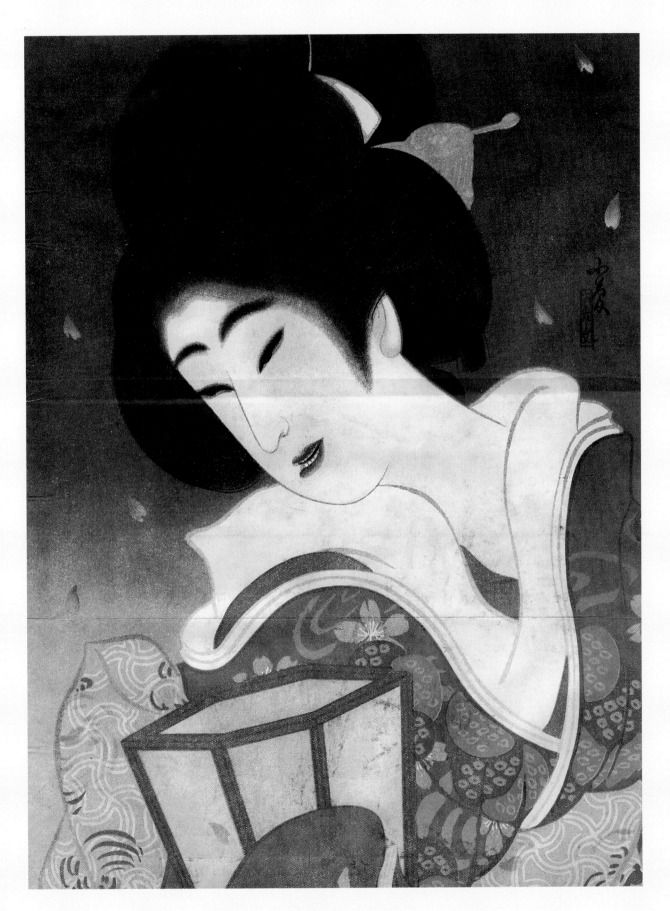

Tachibana Sayume
[unknown title]

PLATE 97

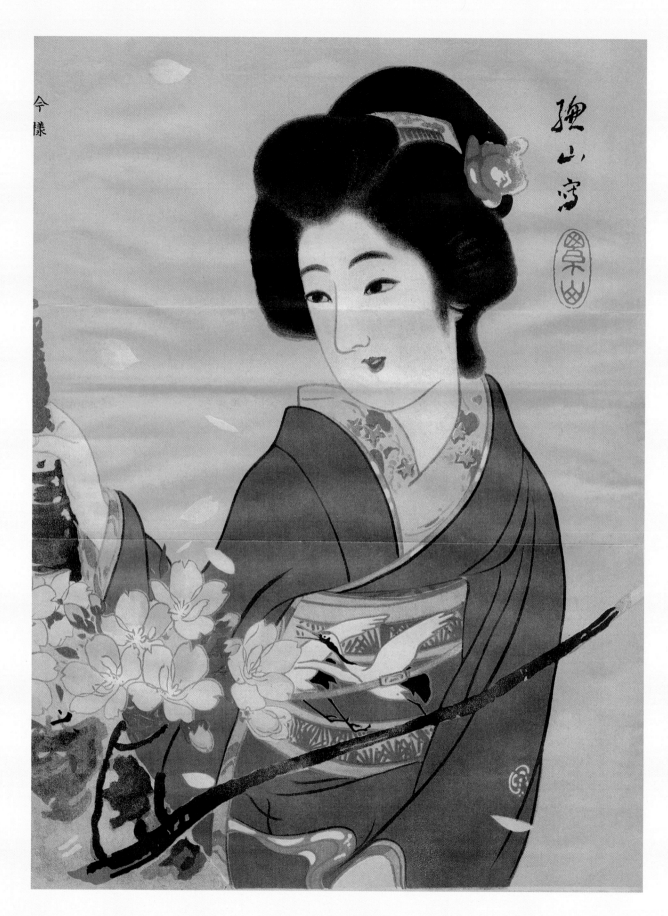

今樣

Itô Sôzan
"Fashion Now" *(Imayô)*

PLATE 98

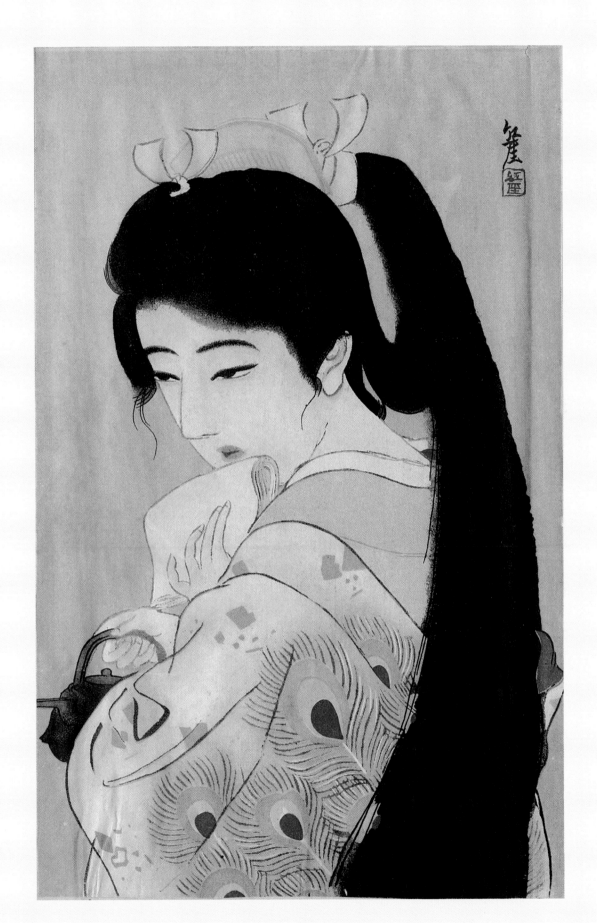

Noguchi Kôgai
[unknown title]

PLATE 99

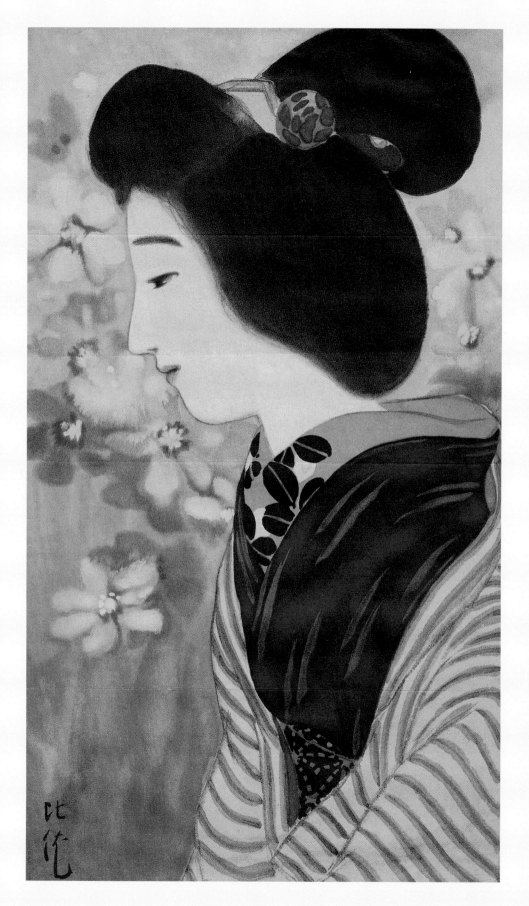

Takeda Hisa
[unknown title]

PLATE 100

COMPLETE PLATE INFORMATION

PLATE 1
Artist: Hirezaki Eihô (1880–1968)
Title: "Wedding Day" (Totsugu hi)
Magazine: Shufunotomo (Tôkyô kasei kenkyûkai)
Issue & Date: Vol. 2, No. 4, April 1918 (Taishô 7)
Printing Company: unknown

PLATE 2
Artist: Hirezaki Eihô (1880–1968)
Title: from A Hair in a Field (Hatake no kami no ke)
[a kôdan story by Chiyoda Kinkyô]
Magazine: Goraku sekai (Suzuki shoten)
Issue & Date: Vol. 8, No. 2, February 1920 (Taishô 9)
Printing Company: Ôe Printing Co., Ltd. (Ôe insatsu kabushiki gaisha)

PLATE 3
Artist: Hirezaki Eihô (1880–1968)
Title: "Early Summer" (Shoka)
Magazine: Fujokai (Dôbunkan)
Issue & Date: Vol. 21, No. 6, June 1920 (Taishô 9)
Printing Company: unknown

PLATE 4
Artist: Hirezaki Eihô (1880–1968)
Title: from A Chest of Drawers with a Lingering Spirit (Ki no nokoru tansu) [a kôdan story by Chiyoda Kinkyô.]
Magazine: Goraku sekai (Suzuki shoten)
Issue & Date: Vol. 8, No. 6, June 1920 (Taishô 9)
Printing Company: unknown

PLATE 5
Artist: Hirezaki Eihô (1880–1968)
Title: from The Courageous Woman Sarashina (Yûfu Sarashina)" [a kôdan story by Murai Sadakichi]
Magazine: Goraku sekai (Suzuki shoten)
Issue & Date: Vol. 8, No. 7, July 1920 (Taishô 9)
Printing Company: Ôe Printing Co., Ltd. (Ôe insatsu kabushiki gaisha)

PLATE 6
Artist: Hirezaki Eihô (1880–1968)
Title: "A Hazy Spring Moon Night" (Oborozukiyo)
Magazine: unidentified
Issue & Date: unknown
Printing Company: unknown

PLATE 7
Artist: Kajita Hanko (1870–1917)
Title: "Peach" (Momo)
Magazine: Fujin gahô (Tôkyôsha)
Issue & Date: No. 53, March 1911 (Meiji 44)
Printing Company: Tanaka Photoengraving (Tanaka seihan), Tokyo

PLATE 8
Artist: Kajita Hanko (1870–1917)
Title: "The Empress Jingû" (Jingû kôgô)
(The Empress Jingu who conducted the Expedition to Korea in A.D. 200.)

Magazine: unidentified
Issue & Date: unknown
Printing Company: unknown

PLATE 9
Artist: Kondô Shiun (active 1912–45)
Title: from "Dancing Girl" (Maihime)
Magazine: unidentified
Issue & Date: unknown
Printing Company: unknown

PLATE 10
Artist: Sudô Munekata (act. 1893–1913)
Title: "A Daughter of the Iseya" (Iseya no musume)
Magazine: unidentified
Issue & Date: unknown
Printing Company: unknown

PLATE 11
Artist: Sudô Munekata (act. 1893–1913)
Title: from Story of the Labyrinth Pavilion (Meirôki)
Magazine: unidentified
Issue & Date: unknown
Printing Company: unknown

PLATE 12
Artist: Otake Kokkan (1880–1945)
Title: "Reaching Womanhood" (Myôrei masani hatachi)
[This month marks the 20th anniversary of establishment of Hakubunkan.]
Magazine: unidentified (Hakubunkan)
Issue & Date: June 1907 (Meiji 40)
Printing Company: unknown

PLATE 13
Artist: Kurihara Gyokuyô (1883–1923)
Title: "Morning Glory" (Asagao)
Magazine: Fujin gahô (Tôkyôsha)
Issue & Date: No. 110, July 1915 (Taishô 4)
Printing Company: Koshiba Photoengraving Printing (Koshiba seihan insatsu), Tokyo)

PLATE 14
Artist: Kurihara Gyokuyô (1883–1923)
Title: "The Beginning of the 11th Month"
(Shimotsuki hajime)
Magazine: Fujokai (Dôbunkan)
Issue & Date: Vol. 20, No. 5, November 1919 (Taishô 8)
Printing Company: unknown

PLATE 15
Artist: Kurihara Gyokuyô (1883–1923)
Title: "Autumn [Exhibition] in Ueno" (Aki no Ueno)
Magazine: Fujokai (Dôbunkan)
Issue & Date: Vol. 22, No. 4, October 1920 (Taishô 9)
Printing Company: Mitsuma Printing & Co (Mitsuma insatsu gômei gaisha), Tokyo

PLATE 16
Artist: Kurihara Gyokuyô (1883–1923)
Title: "Morning" *(Asa)*
Magazine: *Fujin sekai* (Jitsugyô no nihonsha)
Issue & Date: Vol. 15, No. 10, October 1920 (Taishô 9)
Printing Company: unknown

PLATE 17
Artist: Kurihara Gyokuyô (1883–1923)
Title: "Morning in Early Summer" *(Shoka no asa)*
Magazine: *Fujin sekai* (Jitsugyô no nihonsha)
Issue & Date: Vol. 16, No. 6, June 1921 (Taishô 10)
Printing Company: unknown

PLATE 18
Artist: Kurihara Gyokuyô (1883–1923)
Title: "Flower Blooming Time" *(Hana saku koro)*
Magazine: *Fujin sekai* (Jitsugyô no nihonsha)
Issue & Date: Vol. 17, No. 3, March 1922 (Taishô 11)
Printing Company: unknown

PLATE 19
Artist: Kasai Hikono (1896–1920)
Title: "Early Summer" *(Shoka)*
Magazine: *Bungei kurabu* (Hakubunkan)
Issue & Date: Vol. 23, No. 7, May 1917 (Taishô 6)
Printing Company: unknown

PLATE 20
Artist: Kawasaki Rankô (1882–1918)
Title: "[Soldiers] Comfort Bag" *(Imonbukuro)*
Magazine: *Fujin gahô* (Tôkyôsha)
Issue & Date: No. 102, November 1914 (Taishô 3)
Printing Company: Koshiba Photoengraving Printing (Koshiba seihan insatsu), Tokyo

PLATE 21
Artist: Kawasaki Rankô (1882–1918)
Title: "Evening Moon" *(Yoizuki)*
Magazine: *Fujin gahô* (Tôkyôsha)
Issue & Date: No. 111, August 1915 (Taishô 4)
Printing Company: Koshiba Photoengraving Printing (Koshiba seihan insatsu), Tokyo

PLATE 22
Artist: Ishiyama Taihaku (1893–1961)
Title: "Evening" *(Tasogare)*
Magazine: *Kôdan zasshi* (Hakuyûsha)
Issue & Date: Vol. 3, No. 6, June 1917 (Taishô 6)
Printing Company: unknown

PLATE 23
Artist: Ikeda Terukata (1883–1921)
Title: "An October Diary" *(Jûgatsu no nikki)*
Magazine: *Katei zasshi* (Hakubunkan)
Issue & Date: Vol. 1, No. 5, October 1915 (Taishô 4)
Printing Company: unknown

PLATE 24
Artist: Ikeda Terukata (1883-1921)
Title: "Spring at Saruwakachô" *(Saruwakachô no haru)*
Magazine: *Engei gahô* (Engeigahôsha)
Issue & Date: Vol. 5, No. 1, January 1918 (Taishô 7)
Printing Company: Tokyo Seibidô

PLATE 25
Artist: Ikeda (Sakakibara) Shôen (1886–1917)
Title: "Spring Dressing Up" *(Shunsô)*
Magazine: *Fujin gahô* (Tôkyôsha)
Issue & Date: No. 50, January 1911 (Meiji 44)
Printing Company: unknown

PLATE 26
Artist: Ikeda (Sakakibara) Shôen (1886–1917)
Title: "Intermission" *(Makuai)*
Magazine: *Fujin gahô* (Tôkyôsha)
Issue & Date: No. 101, October 1914 (Taishô 3)
Printing Company: Koshiba Photoengraving Printing (Koshiba seihan insatsu), Tokyo

PLATE 27
Artist: Shiizuka Shôka (act.1907–1922)
Title: "The Chirping of Insects" *(Mushi no ne)*
Magazine: *Fujin gahô* (Tôkyôsha)
Issue & Date: No. 99, August 1914 (Taishô 3)
Printing Company: Koshiba Photoengraving Printing (Koshiba seihan insatsu), Tokyo

PLATE 28
Artist: Shiizuka Shôka (act.1907–1922)
Title: "At a Summer Resort" *(Hishochi nite)*
Magazine: *Fujokai* (Dôbunkan)
Issue & Date: Vol. 26, No. 2, August 1922 (Taishô 11)
Printing Company: unknown

PLATE 29
Artist: Kaburaki Kiyokata (1878–1972)
Title: from *Empty (Kûkyo)* [a novel by Mayama Seika]
Magazine: *Shinshôsetsu* (Shunyôdô)
Issue & Date: Vol. 15, No. 7, July 1910 (Meiji 43)
Printing Company: Tôyô insatsu kabushiki gaisha in (printed by Tôyô Printing Co. Ltd.)

PLATE 30
Artist: Kaburaki Kiyokata (1878–1972)
Title: "Snow Rabbit" *(Yuki no usagi)*
Magazine: *Fujin gahô* (Tôkyôsha)
Issue & Date: No. 104, January 1915 (Taishô 4)
Printing Company: Tanaka Photoengraving (Tanaka seihan sanshoku insatsu), Tokyo

PLATE 31
Artist: Kaburaki Kiyokata (1878–1972)
Title: "The Greengrocer Oshichi" *(Yaoya Oshichi)*
Magazine: *Shin engei* (Genbunsha)
Issue & Date: Vol. 2, No. 12, December 1917 (Taishô 6)
Printing Company: unknown

PLATE 32
Artist: Kaburaki Kiyokata (1878–1972)
Title: "Plum Blossoms" *(Sumomo no hana)*
Magazine: *Fujokai* (Dôbunkan)
Issue & Date: Vol. 23, No. 4, April 1921 (Taishô 10)
Printing Company: unknown

PLATE 33
Artist: Ishii Tekisui (1882–1945)
Title: from *A Woman of Masakado (Masakado no onna)* [a story by Ôhashi Seiha]
Magazine: *Omoshiro kurbu* (Kôdansha)

Issue & Date: Vol. 4, No. 8, June 1919 (Taishô 8)
Printing Company: unknown

PLATE 34
Artist: Ishii Tekisui (1882–1945)
Title: "Autumn Shower" (*Shigure*)
Magazine: *Fujinkai* (Tôkyôsha)
Issue & Date: Vol. 3, No. 10, October 1919 (Taishô 8)
Printing Company: unknown

PLATE 35
Artist: Ishii Tekisui (1882–1945)
Title: "Christmas Morning" (*Kurisumasu no asa*)
Magazine: *Shufunotomo* (Tôkyô kasei kenkyûkai)
Issue & Date: Vol. 3, No. 12, December 1919 (Taishô 8)
Printing Company: unknown

PLATE 36
Artist: Ishii Tekisui (1882–1945)
Title: "New Year" (*Shinshun*)
Magazine: *Fujin gahô* (Tôkyôsha)
Issue & Date: No. 193, January 1922 (Taishô 11)
Printing Company: unknown

PLATE 37
Artist: Itô Shinsui (1898–1972)
Title: Dahlia" (*Dariya*)
Magazine: *Fujokai* (Dôbunkan)
Issue & Date: Vol. 22, No. 8, August 1920 (Taishô 9)
Printing Company: Mitsuma Printing & Co (Mitsuma insatsu gômei gaisha), Tokyo

PLATE 38
Artist: Itô Shinsui (1898–1972)
Title: "Frosty Morning" (*Shimo no asa*)
Magazine: *Fujokai* (Dôbunkan)
Issue & Date: Vol. 23, No. 2, February 1921 (Taishô 10)
Printing Company: Mitsuma Printing & Co (Mitsuma insatsu gômei gaisha), Tokyo

PLATE 39
Artist: Itô Shinsui (1898–1972)
Title: "Rainbow" (*Niji*)
Magazine: *Fujin sekai* (Jitsugyônonihonsha)
Issue & Date: Vol. 16, No. 7, July 1921 (Taishô 10)
Printing Company: Mitsuma Printing & Co. (Mitsuma insatsu gômei gaisha), Tokyo

PLATE 40
Artist: Itô Shinsui (1898–1972)
Title: unknown
Magazine: unidentified
Issue & Date: unknown
Printing Company: unknown

PLATE 41
Artist: Itô Shinsui (1898–1972)
Title: "Balcony" (*Nikai sajiki*)
Magazine: unidentified
Issue & Date: unknown
Printing Company: unknown

PLATE 42
Artist: Kakiuchi Seiyô (1890–1982)
Title: "Moth" (*Ga*)
Magazine: *Fujokai* (Dôbunkan)

Issue & Date: Vol. 22, No. 2, August 1923 (Taishô 12)
Printing Company: Mitsuma Printing & Co. (Mitsuma insatsu gômei gaisha), Tokyo

PLATE 43
Artist: Masuda Gyokujô (1881–1955)
Title: "Nail Clipping" (*Tsumekiri*)
Magazine: *Fujin sekai* (Jitsugyô no nihonsha)
Issue & Date: Vol. 15, No. 2, February 1920 (Taishô 9)
Printing Company: Mitsuma Printing & Co. (Mitsuma insatsu gômei gaisha), Tokyo

PLATE 44
Artist: Masuda Gyokujô (1881–1955)
Title: "At the Top of Mt. Fuji" (*Fuji no chôjô nite*)
Magazine: *Fujin sekai* (Jitsugyô no nihonsha)
Issue & Date: Vol. 16, No. 9, September 1921 (Taishô 10)
Printing Company: Mitsuma Printing & Co. (Mitsuma insatsu gômei gaisha), Tokyo

PLATE 45
Artist: Igawa Sengai (1876–1961)
Title: "Mother's Absence" (*Haha no rusu*)
Magazine: *Fujin gahô* (Tôkyôsha)
Issue & Date: No. 51, January 1911 (Meiji 44)
Printing Company: unknown

PLATE 46
Artist: Igawa Sengai (1876–1961)
Title: "White Plum" (*Hakubai*)
Magazine: *Fujin gahô* (Tôkyôsha)
Issue & Date: No. 119, February 1916 (Taishô 5)
Printing Company: unknown

PLATE 47
Artist: Igawa Sengai (1876–1961)
Title: from *A Pair of Pines (Hiyoku no matsu)*
[a novel by Gotô Chûgai]
Magazine: *Kôdan kurabu* (Kôdansha)
Issue & Date: Vol. 9, No. 3, February 1919 (Taishô 8)
Printing Company: unknown

PLATE 48
Artist: Igawa Sengai (1876–1961)
Title: from *Agemaki of Kyoto (Kyô no Agemaki)*
[a novel by Inaoka Nunosuke]
Magazine: *Kôdan kurabu* (Kôdansha)
Issue & Date: Vol. 9, No. 4, March 1919 (Taishô 8)
Printing Company: unknown

PLATE 49
Artist: Igawa Sengai (1876–1961)
Title: from *Lady Shizuka (Shizuka gozen)*
[a novel by Hasegawa Shigure]
Magazine: *Kôdan kurabu* (Kôdansha)
Issue & Date: Vol. 9, No. 5, April 1919 (Taishô 8)
Printing Company: unknown

PLATE 50
Artist: Igawa Sengai (1876–1961)
Title: from *Flower of a Wintry Field (Kareno no hana)*
[a novel by Hirai Banson]
Magazine: *Kôdan kurabu* (Kôdansha)
Issue & Date: Vol. 9, No. 8, June 1919 (Taishô 8)
Printing Company: unknown

PLATE 51
Artist: Igawa Sengai (1876–1961)
Title: from *Sword Dance (Tsurugi no mai)*
[a novel by Ôhashi Seiha]
Magazine: *Kôdan kurabu* (Kôdansha)
Issue & Date: Vol. 10, No. 7, May 1920 (Taishô 9)
Printing Company: unknown

PLATE 52
Artist: Igawa Sengai (1876–1961)
Title: from *The Descent of the Celestial Maiden (Tennyo kôrin)*
[a novel by Inaoka Nunosuke]
Magazine: *Kôdan kurabu* (Kôdansha)
Issue & Date: Vol. 10, No. 8, June 1920 (Taishô 9)
Printing Company: unknown

PLATE 53
Artist: Ishii Hôshô (act. c.1920)
Title: "Before the Mirror" *(Kagami no mae)*
Magazine: *Fujokai* (Dôbunkan)
Issue & Date: Vol. 22, No. 12, December 1920 (Taishô 9)
Printing Company: unknown

PLATE 54
Artist: Uemura Shôen (1875–1949)
Title: "Blue Bamboo Blind" *(Aosudare)*
Magazine: *Fujin gahô* (Tôkyôsha)
Issue & Date: No. 98, July 1914 (Taishô 3)
Printing Company: Koshiba Photoengraving Printing (Koshiba seihan insatsu), Tokyo)

PLATE 55
Artist: Uemura Shôen (1875–1949)
Title: "Peaceful" *(Nodoka)*
Magazine: *Fujin gahô* (Tôkyôsha)
Issue & Date: No. 107, April 1915 (Taishô 4)
Printing Company: Koshiba Photoengraving Printing (Koshiba seihan insatsu), Tokyo)

PLATE 56
Artist: Kitano Tsunetomi (1880–1947)
Title: "Sewing a Bridal Cloth" *(Yomegoromo o nuu)*
Magazine: *Jogaku sekai* (Hakubunkan)
Issue & Date: Vol. 12, No. 9, June 1912 (Meiji 45)
Printing Company: unknown

PLATE 57
Artist: Kitano Tsunetomi (1880–1947)
Title: "Battledore" *(Hagoita)*
Magazine: *Jogaku sekai* (Hakubunkan)
Issue & Date: Vol. 14, No. 2, January 1914 (Taishô 3)
Printing Company: unknown

PLATE 58
Artist: Hata Tsuneharu (1883–?)
Title: Ogata Michiko from *Things Fleeting Away (Sugiyuku mono)* [a story by Yuasa Kenkichi]
Magazine: *Shufunotomo* (Tôkyô kasei kenkyûkai)
Issue & Date: Vol. 6, No. 1, January 1922 (Taishô 11)
Printing Company: unknown

PLATE 59
Artist: Shima Seien (1892–1970)
Title: "Fig" *(Ichijiku)*

Magazine: *Jogaku sekai* (Hakubunkan)
Issue & Date: Vol. 14, No. 9, July 1914 (Taishô 3)
Printing Company: unknown

PLATE 60
Artist: Shima Seien (1892–1970)
Title: "Utamaki" *(Utamaki)*
Magazine: *Fujin gahô* (Tôkyôsha)
Issue & Date: No. 100, September 1914 (Taishô 3)
Printing Company: unknown

PLATE 61
Artist: Shima Seien (1892–1970)
Title: "A Girl in Sorrow" *(Kanashimi no shôjo)*, Tazuko from *Golden Fan (Kinsen)* [a novel by Watanabe Katei]
Magazine: *Shufunotomo* (Tôkyô kasei kenkyûkai)
Issue & Date: Vol. 4, No. 4, April 1920 (Taishô 9)
Printing Company: unknown
[See Tazuko in story "Kinsen" (Shôsetsu "Kinsen" no Tazuko o gosanshô kudasai)
[Chapter of "Anesthetic" (Masuiyaku no maki).
(The 16th chapter)]

PLATE 62
Artist: Shima Seien (1892–1970)
Title: "Hisako from *Golden Fan*" *(Kinsen no Hisako)*
[a novel by Watanabe Katei]
Magazine: *Shufunotomo* (Tôkyô kasei kenkyûkai)
Issue & Date: Vol. 4, No. 6, June 1920 (Taishô 9)
Printing Company: unknown
[Chapter "Street Fortune-teller" (Tsujiurauri no maki) (The 18th chapter)]

PLATE 63
Artist: Shima Seien (1892–1970)
Title: "Nobuko from *Golden Fan*" *(Kinsen no Nobuko)*
[a novel by Watanabe Katei]
Magazine: *Shufunotomo* (Tôkyô kasei kenkyûkai)
Issue & Date: Vol. 4, No. 8, August 1920 (Taishô 9)
Printing Company: unknown
[Chapter of "Sacrifice" (Gisei no maki) (The 20th chapter)]

PLATE 64
Artist: Shima Seien (1892–1970)
Title: "Sumiko from *Golden Fan*" *(Kinsen no Sumiko)*
[a novel by Watanabe Katei]
Magazine: *Shufunotomo* (Tôkyô kasei kenkyûkai)
Issue & Date: Vol. 4, No. 9, September 1920 (Taishô 9)
Printing Company: unknown
[Chapter of "Love Rival" (Koigataki no maki)
(The 21st chapter)]

PLATE 65
Artist: Shima Seien (1892–1970)
Title: "Surprise Reunion *(Kaikô no maki)*"; chapter from *Golden Fan (Kinsen)* [a novel by Watanabe Katei]
Magazine: *Shufunotomo* (Tôkyô kasei kenkyûkai)
Issue & Date: Vol. 4, No. 11, November 1920 (Taishô 9)
Printing Company: unknown
[Chapter "Surprise Reunion" (Kaikô no maki)
(The 23rd chapter)]

PLATE 66
Artist: Shima Seien (1892–1970)
Title: "Mrs. Nobuko from *Golden Fan*" (*Kinsen no Nobuko fujin*) [a novel by Watanabe Katei]
Magazine: Shufunotomo (Tôkyô kasei kenkyûkai)
Issue & Date: Vol. 4, No. 12, December 1920 (Taishô 9)
Printing Company: unknown
[Chapter of "Full Moon" (Mangetsu no maki) (The 24th chapter)]

PLATE 67
Artist: Shima Gyofû (or Issui) (1885–1968)
Title: unknown
Magazine: unidentified
Issue & Date: unknown
Printing Company: unknown

PLATE 68
Artist: Kitani (Yoshioka) Chigusa (1895–1947)
Title: "Visit" *(Hômon)*
Magazine: *Fujokai* (Dôbunkan)
Issue & Date: Vol. 19, No. 5, May 1919 (Taishô 8)
Printing Company: unknown

PLATE 69
Artist: Kitani (Yoshioka) Chigusa (1895–1947)
Title: "Kamo River" *(Kamogawa)*
Magazine: *Fujokai* (Dôbunkan)
Issue & Date: Vol. 22, No. 1, July 1920 (Taishô 9)
Printing Company: unknown

PLATE 70
Artist: Kitani (Yoshioka) Chigusa (1895–1947)
Title: "Small Talk after a Meal" *(Shokugo shôwa)*
Magazine: *Fujokai* (Dôbunkan)
Issue & Date: Vol. 23, No. 3, March 1921 (Taishô 10)
Printing Company: unknown

PLATE 71
Artist: Morita Hisashi (dates unknown)
Title: "Under the Flowers" *(Hana no shita)*
Magazine: *Kôdan zasshi* (Hakuyûsha)
Issue & Date: Vol. 3, No. 4, April 1917 (Taishô 6)
Printing Company: unknown

PLATE 72
Artist: Morita Hisashi (dates unknown)
Title: "The Song of the Birds" *(Kotori no uta)*
Magazine: *Fujokai* (Dôbunkan)
Issue & Date: Vol. 22, No. 11, November 1920 (Taishô 9)
Printing Company: unknown

PLATE 73
Artist: Morita Hisashi (dates unknown)
Title: "A Ringing Bell" *(Kane wa naru)*
Magazine: *Jogaku sekai* (Hakubunkan)
Issue & Date: Vol. 20, No. 12, December 1920 (Taishô 9)
Printing Company: unknown

PLATE 74
Artist: Morita Hisashi (dates unknown)
Title: "Christmas Night" *(Kurisumasu no yoru)*
Magazine: *Jogaku sekai* (Hakubunkan)
Issue & Date: Vol. 21, No. 12, December 1921 (Taishô 10)
Printing Company: unknown

PLATE 75
Artist: Morita Hisashi (dates unknown)
Title: "Flower Petal Blizzard" *(Hanafubuki)*
Magazine: *Fujokai* (Diobunkan)
Issue & Date: Vol. 25, No. 5, May 1922 (Taishô 11)
Printing Company: unknown

PLATE 76
Artist: Nakazawa Hiromitsu (1874–1964)
Title: "The Plum House" *(Ume no yado)*
Magazine: *Fujin gahô* (Tôkyôsha)
Issue & Date: No. 52, February 1911 (Meiji 44)
Printing Company: unknown

PLATE 77
Artist: Hayashi Tadaichi (1895–1972)
Title: "A Fine Autumn Day" *(Akibare)*
Magazine: *Fujin sekai* (Jitsugyônonihonsha)
Issue & Date: Vol. 15, No. 11, November 1920 (Taishô 9)
Printing Company: Mitsuma Printing & Co. (Mitsuma insatsu gômei gaisha), Tokyo

PLATE 78
Artist: Ogasawara Kanzô (dates unknown)
Title: "Out to a Spring Field" *(Haru no no ni dete)*
Magazine: *Jogaku sekai* (Hakubunkan)
Issue & Date: Vol. 21, No. 4, April 1921 (Taishô 10)
Printing Company: unknown

PLATE 79
Artist: Kitazawa Rakuten (1876–1955)
Title: "Exposed in a Field" *(Nozarashi)*
Magazine: *Shin shôsetsu* (Shun'yôdô)
Issue & Date: Vol. 17, No. 8, August 1912 (Meiji 45)
Printing Company: unknown

PLATE 80
Artist: Hosokibara Seiki (1885–1958)
Title: unknown
Magazine: unidentified
Issue & Date: unknown
Printing Company: unknown

PLATE 81
Artist: Suzuki Kenko (dates unknown)
Title: "Autumn Thoughts" *(Shûshi)*
Magazine: *Fujin kôron* (Chûô kôronsha)
Issue & Date: Vol. 1, No. 10, October 1916 (Taishô 5)
Printing Company: Offset Printing & Co., Kanda, Tokyo

PLATE 82
Artist: Suzuki Kenko (dates unknown)
Title: "Bird Shadow" *(Torikage)*
Magazine: *Fujokai* (Dôbunkan)
Issue & Date: Vol. 21, No. 2, February 1920 (Taishô 9)
Printing Company: unknown

PLATE 83
Artist: Anzai Kiyoko (dates unknown)
Title: unknown
Magazine: unidentified
Issue & Date: unknown
Printing Company: unknown

PLATE 84
Artist: Honda Bokudô (dates unknown)
Title: "The Chirping of Insects" (Mushi no koe)
Magazine: unidentified
Issue & Date: unknown
Printing Company: unknown

PLATE 85
Artist: Asai Mitsui (dates unknown)
Title: "Looking at the Sea" (Umi o nagamete)
Magazine: Jogaku sekai (Hakubunkan)
Issue & Date: Vol. 21, No. 3, March 1921 (Taishô 10)
Printing Company: unknown

PLATE 86
Artist: Hamaoka Orie (dates unknown)
Title: "Blurry Willow" (Yanagi kemuru)
Magazine: Bungei kurabu (Hakubunkan)
Issue & Date: Vol. 25, No. 7, May 1919 (Taishô 8)
Printing Company: unknown

PLATE 87
Artist: Ikari Keisui (dates unknown)
Title: "Early Summer Rain" (Samidare)
Magazine: Bungei kurabu (Hakubunkan)
Issue & Date: Vol. 26, No. 7, May 1920 (Taishô 9)
Printing Company: unknown

PLATE 88
Artist: Inoue Takeo (dates unknown)
Title: "A Fan of Sadanji" (Sadanji hiiki)
Magazine: Bungei kurabu (Hakubunkan)
Issue & Date: Vol. 26, No. 16, December 1920 (Taishô 9)
Printing Company: unknown

PLATE 89
Artist: Kiriya Tenkô (dates unknown)
Title: "After an Evening Shower" (Yûdachi no ato)
Magazine: Fujokai (Dôbunkan)
Issue & Date: Vol. 24, No. 2, August 1921 (Taishô 10)
Printing Company: unknown

PLATE 90
Artist: Morita Sanae (dates unknown)
Title: "First Sun Light of the New Year" (Hatsuhikage)
Magazine: Jogaku sekai (Hakubunkan)
Issue & Date: Vol. 21, No. 1, January 1921 (Taishô 10)
Printing Company: unknown

PLATE 91
Artist: Nagai Hôsen (dates unknown)
Title: "A Box" (Sajiki)
Magazine: Bungei kurabu (Hakubunkan)
Issue & Date: Vol. 26, No. 4, March 1920 (Taishô 9)
Printing Company: unknown

PLATE 92
Artist: Niizeki Seika (dates unknown)
Title: "Tipsy" (Horoyoi)
Magazine: Bungei kurabu (Hakubunkan)
Issue & Date: Vol. 26, No. 5, April 1920 (Taishô 9)
Printing Company: unknown

PLATE 93
Artist: Okumura Ringyô (dates unknown)
Title: "Cosmos" (Akizakura)
Magazine: Bungei kurabu (Hakubunkan)
Issue & Date: Vol. 25, No. 13, October 1919 (Taishô 8)
Printing Company: unknown

PLATE 94
Artist: Yoshida Shûkô (1887–1946)
Title: "Morning Glory" (Asagao)
Magazine: Fujokai (Dôbunkan)
Issue & Date: Vol. 24, No. 1, July 1921 (Taishô 10)
Printing Company: Mitsuma Printing & Co (Mitsuma insatsu gômei gaisha), Tokyo

PLATE 95
Artist: Yoshino Naokata (dates unknown)
Title: "The Courtesan Akoya" (Yûkun Akoya)
Magazine: Engei gahô (Engeigahôsha)
Issue & Date: Vol. 5, No. 1, January 1918 (Taishô 7)
Printing Company: unknown

PLATE 96
Artist: Fukiya Kôji (1898–1979)
Title: unknown
Magazine: unidentified
Issue & Date: unknown
Printing Company: unknown

PLATE 97
Artist: Tachibana Sayume (1892–1970)
Title: unknown
Magazine: unidentified
Issue & Date: unknown
Printing Company: unknown

PLATE 98
Artist: Itô Sôzan (1884–?)
Title: "Fashion Now" (Imayô)
Magazine: unidentified
Issue & Date: unknown
Printing Company: unknown

PLATE 99
Artist: Noguchi Kôgai (dates unknown)
Title: unknown
Magazine: unidentified
Issue & Date: unknown
Printing Company: unknown

PLATE 100
Artist: Takeda Hisa (dates unknown)
Title: unknown
Magazine: unidentified
Issue & Date: unknown
Printing Company: unknown